THE PHOTOGRAPHY
OF CRISIS

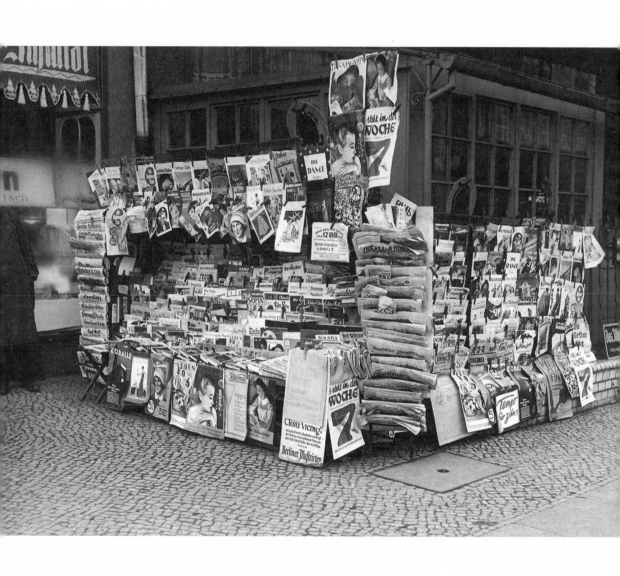

daniel h. magilow

THE PHOTOGRAPHY
OF CRISIS
the photo essays of
weimar germany

the pennsylvania state university press
university park, pennsylvania

An earlier version of chapter 2 has been published as Daniel H. Magilow,
"Photography's Linguistic Turn: On Werner Graeff's *Here Comes the
New Photographer!* and Photographic How-To Manuals of the 1920s,"
in *On Writing with Photography*, ed. Liliane Weissberg and Karen Beckman
(Minneapolis: University of Minnesota Press, forthcoming).

Library of Congress Cataloging-in-Publication Data
Magilow, Daniel H., 1973–
The photography of crisis : the photo essays of Weimar Germany /
Daniel H. Magilow.
 p. cm.
Includes bibliographical references and index.
Summary: "Examines photo essays from Weimar Germany's many social
crises. Traces photography's emergence as a new language that German
photographers used to intervene in modernity's key political and
philosophical debates: changing notions of nature and culture, national
and personal identity, and the viability of parliamentary democracy"
—Provided by publisher.
ISBN 978-0-271-05422-3 (cloth : alk. paper)
1. Photography—Germany—History—20th century.
2. Photography—Social aspects—Germany—History—20th century.
3. Vernacular photography—Germany—History—20th century.
4. Germany—History—1918–1933—Sources.
I. Title.

TR73.M34 2012
770.943—dc23
2012015475

to the memory of mark g. magilow (1943–2009)

contents

illustrations

acknowledgments

The Photography of Crisis: The Photo Essays of Weimar Germany is a project over a dozen years in the making, and in that time I have incurred countless intellectual debts to a great many colleagues, friends, institutions, family members, and others whose help and support made this book possible. I apologize in advance to anyone whom I have forgotten to acknowledge by name but who deserves my thanks.

Michael W. Jennings of the German Department at Princeton University deserves thanks for teaching me to be a better reader, writer, and thinker. Other colleagues who commented on my work at various stages and who deserve special thanks are (in alphabetical order) Chad Black, Megan Bryson, Elizabeth Cronin, Robert Ehrenreich, Steven Feldman, Christian Goeschel, Chris Hebert, Krista Hegburg, Rajka Knipper, Susan Magilow, Elizabeth Otto, Simone Schweber, Robert Stolz, and David Tompkins. Lisa Silverman merits special thanks for her close reading of and meticulous commentary on the entire manuscript.

Institutional funding from the German Academic Exchange Service (DAAD) helped afford me the access to resources and the time necessary to complete this book, as did the support of the University of Tennessee's Department of Modern Foreign Languages and Literatures, the University of Tennessee's Exhibit, Performance, and Publication Expenses Fund, and the University of Tennessee Humanities Initiative. So too did funds granted through a Pearl Resnick Postdoctoral Fellowship at the Center for Advanced Holocaust Studies, United States Holocaust Memorial Museum. I am grateful to the Emerging Scholars Publication Program at the Center for Advanced Holocaust Studies for its support in the preparation of the manuscript and of the book proposal, although the statements made and views expressed are solely my own. Thanks are also due to the staff of The Pennsylvania State University Press for their myriad efforts.

Most of all, however, I thank my family for their support through what has not always been an easy process. For their love and companionship I thank Andrew, Stephanie, Avner, Madeleine, Susan, and Marian Magilow, Greg Freed, and, of course, canine companions Raoul and Rifke. I dedicate this book to the memory of my father, Mark G. Magilow (1943–2009). While he sadly did not live to see the completion of this project, his influence and memory inhabit each and every page.

introduction
the photography of crisis: the visual turn
and the photo essays of weimar germany

A 1932 photograph of a newsstand on Berlin's Kaiserallee by Friedrich Seiden-
stücker presents not only a typical view of modern city life but also the setting, plot,
and characters of a critical drama of modern media and cultural history (fig. 1).
Throughout his sixty years as a professional photographer in Berlin, Seidenstücker
captured scenes of German culture in flux. At the time he took this photograph,
newsstands like these had become regular features of the urban street. Corner kiosks
sold tabloid-format newspapers and magazines well suited for easy reading during
the commute on Berlin's rapidly growing and increasingly crowded subway. Seiden-
stücker's newsstand overflows with newspapers and magazines—966, according to the
photograph's caption—but even so, it probably did not stand out too much amid
the booming street culture of Berlin in the late 1920s and early 1930s. To the con-
trary, it surely fit in seamlessly with the myriad surfaces of modern urban life: the
ubiquitous signs and advertisements, many in flashy typefaces or neon; the enticing
shopwindows with dioramas of the latest modern conveniences; and movie theaters
so self-consciously decadent that they were called palaces. Were it not for Seiden-
stücker's decision to record this moment of daily life in the Weimar Republic—
Germany's short-lived and ultimately failed experiment in democracy from 1919 to
1933—this corner kiosk might simply have faded into history.

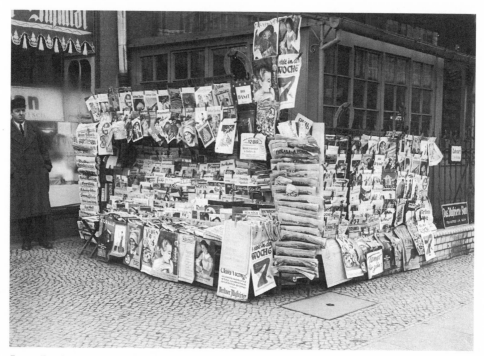

Fig. 1 Friedrich Seidenstücker, "Zeitungskiosk mit 966 Exemplaren in der Kaiserallee" (Newspaper kiosk on the Kaiserallee with 966 titles), 1932. Berlinische Galerie, Berlin. © Bildarchiv Preußischer Kulturbesitz.

Yet Seidenstücker's image also represents a dramatic juncture in German history. It captures a moment at the end of the Weimar Republic as Germany transitioned from an unstable democracy with fierce ideological divisions and a teeming culture into a one-party society that embraced war and ultimately genocide. In a crude sense, the newsstand looks like a kind of theater. Its columns, racks, and piles of newspapers and periodicals create a proscenium. Recessed layers of periodicals form an orchestra pit and stage covered by a curtain of illustrated newspapers. A bystander within the image and viewers outside of it together stand in for both anxious German audiences of the early 1930s and a posterity still curious about the drama whose outcome became the twentieth century's focal point. Even the newsstand's location on Berlin's imperially named Kaiserallee (Emperor's Avenue) points to a broader historical drama: today, that same avenue carries the decidedly less imperial name Bundesallee (Federal Avenue). What exactly was this drama that took place toward the end of the Weimar Republic, and how does Seidenstücker's image of a crowded Berlin newsstand offer a new entry point into it? What is it about photography, in other words, that distinctively helps us investigate the political, aesthetic, and social crises of Weimar Germany? At least in part, the answers lie in the publications that the photograph depicts, for they form both this drama's medium and its message.

One might better understand the moment and broader context that Seiden-stücker captured by reading the photograph as his contemporary Siegfried Kracauer might have. To the journalist and cultural critic Kracauer, photography is photography not because of what it depicts—here, a newsstand on a city street—but by virtue of what it interrupts—in this case, the sensory overload of modern city space. In this light, Seidenstücker's photograph embodies a series of conflicts precisely because it is a photograph: it records the fast pace of Weimar modernity in a medium that, through its muteness and paralysis, forms the antithesis of modernity's intensified nervous stimulation.[1] Or as Eduardo Cadava has put it, "The significance of photography lies not with its ability to reproduce a given object, but rather with its ability to tear it away from itself."[2] We observe in Seidenstücker's image the paradoxical notion of a frozen moment of a culture in flux. In 1932, Germany was mired in the depths of the Great Depression, and unemployment figures reached their peak of more than six million that year.[3] Meanwhile, street clashes between Communists and National Socialists produced what one commentator called a "schleichender Bürgerkrieg" (creeping civil war).[4] Yet in this photograph, Weimar Germany's fast pace, its thrills, its energy, but also its chaos and crises, grind to a standstill.

Seidenstücker's newsstand represents one of the most important sites where German thinkers established Weimar Germany's lasting cultural legacy. Public intellectuals such as Kracauer published not only books, novels, and academic studies but also articles, essays, and feuilletons in the specialized and mass media. Kracauer developed his theories about mass culture's effects on the middle class both in books such as *Die Angestellten* (*The Salaried Masses*) and in the feuilletons he published as the film critic for the *Frankfurter Zeitung*. In addition to book-length works such as *Einbahnstraße* (*One-Way Street*) and *Ursprung des deutschen Trauerspiels* (*The Origin of German Tragic Drama*), the German Jewish philosopher and cultural critic Walter Benjamin eked out a living through book reviews and articles that appeared in popular newspapers and literary reviews such as the *Vossische Zeitung* and *Die Literarische Welt*. Countless other examples attest to key intellectuals' interest in shorter essayistic and journalistic forms. This interest transcended political boundaries: key right-wing figures also advanced ideas in book-length forms as well as in the journalistic realm. For instance, alongside *Das abenteuerliche Herz* (*The Adventurous Heart*) and *Der Kampf als inneres Erlebnis* (Struggle as inner experience)—two extended texts that glorified his experiences in World War I—Ernst Jünger spread his protofascist ideas in publications with provocative titles such as *Das Reich* (The empire), *Widerstand: Zeitschrift für nationalrevolutionäre Politik* (Resistance: Journal for national revolutionary politics), and *Der Vormarsch: Blätter der nationalistischen Jugend* (The forward march: Magazine of the nationalist youth). In short, the debates and arguments, as well as the street fights and riots, that pockmarked Weimar Germany's politically fractured landscape replayed themselves not just in books, scholarly

journals, and other traditional intellectual venues. They also took place in the rhe-torical struggles on the pages of the popular press and in a diverse array of narrative photographic forms.

The publications on Seidenstücker's newsstand are thus not significant merely because photographs appeared alongside their record of Weimar Germany's key debates. Rather, they used photographs in new ways—in novel essayistic forms that did more than just illustrate the text. As the sites of political debate changed, so too did the forms in which those struggles unfolded. The turbulent final years of the Weimar Republic provided the stage for an important development in visual repre-sentation: the photo essay. The sequencing or arrangement of photographs to tell stories, make arguments, communicate ideas, elicit narratives, evoke allegories, and persuade listeners to accept new ways of seeing and thinking had accompanied the medium since its origins in the early nineteenth century. But while the photo essay did not, strictly speaking, debut in Weimar Germany, the combination of text and image in a way that shifted the terms of their interaction found its first starring role there.[5] Just as Germany's most significant writers and thinkers advanced arguments in both the popular media and extended book-length works, so too did its most important photographers intervene in these same debates through the use of a vari-ety of photo essay forms. Like their colleagues who published scholarly books as well as journalistic works, they published not only photo stories for the illustrated press but also longer book-length photo essays about more abstract philosophical and cul-tural concerns. In the late Weimar period, before television's heyday, the photo essay flourished as a central, ideologically charged artifact.

Whereas for much of the nineteenth century, photography had been a techni-cally complex activity associated with fine art, it had by this time become a practice in which a general, nonspecialist population could partake simply by depressing a button. Advances in printing technology had made it possible not only to reproduce photographs on paper but also to make thousands of copies of those images and dis-seminate them in books, newspapers, and advertisements to a new and increasingly urban mass market. As it became possible to produce photographs almost as easily as language, photographs took on new roles in original forms. To be sure, photography had never been limited exclusively to illustrating text. But the emergence of forms that more ambitiously replicated the functions and effects of traditional written lan-guage suggests that in the cultural crucible of Weimar Germany a significant and lasting shift occurred in how we understand text and image.

This book examines an especially significant moment of this visual turn—the development of the Weimar photo essay—through readings of several seminal works and examinations of the discursive contexts in which they appeared. The newspaper photo stories alluded to in Seidenstücker's image as well as other forms, including

portrait collections, book-length assemblages of nature photography, and exper-
imental modernist photobooks, all reveal photography's broad linguistic dimen-
sions. Photographers could organize photographs with greater and lesser degrees
of structure and use them to tell stories, make arguments, communicate ideas, and
persuade listeners to see, think, and ultimately act in new ways. To the reader, stu-
dent, and scholar of Weimar Germany today, the photo essay provides a unique lens
through which to read, or rather reread, this tumultuous but exciting era in modern
German history and to examine a profound sense of enthusiasm for a new represen-
tational technology.

If, as theorists ranging from Georg Simmel to Walter Benjamin have suggested,
modernity consists of a series of shock experiences, then the photo essay, which very
literally depends on instantaneous clicks and exploding flash bulbs, allows moder-
nity to illuminate itself by means of a form constructed from these very shocks. The
photo essay opens up a critical period of German cultural history by utilizing one of
that period's unique forms of self-representation. We see this era's dramas and crises
"acted out" in photo essays, and, consequently, reading the photo essays from the
later years of the Weimar Republic lets us excavate and reconstruct key debates with a
level of detail unique to photography. We can then see how the ostensible "objectiv-
ity" of photographs in fact skewed and molded the ways in which audiences perceived
the world around them.

By the mid- to late 1920s, German photographers, thinkers, and critics—clearly
influenced by the ubiquity and popularity of such varied forms of narratively orga-
nized photography—commented explicitly on photography's "language-like" abil-
ities. In 1928, using the phrase that Walter Benjamin would later famously cite in
"Little History of Photography," the painter, photographer, and Bauhaus profes-
sor László Moholy-Nagy noted in his essay "Fotografie ist Lichtgestaltung" (Pho-
tography is design with light) that the illiterates of the future would be those who
could not read images, rather than words.[6] Writing in *Das Kunstblatt* (The art paper)
in 1928, Johannes Molzahn, another painter and photography enthusiast, appealed
to his readers with the title "Nicht mehr Lesen! Sehen!" ("Stop Reading! Look!").[7]
He too highlighted photography's affinities to written language by implying that
photographs could do the work of written words. Benjamin, Moholy-Nagy, Mol-
zahn, and many others demanded that photography not be defined and understood
solely in opposition to painting or other art forms. Photography was not simply a
form of painting for the artistically unskilled. Rather, it was to be understood in
terms of its own capabilities and limitations as a medium—of which signification
akin to writing was a part. In their own lifetimes, writers and photographers had
seen this potential realized and exploited in entirely new ways. It was becoming clear
that photography was coming into its own as a means of communication. In 1927,

Albert Renger-Patzsch argued in the German photography annual *Das Deutsche Lichtbild* (The German photograph) that this uniquely modern medium must be understood on its own terms. "Let us . . . leave art to the artists," he wrote, "and let us try to use the medium of photography to create photographs that can endure because of their *photographic* qualities—without borrowing from art."[8]

This book approaches this moment of the visual turn in German modernism with the fundamental premise that the diverse manifestations and subgenres of the photo essay in Weimar Germany were both a reflection of and contributor to the enormous changes in culture, society, and technology during this tumultuous period. As Pepper Stetler has eloquently argued with reference to photobooks, these forms "staged dialectics of unity and fragmentation, coherence and discord that were at the heart of visual experiences in the Weimar Republic."[9] But photo essays were not limited to art books. Different photo essay genres—whether one-page illustrated text-image news stories in illustrated magazines, nature photography anthologies, physiognomic portrait books, or experimental photo essays—did more than just document the complex dreams, aspirations, realities, and crises of Weimar Germany. German photo essays of the late 1920s and early 1930s blossomed as a distinctly modern, technologically inflected vehicle used by writers and photographers to participate in crucial aesthetic, political, and cultural debates. Yet for all of the familiar focus on Weimar cinema, scholarship has not paid nearly as much attention to photo essays, even though millions of readers encountered them in illustrated magazines and books and even though twenty periodicals (illustrated and otherwise) were sold for every movie ticket.[10]

Toward a Definition of the Photo Essay

Many of the photo essay forms that this book documents and interprets have previously been examined individually—most often in the context of artworks by individual photographers—as examples of the burgeoning practice of photojournalism in illustrated magazines or as examples of the photobook.[11] Scholarship has not, however, considered these ostensibly discrete photographic forms together as legitimate objects of comparison, because to today's viewers they do not appear to be so similar. A one-page photoreportage with low-quality photographs printed in a disposable illustrated magazine may seem to have little in common with an experimental photobook published in a limited luxury edition. Yet contemporaries in Weimar Germany understood these varied forms of narrative photography as belonging to the same visual turn about which Benjamin, Moholy-Nagy, and Molzahn spoke. Writers, photographers, editors, and cultural commentators viewed the traffic in

photographs and the new ubiquity of photographically illustrated books, magazines, advertisements, and other publications as, in one journalist's words, "a sign of the times."[12] The photographers who published photobooks with more explicitly aesthetic pretensions regularly sold individual images to photographically illustrated magazines known as *Illustrierten* to be used in these publications' own forays into narrative photography.

Moreover, these diverse photo essay forms evince shared concern with the pressing (and also not so pressing) political and social issues of their time and the optimistic view that photography could help resolve them: the fragility of Weimar democracy after the compounded crises of defeat in World War I, including political revolution and hyperinflation; the profound transformations of the natural world in the modern age; the perception that Germany faced a critical identity crisis of world-historical importance; and, of course, the manifold new forms of diversion and recreation available in a modernized world. Photographers with profoundly heterogeneous political and aesthetic leanings and thematic interests in Weimar Germany produced important works about a long list of important topics. The Bauhaus-trained photographer Moishe Vorobeichic reflected on the fate of Jews in the face of modernity and secularization in *Ein Ghetto im Osten: Vilna* (*The Ghetto Lane in Vilna*). Else Neuländer-Simon, working pseudonymously as Yva, composed picture stories for the culture magazine *Uhu* about changing gender roles and the figure of *die Neue Frau* (the New Woman).[13] Essayist and satirist Kurt Tucholsky teamed with the Dadaist photomonteur John Heartfield to criticize rabid nationalism in *Deutschland, Deutschland über alles.* And architect Erich Mendelssohn dissected Germany's love-hate relationship with America in *Amerika: Bilderbuch eines Architekten* (*America: An Architect's Picture Book*).[14] These examples—and there are many more—speak not only to the wide range of topics that photo essayists addressed; they also point to a new but, as we shall see, ultimately misguided confidence in the roles photo essays could play in shaping opinions in ways that words or images on their own did or could not. In photo essays, photographs may have functioned like written or spoken language, but as with written or spoken language, they could also be co-opted and misused.

Aside from their common historical origins and shared thematic interests, photo essays are also significant as a marker of an important aesthetic change more often considered in the context of written language. Like the major works by modernist authors such as Alfred Döblin, Marcel Proust, or James Joyce, narrative photography participated in modernism's challenge to traditional modes of reading and understanding. The presence of photographs in print media demanded that audiences learn to read the pages in front of them in new ways. Regarding the relationship of text and image in interwar Europe, art historian Matthew S. Witkovsky has rightfully suggested that photo essays "shifted the traditional terms of their interaction."[15]

The diverse photo essay forms of Weimar Germany are evidence of this shifting, which makes it possible to think about them together under an umbrella of conceptual unity that today may not seem as self-evident.

Many contemporaries indeed recognized such a shift. In the photobook *Es kommt der neue Fotograf!* (*Here Comes the New Photographer!*), Werner Graeff celebrated photography's power in various fields of human endeavor, including art, science, journalism, and advertising. Assembled in connection with the Deutscher Werkbund's 1929 Film und Foto (FiFo) exhibition—a retrospective look at the vast changes in recent visual culture—Graeff's book also provided examples of distinct forms of photographic texts. Alongside examples of "art photography," including camera-less photograms, photomontage, and sharply focused still lifes, Graeff singled out photography's commercial and functional uses, especially in newspaper photoreportage, advertising, and propaganda. All of these forms appeared in a book that, as we shall see, self-referentially exemplified a broad-based and historically unprecedented openness on the part of photographers and readers to this modern medium's myriad rhetorical possibilities. If we consider the photo essay and its constituent subgenres—both those today considered closer to art and those considered more akin to journalism—we can envisage how contemporaries understood these different kinds of photography. It also helps us grasp the photo essay's development, including the new ubiquity of the photograph and the new receptivity to photography, as part of a broad-based cultural trend in Weimar Germany.

Whatever their physical appearance or aesthetic status today, Weimar photo essays share other significant affinities, particularly as commodities produced and consumed in a bustling consumer economy. The works of August Sander and Albert Renger-Patzsch offer two useful examples. Like many of the photographers known for their art books, both Sander and Renger-Patzsch were, in their "day jobs," commercial photographers who took portraits (Sander) and photographed industrial objects (Renger-Patzsch) for clients, and they also sold photographs to image-hungry Illustrierten.[16] Sander's business correspondence contains exchanges with Peter Suhrkamp, the editor of the Ullstein publishing company's culture magazine *Uhu,* that show he understood the various uses of his photographs, both in newspapers and in his photobook *Antlitz der Zeit* (*Face of Our Time*), as interrelated and not mutually exclusive. Similarly, as part of the pre-Christmas marketing campaign for *Die Welt ist schön* (*The World Is Beautiful*), the *Berliner Illustrirte Zeitung* published a short photo story with Renger-Patzsch's photographs and a laudatory review by Thomas Mann on December 23, 1928. Such examples underscore the value of approaching the photobooks for which photographers are best known today alongside the other photo essay forms, including more ephemeral ones such as photoreportage, in which their work sometimes appeared. These varied photo essay forms were all part of a new traffic in

photographs that revealed the thorough interconnectedness of the previously more autonomous realms of commercial photography and art photography. All were possible because of a new receptivity to, and new optimism about, mechanically produced imagery.

Scholarship has not generally considered the many interrelated but discrete photo essay genres with an eye to how they developed in the specific cultural-historical milieu of Weimar Germany. What has emerged instead is a scholarly literature that focuses more on individual photo essay subgenres than on their shared conceptual frameworks and historical commonalities. In other words, the focus tends to be on what photo essays mean today rather than on what they meant in their own time. For instance, the two-volume work *The Photobook: A History,* by Martin Parr and Gerry Badger, elides photo essay subgenres, including portrait books, anthologies, and literature/photography hybrids, framing them primarily as fetishizable objects for art-historical connoisseurship or aesthetic contemplation. Photo essays from Weimar Germany receive no special attention in spite of their influential and pioneering role in the form's development.[17] Parr and Badger define the photobook through references to other art forms such as the "literary novel" and as a work akin to the output of the cinematic auteur. Such scholarship, which also includes Andrew Roth's *The Book of 101 Books* and *The Open Book: A History of the Photographic Book from 1878 to the Present,* often appears in the context of exhibition catalogues. This trend in scholarship demarcates the photobook as a discrete and aesthetically autonomous object. Such fetishistic interest in this type of photo essay derives more from an appreciation of photo essays' physical form than from extensive interest in their conceptual unity. How these works functioned in their day as *narratives* is especially downplayed, oversimplified, or ignored.[18]

Along similar lines, scholarship on photoreportage does not typically consider the interconnectedness of newspaper photo stories and photobooks. Discussion of the journalistic photo essay often appears in histories of a "golden age" of photojournalism, where it is understood in isolation and with a profound degree of nostalgia as a moment in the history of journalism that television and later the Internet have rendered quaintly anachronistic.[19] Histories such as Tim Gidal's firsthand accounts of the origins and evolution of modern photojournalism rightfully emphasize the novelty of photoreportage in Weimar Germany and the pioneering roles of certain figures.[20] But they generally do not integrate the formal achievements of newspaper photo stories and their focus on using images to tell stories, construct arguments, and communicate into broader trends of narrative photographic forms and the profound enthusiasm for them in Weimar society. At the same time, these studies retroactively construct the world of interwar German photojournalism as an "all-boys club" of intrepid male reporters and downplay or completely ignore

the contributions of Germaine Krull, Lotte Jacobi, Annelise Kretschmer, Alice Lex-Nerlinger, Else Neuländer-Simon (Yva), and other important women photographers. The gendered narrative of photojournalism would, decades later, have to be correctively reinscribed into the foundational story of Weimar photography.[21]

Interpreting the Photo Essay

For all of the formal and thematic diversity apparent in the photo essay's constituent subgenres, what unites these forms is not what they *are* as objects but what they *do* as forms of narrative. This naturally invites two questions: What do they in fact do (or, at least, what did they try to do) and how should one approach them? Just as modernist literature's narrative strategies of interior monologues, collage, and self-reflexivity challenged traditional modes of reading, so too did photo essays make reading into an interactive endeavor resembling a kind of game.[22] If the complicated and quasi-linguistic relationships between individual photographs and an entire photographic narrative presented new opportunities for authorial expression, they also challenged traditional modes of reading. Readers encountered photo essays in familiar venues, particularly in the popular press and in books that, through their formal novelty and thematic focus, demanded that they be read with attention to their proximate historical contexts. Photo essays structure relationships between their parts (individual photographs) and their whole (the entire narrative) with greater and lesser degrees of narrative unity. In some cases, as in photographic anthologies, subject matter presented in an introductory text creates structure by virtue of thematic commonalities. In illustrated magazines, commercial considerations such as advertising space, the need for attractive images, and even the boundaries of a tabloid-size page (or pages) condition the look and feel of individual photo stories. In still other cases, as in the photobooks *Face of Our Time* by Sander and *The World Is Beautiful* by Renger-Patzsch, subtle formal traits or narrative rhythms govern the sequencing of images, and textual accompaniment is relegated to short captions, checklists at the back of the book, or extended narrative introductions.[23]

This diversity of narrative structures carries with it the demand to develop new modes of reading. This book takes as its interpretive approach to the Weimar photo essay a hermeneutic model that Walter Benjamin articulated in his *Denkbild* (thought figure) "Brezel, Feder, Pause, Klage, Firlefanz" ("Pretzel, Feather, Pause, Lament, Clowning"). Benjamin described a Biedermeier-era parlor game that offers a useful conceptual model for thinking about how, specifically, photo essays construct, reconfigure, and even resist our attempts to read and interpret them. In the parlor game, each player had to link a series of ostensibly unrelated words into a coherent

sentence.[24] The goal was to construct the shortest sentence possible out of the given words. Benjamin imagines the creative movement between these parts as a paradigm for all forms of reading and writing, noting that "in reality, something of this perspective is contained in every act of reading."[25] Photo essays complicate this further because they consist of another set of symbols—photographs—that have generated their own mythologies of straightforwardness and immediacy. Those symbols are inscribed, organized, or sequenced into an additional syntactic structure. Although composed of discrete images, this sum (the photo essay) is greater than its parts (photographs and words).

The entirety of the montage of images in a photo essay becomes what Umberto Eco has theorized as an "open work," one that "produces in the interpreter acts of conscious freedom, putting him at the center of a net of inexhaustible relations among which he inserts his own form."[26] This new mode of textuality both invokes and differs from traditional forms of reading and writing. In their various guises, photographic narratives and sequences evoke explicit or implicit meanings for readers. The burden of interpreting those meanings falls to the readers, who must mediate a photograph's denotative and connotative dimensions. With some photo essay genres—notably photo stories in illustrated magazines or explicitly didactic photobooks such as Graeff's *Here Comes the New Photographer!*—titles, captions, accompanying articles, and introductory essays quickly constrain interpretive possibilities and elicit specific interpretations. With other forms, however, especially those in which images feature only captions, "overreading" emerges as a significant danger for photographic narratives. Photography criticism is particularly susceptible to accusations of what Colin Davis has termed "critical excess."[27] The reason for accusing critics of overreading rests largely on the received but misguided tendency to "underread" images—that is, to subscribe to the naïve rhetoric of photographic indexicality and transparency and the corollary belief that photographs do not require interpretation because they somehow "speak for themselves." In other cases, the act of critical photographic interpretation is perceived as an affront to the beauty of the photograph as an artwork.

A final issue related to the method of interpreting diverse photo essay forms is that of nomenclature. Why is the form called a photo *essay* and not, for instance, as W. J. T. Mitchell asks, a "photo novel" or "photo lyric"? And what do such names imply? In posing this question, Mitchell rightfully stresses affinities between diverse photo essayistic forms (photoreportage, photobooks, anthologies) and the referential and experimental qualities of personal and informal essays. Mitchell notes that one typically encounters essays (traditional or photo) in the context of books, magazines, newspapers, or other print media. In that both written essays and photo essays emphasize private viewpoints, personal memories, and autobiographical concerns,

a cultural history of the visual essay form is wise to combine "literary" or "textual" approaches with historical contextualization or photographic criticism.[28] The generally reflective, subjective, and unsystematic nature of essays nevertheless poses very real difficulties for scholarship. Theodor Adorno suggested as much in "Der Essay als Form" ("The Essay as Form") when he argued, "The essay . . . does not let its domain be prescribed for it."[29] Studies of the German essay tradition range from Ludwig Rohner's multivolume attempt to establish a canon of German essays (on the one hand) to Adorno's objection (on the other) that the object of evaluation will necessarily cause any such totalizing approach to fail.[30] Writing a history of the photo essay presents similar challenges.

The enormous number of photo essays that appeared in Weimar Germany offers a rich corpus from which to choose examples of the form's many manifestations and subgenres. This book offers a historically informed interpretive history of the Weimar photo essay based on close readings of examples by well-known photo essayists of the time. The subsequent chapters present analyses of their works, which speak to the diverse range of photo essayistic forms: photobooks marketed in connection with important art exhibitions that announced new roles for photography; photo stories about current events in Illustrierten, which became the public laboratories for experimentation with photographic narratives; portrait books that influenced intellectuals and public opinion; and photo essays that provided grist for propagandists across the political spectrum. Although one could easily include other works in lieu of or in addition to those addressed here, I have chosen instead to structure this cultural history of the Weimar photo essay in a manner similar to the form it analyzes: this study selects revealing examples from a larger corpus of texts and, like the player in the Biedermeier parlor game, navigates them in, one would hope, an interesting and elegant manner.

Chapters 1 and 2 present broader background on the aesthetic and cultural context of Weimar Germany through readings of photo essays that were explicit about their status as photographic narratives. Chapter 1 historicizes the controversies surrounding photography at the time by examining Graeff's highly self-referential work *Here Comes the New Photographer!* Graeff's popularization of the principles of the constructivist avant-garde movement known as the *Neues Sehen* (New Vision) stands out for many reasons. Most of all, it was a key indicator of the new receptivity to and optimism about the new photographic forms that became a hallmark of the visual culture of Weimar Germany. Graeff self-reflexively draws attention to his use of photography, but for more programmatic purposes. His book not only catalogues the various formal techniques that photographers used in photo essays but also directly refutes critics' objections to photography. Graeff accomplishes these rhetorical goals performatively. In *Here Comes the New Photographer!* he does not simply

advocate for photography; he uses a photographic narrative as his vehicle of choice for promoting a new medium and its communicative possibilities.

Chapter 2 examines the crucial intermediary space between still images and book-length photo essays: the popular photo stories of Illustrierten, Weimar Germany's photographically illustrated magazines, where the reading public most frequently encountered narrative photography. Although contemporary critics attacked the image-heavy Illustrierten as sensational examples of a "dumbed-down" culture, these magazines offered an important space for experiments in photographic form, both by editors such as Kurt Korff and Stefan Lorant and by star photojournalists, some of whom published book-length photo essays alongside their work as freelance or commercial photographers. When these same photographers published photobooks, they did so fully cognizant of the impact of formal sequencing on the ways in which their photographs conveyed meaning. As a close reading of the photo essays within a single issue of Lorant's *Münchner Illustrierte Presse* shows, however, Illustrierten were not simply a sign of a broader shift in sensibilities toward images; they played an active role in that shift by enthusiastically showcasing how they used photography. They regularly trumpeted photography's potential to teach readers a new way of seeing and interpreting the complex world around them, and in their layouts they encouraged specific modes of perception vis-à-vis groups of multiple photographs. Nevertheless, as we shall see, this optimism about technology proved to be misguided. Rather than demystifying the complexity of Weimar Germany, Illustrierten merely added more layers to it. Through new forms and new formal techniques, illustrated magazines presented narrative photography as a path to greater knowledge and enlightenment about the rapidly changing world. Yet these same forms and techniques were readily co-opted for reactionary purposes, even if they maintained the sheen of "the new."

Unlike the short photo stories of Illustrierten or a polemic such as *Here Comes the New Photographer!,* which actively guided readers through accompanying text and captions, extended book-length photo essays (photobooks) more actively segregated text from image. This photo essay form became an important means by which photographers addressed pressing philosophical and cultural concerns of Weimar Germany. Chapters 3, 4, and 5 present case studies of sets of photobooks that coalesced around specific thematic interests. These chapters examine how photo essays can be understood as being in dialogue with other photographic forms as well as traditional essay forms. Chapter 3 argues that photobooks constructed from still photographs of flowers and landscapes—ostensibly benign subject matters—were in fact a way for photographers to participate in heated debates about urbanism and modernization. Albert Renger-Patzsch's *Die Welt ist schön* (*The World Is Beautiful*) and Paul Dobe's *Wilde Blumen der deutschen Flora* (Wildflowers of German flora) offer antagonistic

arguments about nature, a category regularly invoked in literary and philosophical texts to criticize urbanism, to justify back-to-basics social practices ranging from dietary reform to physical fitness, and to justify racist ideologies. As a thematically organized set of flower photographs with an incendiary introductory text, Dobe's photobook rather uncritically venerates "the natural." By contrast, Renger-Patzsch's photobook lends itself to a reading more in line with a culture whose expressions of a "return to nature" ethos were as varied as nudist *Freikörperkultur* (free body culture) and youth-based scouting movements such as the *Wandervogel* (literally, migratory bird). Through a contrapuntally sequenced photo essay, Renger-Patzsch argues against those who would uncritically venerate nature as the cure for all of the modern world's ills. First, he establishes a narrative rhythm of thematically linked photographs. He then introduces jarring images that radically shift the narrative flow. The end result is a photographic series inviting readers to question the reductiveness of the "return to nature" idealism that held such currency among *völkisch* nationalists, those invested in the idea that their identity was linked organically to German blood and German soil.

From this discussion of the "nature of nature" discourse in the photobook, chapter 4 moves to a more specific analysis of the "German condition" by examining the role of another photo essay subgenre, the portrait collection, in Weimar-era debates on national and racial identity. Alongside photobooks such as Helmar Lerski's *Köpfe des Alltags* (Everyday heads) and Erna Lendvai-Dircksen's *Das deutsche Volksgesicht* (The face of the Germanic folk), August Sander's *Antlitz der Zeit* (Face of Our Time) invokes the rhetoric of physiognomy, the belief that external bodily characteristics are indicative of deeper psychological and spiritual conditions. Featuring a sequence of portraits organized in a rise-and-fall narrative structure that accords with a model theorized by Oswald Spengler, whose work Sander admired, *Face of Our Time* offers a damning allegory of Weimar Germany. Through portrait photography, Sander participated in the widespread contemporary interest in Germany that sought to come to grips with its identity crisis and to diagnose and define it amid the economic and political turmoil of the 1920s and early 1930s. Sander's photobook concurrently provides a new optic through which to read Walter Benjamin's *Deutsche Menschen* (*German Men and Women*), an essayistic, chronologically organized collection of letters expressing similar interests in physiognomy, photography, and defining the time. Elsewhere Benjamin paid homage to Sander (famously calling his work a "training manual"), but ultimately he critiques Sander's faith in the use of photographic typologies and individual examples to make broader claims about German identity. Benjamin uses language to do the work that Sander does with photographs, but he arrives at a different conclusion. He maintains an optimism about Germany, even though he published his book in 1936 during the dark years of fascism. The implicit

dialogue between these works stresses the photo essay's important links to the Weimar culture of feuilletons and essay writing.

Chapter 5, the final set of readings, considers two photo essays constructed from snapshots: star photojournalist Dr. Erich Salomon's *Berühmte Zeitgenossen in unbewachten Augenblicken* (Famous contemporaries in unguarded moments) and Ferdinand Bucholtz and Ernst Jünger's anthology *Der gefährliche Augenblick* (The dangerous moment). These works represent two different photo essayistic responses to Weimar Germany's rhetoric of crisis, struggle, and the decisive moment. Their authors used photography to address this widespread and inflated rhetoric. However, whereas the photobook by the socially well-connected Salomon offers a more affirmative view of parliamentary democracy—albeit one that, considering Salomon's vulnerability as a German Jew, appears strikingly naïve in retrospect—Bucholtz and Jünger explicitly celebrate danger and condemn the reigning liberal order. These works stage an implicit debate about who controlled discourse. While loaded words and phrases such as *Kampf* (struggle) and *Moment der Entscheidung* (moment of decision) have become synonymous with the Right and its attempts to expand its popular appeal, Salomon's work shows that these terms—and the historical situation in which they were anchored—were far from predestined in Weimar Germany.

By way of conclusion, this book reflects on the culture of German photo essays in the period following 1933 and beyond. Many of the notable figures of Weimar Germany's photo essay culture went into exile or, as in Salomon's case, met their deaths in concentration camps. At the same time, however, photo essays and photobooks continued to blossom. Even before 1933, the new modes of perception that photo essays encouraged were being co-opted for propaganda purposes, and after the rise of National Socialism this trend continued in force. Modernist photography and narrative photography did not simply disappear. Rather, the new regime adapted them for its own purposes, where they served very different cultural and political roles, with horrific consequences.

1

the new receptivity and the new photographer

Werner Graeff's *Here Comes the New Photographer!*

Although no single photobook epitomizes Weimar Germany's receptivity to narrative photography, one photobook certainly comes close: *Es kommt der neue Fotograf!* (*Here Comes the New Photographer!*) by Werner Graeff. Graeff's work achieved such renown in photography circles that its title became a catchphrase of sorts. By more closely examining how Graeff and the Deutscher Werkbund's 1929 Film und Foto (FiFo) exhibition explicitly and implicitly defined "the New Photography" and "the New Photographer," one can better historicize new attitudes toward photography and the active roles photographers played in forming them. These shifts combined with existing technologies for producing, reproducing, printing, and disseminating photographs and opened the floodgates for the many photo essay forms analyzed in this study's subsequent chapters. Unlike these works, however, *Here Comes the New Photographer!* explicitly used text and image to engage with and indeed to encourage a new and receptive attitude toward photography. What the photobooks of Albert Renger-Patzsch, August Sander, Erich Salomon, and others would later attempt implicitly with their photographic series, Graeff did openly and polemically in *Here Comes the New Photographer!*

The important shift confronted head-on in *Here Comes the New Photographer!* concerns photography's reorientation in relation to the written word. Historians have long noted that interwar photographic avant-gardes helped photography achieve aesthetic legitimacy and institutional recognition in galleries, museums, and

journals.[1] *Here Comes the New Photographer!* points to an equally significant but less examined phenomenon. As photography began to make inroads as museum-worthy art, it also began, in large part through photo essays, to colonize areas of public discourse that theretofore had been almost exclusively the domain of written language and in which photographs served primarily illustrative roles. In Central Europe in the late 1920s, photographs became more than just a tool to illustrate or supplement text. Rather, photographers used them to reconsider the relationship between words and images.[2] Photographs *became* the text, but only when photographers conferred upon them the functions of written and spoken language. In new forms, including the photo essay, photographs fulfilled tasks now taken for granted: they became the vehicles by which photographers could narrate stories, engage in polemics, and have their say in key controversies.

Here Comes the New Photographer! provides a useful case study for historicizing this new relationship among modernity, photography, and language in Germany in the 1920s. The self-referentiality and explicitness with which Graeff addresses these issues speaks to a new receptivity to photography in an increasing range of contexts. Whereas photo stories still used captions and formal layouts to guide readers and whereas, as we shall see, modernist photobooks shifted that work more to readers, Graeff's book serves as a transitional space. It guides readers through its argument with the playfulness of a photo story from an illustrated magazine. Yet, in length and scope, Graeff's argument transcends what he could have accomplished in an illustrated magazine. The presentation of his claims in book form (rather than in newsprint) lends the argument an added degree of permanence and significance that it would otherwise lack.

As evidence of the new receptivity to the repurposing of photography, it is instructive to examine how *Here Comes the New Photographer!* invokes three genres—each traditionally associated with written text—and refits them with photographs. These acts of refitting showcase the optimism that Graeff and many others shared for photography's rhetorical possibilities. First and foremost, *Here Comes the New Photographer!* is a manifesto of one of the signature moments of Central European photographic avant-gardes in the 1920s and 1930s: the *Neues Sehen* (New Vision). Second, it is a training manual, modeled on a reading textbook, for the New Photographer. And, finally, relying as much on images as on the written word for its argument, *Here Comes the New Photographer!* is a vivid example of a Weimar photo essay. In mimicking genres conventionally associated with words, *Here Comes the New Photographer!* makes a uniquely compelling argument that photojournalists and art photographers would implicitly expand upon: not only did photo essays offer a valuable tool with which to confront and debate the challenges of modernity in interwar Germany, but they also substantially altered how ideas could be communicated.

Film und Foto

Just as language depends on context for meaning, understanding *Here Comes the New Photographer!* and the new receptivity to narrative photography it thematized demands that one understand the immediate aesthetic and institutional contexts in which it originated. The five-thousand-copy first edition of Graeff's book quickly sold out when it was published in conjunction with the 1929 Film und Foto exhibition, a massive show widely understood as the New Vision's "coming-out party." Historian of photography Christopher Phillips has defined the New Vision as "part of a wider, utopian project that aimed to teach men and women to contend with the unprecedented demands of an increasingly urban, mechanical age." It also represented a "desire to break with the perceptual habits and the pictorial customs of the past."[3] The New Vision is associated first and foremost with László Moholy-Nagy, the painter, photographer, and teacher affiliated with the Bauhaus, where Graeff studied in the early 1920s. Graeff knew Moholy-Nagy before the latter took over as instructor of the foundation course at the Bauhaus in 1923, and *Here Comes the New Photographer!* is in many ways a popularization of Moholy-Nagy's theories of vision and perception.

In the early and mid-1920s, Moholy-Nagy articulated his opinions of photography's legitimate function in two texts now widely considered canonical manifestoes of the New Vision: his 1922 essay "Produktion-Reproduktion" ("Production-Reproduction") and his 1925 book *Malerei Fotografie Film* (*Painting Photography Film*). Moholy-Nagy believed that photography should facilitate new sensory relationships with the world and valued imagery that managed to construct relationships rather than just represent known ones. In making such a claim, Moholy-Nagy challenged conventional wisdom that had long esteemed photography—and indeed representation in general—as the means to reproduce the world with a high degree of fidelity.[4] Opposing this aesthetic of mimesis—and the pictorialist movement that believed photography should mimic human perception—Moholy-Nagy argued that photographs should allow one to see what previously was invisible. In so doing, he believed, photography could offer new insights about the world. To this end, Moholy-Nagy championed new photographic technologies and forms unique to modernity, including aerial photography, X-ray photography, microscopy, camera-less photographs (photograms), photo essays, and, of course, film. These forms offered exemplary tools with which to see what has been obscured by nature or, more significantly, *second* nature—those myths, beliefs, and ideologies that have become so familiar as to seem naturalized and ahistorical.[5] Moholy-Nagy labeled such genuine forms of seeing "production." At the same time, he disparaged images that simply rehearsed known relationships as mere "reproduction." Here Moholy-Nagy leveled a less than subtle critique of the popular pictorialist style of art photography

that tried to make photographs look like paintings. According to Peter C. Bunnell, two concepts were foremost in pictorialism: first, "that making meaningful, expressive photographs required discipline, considerable intentness and knowledge of the traditional arts," and, second, that "producing a fine photographic print was an act analogous to the creative endeavor in any medium."[6] With their soft-focus aesthetic, pictorialist images sought to reproduce the subtly hazy quality of vision as manifested in impressionist paintings. To Moholy-Nagy and Graeff, however, pictorialism too quickly foreclosed on photography's potential as a vehicle for social change by relegating it to the status of an art form akin to painting.

By privileging production over reproduction, Moholy-Nagy drew attention to the new ways in which viewers interacted with images in modernity, where photographs were no longer simply displayed like paintings in art galleries. Rather, they were increasingly embedded in specific discursive contexts, especially books, newspapers, posters, and advertisements. In such settings, where context conditions how they convey meaning, photographs function as speech acts. Like phrases such as "I apologize," "I pronounce you man and wife," or "You're fired," speech acts do more than just describe the world.[7] They constitute and accompany acts with ethical and legal consequences. Productive photography is ideally a kind of speech act because one rarely separates a photograph from the pragmatic intentions that its context dictates. Advertising photographs and journalistic photo stories are the most obvious examples, but Moholy-Nagy's theory of productive photography also reflected a broader desire: to use photography to revolutionize the senses and, eventually, to revolutionize society and politics.

If Moholy-Nagy's theory of productive photography demanded that mechanically (re)produced images take the lead in shaping human interaction, it will be no surprise that he believed photographs should, like the dialects of human language, come in all shapes and flavors. Throughout the 1920s, photo essayists in general, and photographers of the New Vision in particular, developed a new lexicon of visual techniques, which Graeff surveys and catalogues in *Here Comes the New Photographer!* By the end of the 1920s, these signature techniques had spread well beyond their origins in radical leftist circles, especially among Dadaists, into illustrated newspapers of all political persuasions. These visual strategies today comprise a recognizably familiar visual vocabulary. At the time, however, radical close-ups, unconventional shooting angles, nonrectangular cropping, photomontage, retouching, and other forms of image manipulation challenged the status quo of art photography, which privileged unmanipulated (and ostensibly "authentic") visual impressions. The techniques of the New Vision made photography useful in a greater variety of communicative contexts, particularly those traditionally considered the province of the written word.

By 1929, the Deutscher Werkbund, an organization of architects, designers, and craftsmen who sought to bridge the gap between art and industry, organized

a traveling exhibition about the New Vision and its impact. The exhibition cata-
logue of Film und Foto described the show's purpose thusly: "The development
of photographic equipment, the invention of cinematography, and the perfection
of image-reproduction technology have created an enormous, worldwide field for
[photography's] range and influence. This development came about so surprisingly
that, strangely enough, until today nowhere has the attempt been made to consider
this field in its entirety, to clarify its sphere of influence, and to demonstrate the
potential for its development by showing its best and newest achievements."[8]

At the time that the idea for the Film und Foto retrospective was germinating,
Werner Graeff was a press secretary for the Werkbund. In the late 1970s, reminisc-
ing about the origins of *Here Comes the New Photographer!*, he recalled a conversation he
had in 1929 with Gustav Stotz, the Werkbund's business manager. Stotz commis-
sioned Graeff, not yet thirty years old, to develop two companion volumes for Film
und Foto: *Here Comes the New Photographer!*, about photography, and *Filmgegner von heute—
Filmfreunde von morgen*, co-authored with Hans Richter and loosely translated as *Film
Haters Today, Film Lovers Tomorrow*. In Graeff's words, "[Gustav] Stotz wrote me several
times that I should—no must—do a book about the exhibit. But that was exactly what
I didn't want to do, in that I myself seldom photographed and was also no critic."[9]

Graeff's reservations may in part have been false modesty. In spite of his age,
he was already a published author of two works that appeared in connection with
the Werkbund's 1927 exhibition, Die Wohnung (The Apartment), about Stuttgart's
Weißenhofsiedlung.[10] In the interim, he also published *Eine Stunde Auto* (One-hour
auto) and *Autofahren und was man dazu wissen muß!* (Driving a car and what you need to
know about it!), two drivers' education books. With *Here Comes the New Photographer!*
Graeff could draw on these diverse professional backgrounds—his familiarity with
the Werkbund and its aesthetics as well as his own experiences as a drivers' educa-
tion teacher and author of instructional manuals. He accepted Stotz's assignment
and produced a work that relies on clever turns of phrase while both arguing for
and performing photography's status as a kind of language. With its untranslatable
"existential there" construction, the German title, *Es kommt der neue Fotograf!*, focuses
not merely on the fact that the new photographer is coming. It takes his arrival for
granted. Photography is not something that will have to be reckoned with in the
future. Rather, it is a fact, a given of everyday life, made even more so by the legiti-
mizing gesture of an art exhibition. Consequently, the English title *Here Comes the New
Photographer!* remains a bit of a misnomer; by the time it appeared, photographers
had already found a public widely receptive to new ways of using photographs to
convey information, a receptivity evinced in the popularity of Weimar Illustrierten
and photobooks.

It is more accurate to say that in popularizing the theories of Moholy-Nagy and the New Vision more broadly, Graeff's book heralded not the arrival of photography as art but the concretizing or formalizing of new roles for photographs *beyond* art. *Here Comes the New Photographer!* encourages one to think of photography less as an aesthetic medium that, depending on one's definition of "good art," copies nature, imitates human vision, expresses personal experience, and so on; rather, photography operates as a medium per se, like language, that lends itself to myriad purposes, including—but not limited to—explicitly aesthetic ones. The photoreportage in Illustrierten and the photobooks of August Sander, Albert Renger-Patzsch, Erich Salomon, Ernst Jünger, and others all typify this repurposing of photography in a manner akin to language to address contemporary concerns. In *Here Comes the New Photographer!,* however, this linguistic character reveals itself much more explicitly and self-referentially in the back-and-forth between photography and more traditionally text-based rhetorical forms, which Graeff imitates and expands upon. The first and most conspicuous of such forms is the political manifesto.

Here Comes the New Photographer! as a Manifesto

As a polemical statement of the New Vision's reconceptualizing of photography as language, *Here Comes the New Photographer!* takes on the trappings of a manifesto. In her essay "The Poetics of the Manifesto: Nowness and Newness," Mary Ann Caws describes several relevant characteristics of this form. Manifestoes, as Caws defines them, are self-contained documents, statements of belief, and deliberate attempts to manipulate the public. They "make manifest" certain principles and beliefs, often by juxtaposing them with accepted conventions.[11] Caws further suggests that a manifesto "builds into its surroundings its own conditions for reception," thereby instructing its audience in how to respond.

By this definition, *Here Comes the New Photographer!* is, from its opening sentence, a manifesto not only for photographers but also for those who read photographs. "The goal of this book," Graeff begins on the first page, "is to destroy barriers—not to erect them."[12] Graeff polemically implies that everything one need know about how to make and understand photography lies within the pages of his book. Only photo credits—and not, for instance, footnotes, bibliography, or an academic apparatus—situate the book within its historical context. As a manifesto, it is a polemical form of rhetoric. It constitutes its own authority. And Graeff's modus operandi throughout the work is to compare photographs made according to accepted rules—developed for painting but applied to photography—with those that typify the New Vision.

One can summarize this manifesto's major argument through recourse to the dichotomy of prescriptive versus descriptive linguistics. Extreme prescriptivist linguistics is the normative realm of educators, publishers, and connoisseurs who standardize and value certain forms of language and decry nonstandardized forms as incorrect, degenerate, and corrosive. Descriptive linguistics, on the other hand, is tasked with describing rather than dictating rules. Graeff argues that one should judge photography dynamically and historically based on what it does, not on how well it adheres to certain preexisting rules. In making this claim, he implies that photography, like language, has different "dialects" or realms of action, none of which is better or worse than others. Like language, photography can be normalized and standardized, but those who would dictate rules do so in the service of particular agendas. In diverse ways, from disposable photo stories in Illustrierten to deluxe-edition photobooks, the photo essays of Weimar Germany represent the diversity of these photographic dialects, as well as the futility of defining them in an absolute way.

A key objective of Graeff's project is to expose the normative agendas behind received understandings of photography and image production in general. *Here Comes the New Photographer!* notably resonates with attempts by cubists, Dadaists, and other modernist artists to reveal as constructs ostensibly ahistorical rules. In his seminal 1927 work *Die Perspektive als "symbolische Form"* (*Perspective as Symbolic Form*), for instance, art historian Erwin Panofsky argued that for all of its pretensions to verisimilitude and transcendental truth, rectilinear perspective arose as a distinctly historical phenomenon, a convention of Western painting.[13] Rectilinear perspective uses a variety of devices, such as vanishing points, horizon lines, and the regular diminishment in the sizes of objects, to represent three-dimensional spaces on two-dimensional surfaces.[14] These formal devices negotiate a relationship between the viewing subject and the viewed object. By implicitly claiming to represent space accurately as an infinite, homogeneous whole, Panofsky argued, rectilinear perspective masks diverse symbolic and ideological agendas behind the ostensibly innocent project of simply reproducing the world as it is.

Panofsky's critiques resurface in *Here Comes the New Photographer!,* albeit in a far more populist guise. Like Panofsky, Graeff attacks the established assumption that photography is simply a kind of painting for the untalented, albeit still one with rules that can be mastered. Graeff sets up as argumentative straw men the overgeneralized conventions such as those in *Technik der Lichtbildnerei* (Techniques of photography) by Heinrich Kühn, a leading pictorialist and arguably the most important "art photographer" in German-speaking Europe in the early twentieth century. As late as 1921, Kühn could write with no irony whatsoever that "without a doubt, there are by all means laws, generally valid aesthetic demands on visual composition. A strongly

emphasized slanted line requires in all cases a counterweight; otherwise the image loses its bearing and collapses. Every image must have a middle point, a central motif; otherwise it is not an image, but at most, a view. Light and shadow must be concentrated on the image's most important positions. Exact symmetry of the image's halves is unbearable. The image may not contain two motifs, even those of equal value." Kühn's schema of rules—which continues long beyond this excerpt—imposes the conventions of academic painting on photography. His list ends with the haughty statement "But such things needn't be told to a person of taste. They are to him self-evident."[15] To Kühn, photography is first and foremost an art form, but one that can be defined only through the terms of preexisting media such as painting.

Although such dogmas persisted for decades after Kühn, *Here Comes the New Photographer!* speaks to a key attempt to break their stranglehold over photography. Graeff never cites Kühn—or anyone else—by name, but as a part of his programmatic statement about the need to exploit photography's medium specificity, Graeff contrasts stale images made "according to the rules" with visually striking ones that violate them. The effect of the juxtapositions is obvious. Images that incorporate close-ups, aerial views, photomontage, intentional over- or underexposure, and other avant-garde techniques convey information effectively not in spite of the fact that they violate convention but precisely because they break the rules. If traditional rules and visual protocols encourage one to evaluate an image solely on the basis of its intrinsic qualities and the extent to which it accords with convention, Graeff responds that photographs should be used for particular purposes, that they must "do" something. A "good" image is not simply one that resembles an impressionist painting, as did photographs of the soft-focus pictorialist style popular in Europe for much of the early twentieth century. Rather, a photograph's value depends on its ability to communicate a specific message in a specific context. By referring to the many lucid examples included in his book as well as to newspaper photo stories and the works of well-known photo essayists, Graeff shows how images considered "flawed" according to traditional aesthetic standards communicate information in effective and compelling ways.

"Ah, the Renaissance painters!.," one example begins with characteristic sarcasm. "They caused this strange confusion among today's photographers! Their teachings about perspective!" (fig. 2). Then, above a picture of a city promenade that stretches unobstructed to a vanishing point, Graeff writes, "We don't have any objections against precisely regulated perspective like this." Below the picture, however, he adds in a snide parenthesis, "Except for maybe that it's rather boring. . . . Ultimately, we do not always march down the street with a gaze that is as straight as an arrow." Graeff then presents a playful photomontage—without any vanishing points—that represents this point visually. In it, the same man appears to walk in multiple directions

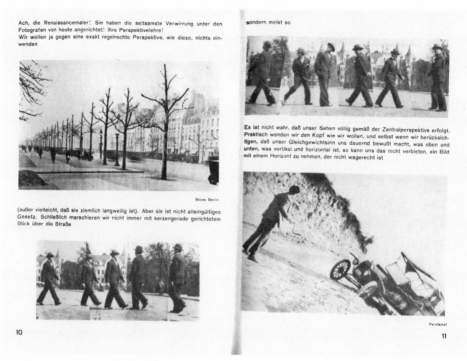

Fig. 2 Werner Graeff, *Es kommt der neue Fotograf!* (Berlin: Hermann Reckendorf, 1929), 10–11.

at the same time. With this photomontage of his own creation, Graeff alludes to the ways in which modern aesthetic representation (modernism) has responded to industrialization and rationalization of everyday life (modernization). The image resonates with the concerns of Georg Simmel and Walter Benjamin about the effect of urban life on the human psyche. Simmel wrote of the metropolis as a distracting site where nervous stimulation intensifies. Benjamin investigated modernity's disorienting effects on perception and posited the *flâneur*, the urban wanderer, as an archetypical modern type.[16] This aimless urban wanderer also avoids walking like a "straight arrow." Graeff's photomontage thus shows the novel ways in which modern photographic representation can respond to the sensory overload that the modern metropolis imposes on the individual. A new age requires that one develop new rules, or at least make the existing ones less restrictive.

In rebelling against photographic tradition, Graeff implicitly repudiates other sacred cows, notably traditional understandings of gender roles. A few images past the photomontage, he positions another cliché for attack. "'Hands should be lit more softly than the face,'" he quotes, adding parenthetically with biting sarcasm, "You are also free to try the opposite" (fig. 3). Below is a photograph by Sasha Stone, an avant-garde photographer also affiliated with the constructivist G-Group.[17] As if mocking this rule, the woman in the image holds a cigarette, and her hands are more

„Die Hände sind gedämpfter zu beleuchten als das Gesicht . ." (Sie dürfen ruhig auch mal das Gegenteil versuchen)

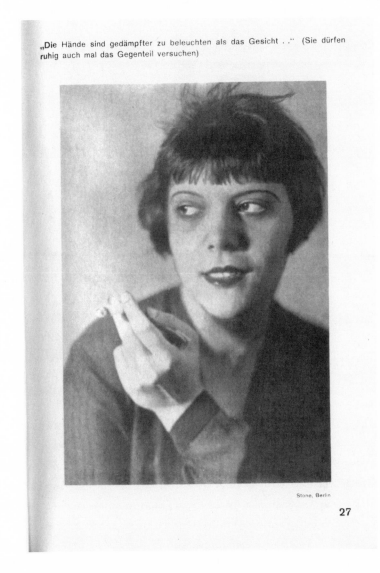

Stone, Berlin

27

Fig. 3 Werner Graeff, *Es kommt der neue Fotograf!*, 27.

emphatically lit than her face. Graeff goes on to list another rule: "'One should avoid at all costs that hands or legs be stretched out toward the camera.'" In a second photograph by Stone, a woman provocatively stretches out both her hands and feet toward the camera.[18] The two women strongly resemble the "New Woman," a cosmopolitan figure with short hair, masculine clothes, and a blasé mien.[19] Whether by sporting a cigarette—a symbol of urban sophistication—or by wearing a short skirt and showing her legs, the women in Stone's photographs contrast starkly with the traditional gender roles of "Kinder, Küche, Kirche" (children, kitchen, church).

The photograph is a striking visual statement, an image that could be used effectively in any of the diverse political, commercial, informational, and critical

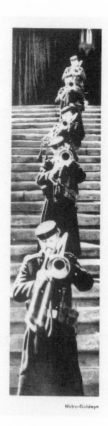

Fig. 4 Werner Graeff, *Es kommt
der neue Fotograf!*, 69.

contexts that regularly appropriated the trope of the New Woman. The New Woman broke the old rules, and so did the photograph of her. With such a photograph, Graeff also alludes to the significant roles women played in the photo essay culture of Weimar Germany. A list of Graeff's contemporaries would include the likes of Else Neuländer-Simon (Yva), Gisèle Freund, Aenne Biermann, Marianne Brandt, Lucia Moholy-Nagy, Germaine Krull, Hedda Walther, and many others.[20] Although to some contemporaries the trope of the New Woman embodied how ideas such as women's liberation threatened established societal and gender hierarchies, Graeff's position on the issue is unambiguously progressive.

Graeff's manifesto of photography as a tool with which to contest artistic and social conventions goes beyond the aesthetic rules that govern the appearance of photographs. It questions even the underlying assumptions about the material status of photographs themselves. Graeff uses several triangular and polygonal images to show, for instance, that a photograph need not be rectangular. As evidenced by an overly elongated photograph of trombonists, customized shapes can harmonize form and content (fig. 4). Formal experimentation with cropping and layout, with its strong affinities to Dadaist photomontage, became an important aspect of photo

stories in the illustrated press. Such examples suggest that photography, especially narrative photographic forms, helped certain trends spread beyond their origins in avant-gardes to reach mass audiences.

Here Comes the New Photographer! also challenges the received wisdom about manipulating negatives and retouching positives. Several experimental photograms—images created by placing objects directly onto photographic paper and then exposing them to light—dispense with cameras altogether.[21] In the book's final chapter, Graeff implores manufacturers of photographic equipment to build new cameras and accessories that allow one to work in unusual settings, photograph from strange angles, use lenses to create new effects, and so forth. If the New Photographer is to photograph a new world, the task demands new tools.[22] Today, imaging technologies as diverse as endoscopes, electron microscopes, skycams, spy satellites, fiber optics, and Photoshop show that Graeff's call, with its lucrative implications, did not go unheeded. Graeff foresaw a future in which photographs would not simply illustrate words or decorate walls. He recognized that unconventional images fulfilled needs and desires still felt today.

Here Comes the New Photographer! as a Training Manual

The new receptivity to visual culture that helped photo essays become so popular in the late 1920s found a voice in slogans and catchphrases that entered public discourse. For instance, Johannes Molzahn's title "Stop Reading! Look!" and Moholy-Nagy's comment that the illiterates of the future will be those who do not know photography both suggest that, at the time, photography was understood as having the potential to replicate, complement, and even replace written language altogether.[23] But these changes demanded that audiences develop a new interpretive skill set. Readers had to learn how to understand images, especially groups of images. This broad-based concern with literacy and reading points to a second key genre evoked in *Here Comes the New Photographer!* and the photo essay form in general: the textbook or training manual.

For all of its antiestablishment claims, advocacy of novel formal techniques, and pronounced desire to break with the past, *Here Comes the New Photographer!* strongly suggests a centuries-old text-image form: the *Fibel* or *Bilderfibel,* an illustrated primer or children's spelling book. A *Fibel* is a didactic text, a "first reader" or A-B-C book that combines signifiers (e.g., the word "apple") with images of the signified (e.g., the edible red fruit). Although the precise German etymology is unclear, *Fibel* very possibly derives from *Bibel* (bible). Until reading primers began to incorporate secular

material in the seventeenth century, they excerpted the Bible, the canonical moral text and often the only available book in preindustrial households.[24]

Like a *Bilderfibel, Here Comes the New Photographer!* addresses its readers as though they are illiterate. This illiteracy is not, however, of the conventional variety. These illiterates are visual illiterates who do not yet understand the complex rhetorical codes of mechanically reproduced images. Graeff reiterates a common sentiment among thinkers, writers, and publishers of diverse political backgrounds in Weimar Germany when he suggests that as photomechanically produced images proliferate, people must learn to read anew. Karl Robert Langwiesche, the conservative nationalist publisher of the popular series Die blauen Bücher (The blue books), remarked that these photobooks on traditional topics might serve as "training manuals" that would reeducate the masses about the richness and beauty of Germany's art, culture, and landscape.[25] On the opposite end of the political spectrum, Walter Benjamin described August Sander's 1929 photobook *Face of Our Time* as a training manual for reading faces.[26]

The concern with visual literacy and with photography as a kind of language led to numerous attempts to rethink books among European avant-gardes, particularly at the Bauhaus and by constructivists. The Russian photographer, graphic designer, and typographer Lazar Markovich Lissitzky, better known as El Lissitzky, undertook just such an experiment in the poetry collection *Dlia golosa (For the Voice)* in 1923. El Lissitzky and Graeff knew each other, as both men collaborated with the Bauhaus and with the avant-garde G-Group. The abstract shapes, colors, and fonts in *Dlia golosa*—and its affinity for "useful" objects such as subway maps and address books—articulated El Lissitzky's constructivist aesthetic. *Dlia golosa* was not simply a book featuring artwork that recorded a cultural heritage; its author understood it as an active agent for political change that helped retrain the senses—a work that, in the words of art critics Yve-Alain Bois and Christian Hubert, offered "reading lessons."[27] Given that Graeff and El Lissitzky traveled in the same artistic circles at the time, the likelihood that Graeff was familiar with *Dlia golosa* is high.

Graeff shared such concerns about reimagining books and literacy, and *Here Comes the New Photographer!* clearly grew out of these interests. He explicitly addressed the matter in a 1927 article for *De Stijl*, a Dutch publication edited by Graeff's Bauhaus colleague, the designer and critic Theo van Doesburg. In this essay, with the appropriately pointed title "Wir wollen nicht länger Analphabeten sein" (We no longer want to be illiterates), Graeff proposed a standardized set of visual codes to help regulate the chaos surrounding another modern innovation: the automobile. He argued that modern technology, particularly modern transportation technology, had created new forms of illiteracy by treating people like children: "We have again become illiterates. In Holland, in Finland, in Czechoslovakia, in Russia, Hungary, Japan, and Argentina we stand helpless, like children at train stations. We see an immense number of signs

that direct, warn, and clarify, but we cannot read them. We need an international language of traffic symbols. For the most important traffic needs, clear and unambiguous signs have to be developed that can be used the same way in all countries."[28]

Drawing equally on his time as a student at the Bauhaus, his subsequent experience as the owner of a drivers' education school, and his authorship of drivers' education books, Graeff proposed an international language for traffic signs. He was not the first to do so. Rather, he was participating in a broad-based movement in the 1920s—one that even occupied the League of Nations—to confront the dangers of increased motor traffic by codifying, standardizing, and unifying diverse types of street signs.[29] True to Bauhaus principles, Graeff's proposed signs relied on basic shapes (circles, squares, and triangles) and primary colors (red, blue, and yellow, plus black and white). This proposal for what one might call a kind of "traffic Esperanto" reflects an enormous optimism and enthusiasm for technology's potential to, in Graeff's words, "sweep aside the anarchy that has ruled until now."[30] In making similar suggestions, *Here Comes the New Photographer!* can be understood as a proposal for a set of road signs for photography. But whereas street signs specifically help prevent traffic jams and automobile accidents, a rulebook for photography has more flexibility. As a textbook or grammar intended to help regulate, control, and develop a new technology, *Here Comes the New Photographer!* encourages photographers to use photography constructively as an agent for social change in all realms of life. In the service of that end, anything goes. The most important rule about photography—one readily apparent in the less programmatically explicit photo essays of other Weimar photographers—is that it *do* something, not that it *be* something.

Here Comes the New Photographer! as a Photo Essay

In addition to announcing a new kind of photography and providing a training manual for new photographers, *Here Comes the New Photographer!* serves as a heavily self-reflexive example of the New Vision's goal to weave photography into the very fabric of modernity and language. Where it performs the rhetorical tasks that it sets out for all photographers, it marks itself as a photo essay. As sequences or narratives composed of images, photo essays imply intention and trajectories, but how discrete photographs convey meaning depends largely on the presence or absence of adjacent images, accompanying captions, and readers' interactions. In the way it constructs and relies upon this sort of open reader/text relationship, *Here Comes the New Photographer!* exemplifies the Weimar photo essay.

The gesture toward involving readers in *Here Comes the New Photographer!* is revealed in the hybrid text-image character of Graeff's sentences. As fundamental parts of the

text rather than mere supplements, the photographs cannot and do not appear in an appended section of plates and illustrations, as they often did in photography text-books. By integrating words and images into the subjects and predicates of sentences, *Here Comes the New Photographer!* attempts to practice what it preaches. Images are not subservient to text, nor is text to images. Rather, each one illustrates and describes the other. Throughout the book, images are part of the very syntax, often interrupt-ing words midsentence. In one exemplary sentence in chapter 3 that demonstrates techniques of the New Vision, Graeff inserts thirteen photographs before reaching a period. By contrast, the opening and closing chapters stand out because they are the only ones featuring extended paragraphs of text without the percussive punctuation of photographs.

In a September 1978 obituary for Werner Graeff published in the *Frankfurter Allge-meine Zeitung,* Hans Georg Puttnies recognized the interdependence of text and image as his book's most important feature. Although Puttnies stressed that *Here Comes the New Photographer!*'s primary importance resides in its attack on photographic conven-tion, he nevertheless claimed that its role as a manifesto and a polemic forms only a small part of its legacy. It was also innovative as a form of narrative akin to, yet different from, cinema. In Puttnies's words, "Werner Graeff's book . . . is the first successful attempt at a narrative unity [*Erzähleinheit*] of photography and language. Halves of sentences give way to photos that continue the argument. The text, the choice of images, and the layout create a symbiosis that otherwise only films, which were also on their way up at the time, had accomplished."[31] Puttnies's claim that *Here Comes the New Photographer!* is the "first successful attempt" at this sort of narrative unity may be exaggerated, but the obituary still points to the work's broader significance as a signpost of the new and welcoming attitude toward images combined with text, which stands out as a key aspect of interwar German culture.

Graeff's book both participated in the trend toward narrative photography and, at the same time, self-referentially pointed out the emergence of this trend. By including in *Here Comes the New Photographer!* specific examples from popular illus-trated weeklies such as the *Berliner Illustrirte Zeitung,* the *Kölnische Illustrierte Zeitung,* and *Der Welt-Spiegel,* all of which featured photoreportage that incorporated techniques of the New Vision, Graeff alludes directly to the mass media's central role in refash-ioning public perception of photography as a kind of language. But this role was not limited to Illustrierten. In the mid-1920s, photo narratives were also appearing independently of magazines as book-length texts. Notable examples—many of which are today considered valuable art objects—include Erich Mendelsohn's popular 1925 *Amerika: Bilderbuch eines Architekten* (*America: An Architect's Picture Book*), Albert Renger-Patzsch's 1928 *Die Welt ist schön* (*The World Is Beautiful*), August Sander's 1929 *Antlitz der Zeit* (*Face of Our Time*), and Franz Roh and Jan Tschichold's 1929 *Foto-Auge* (*Photo-Eye*). This last

volume, like *Here Comes the New Photographer!*, appeared in connection with the Film und Foto exhibition.[32] Many photographs in *Here Comes the New Photographer!*, such as Renger-Patzsch's noteworthy "Adderkopf " (Adder's head), also appeared in these other photobooks and in the popular media. With their reinscription in Graeff's photobook, the semiotic malleability of photographs and photo essays, as well as the self-referentiality of *Here Comes the New Photographer!*, becomes even more conspicuous.

The Critical Reception and Legacy of *Here Comes the New Photographer!*

The warm reception of *Here Comes the New Photographer!* among popular audiences and the book's initial commercial success corresponded with a similarly enthusiastic critical reception among academics and professional circles. Aside from their praise of the specifics of the work, two things stand out in these reviews, even the negative ones. The first is the extent to which they identified Graeff's book as evidence of a broad new receptivity toward visual culture. Second, these reviews mention *Here Comes the New Photographer!* as part of a trend toward combining text and photographs in photo essays.

One 1930 review by Klaus Berger in the *Zeitschrift für Ästhetik und Allgemeine Kunstwissenschaft* (Journal for aesthetics and general art history) merits attention as much for the books with which Berger associated *Here Comes the New Photographer!* as for its specific opinions about Graeff's work. Berger discussed the book alongside several other seminal interwar texts about film and photography, each a major accomplishment in its own right. In addition to Hans Richter's *Film Haters Today, Film Lovers Tomorrow*—the companion volume to *Here Comes the New Photographer!*—Berger reviewed the second edition of Moholy-Nagy's *Painting Photography Film*, the German translation of Vsevolod Pudovkin's *Film Technique*, Béla Balázs's *Visible Man*, and Renger-Patzsch's *The World Is Beautiful*. He described Richter's and Graeff's books as "brothers," a notable point given the extent to which the two collaborated on the projects. Berger noted their shared techniques: "Image and word arise from the same source. . . . The rules of art as typically taught and from which such well-mannered, correct, and stiff images arise, are picked apart one by one."[33] He also recognized that despite their different interests and approaches, these works together marked a fundamental shift in thinking about photographic images and their relationship to adjacent texts. Mechanically produced images must be defined and criticized on their own terms, with attention to their own specific traits, and not always be held up against painting and conventional arts.

An anonymous review in the popular photography magazine *Photographie für Alle* (Photography for everyone) echoed such sentiments.[34] Unlike Berger's review,

however, it stressed that the accomplishment of *Here Comes the New Photographer!* was to unify avant-garde photographic strategies that were widely used and widely recognized but not yet codified in one book. For this reviewer, the use of avant-garde perspectives and photographic manipulation evinced a remarkable and ongoing reeducation of the senses. *Here Comes the New Photographer!* was both the evidence of this shift and a means by which to encourage it further.

Nevertheless, not everyone responded so enthusiastically to *Here Comes the New Photographer!* Those who objected did so in predictable ways. Writing in *Die Kinotechnik* (Cinema technology), the official organ of the Deutsche Kinotechnische Gesellschaft (German Cinema Technology Society), the semi-anonymous reviewer "Kb." remained oblivious to the massive changes in art and in so doing encapsulated in a nutshell the conservative critique of the avant-garde: "No one would want to genuinely doubt that the 'rules of art,' that is, the laws of spatial composition, treatment of tonal values, advantageous perspective, etc. etc. that are splendidly executed in well-known primers and propagated in the academies, still retain today their enormous value and will do so forever.[35] "Kb." further described Graeff's many examples taken from newspapers, magazines, and advertisements as "grotesque" and "sensational." His point that Graeff oversimplifies when he groups "the rules of art" into an undifferentiated mass is accurate, at least in some respects, but it fails to recognize the purpose of Graeff's populist, playful, and self-consciously demagogic tone. Although Graeff bundles rules into a monolithic whole, *Here Comes the New Photographer!* is not simply an argument built through rhetorical straw men. It is concurrently a polemical manifesto that strengthens its own argument by performing the very explicitness that it demands of photographs. Of course, Graeff does not want to dispense with all of the rules of art entirely. He regularly admits that some of them are appropriate in certain situations. His point is simply a more restrained one: these rules are not universally valid for every context. "Kb.," however, fails to recognize that Graeff has presented a nuanced and restrained argument in a loud and argumentative package. Even so, this reviewer points to the paradox of Graeff's programmatic tone: Graeff risks promulgating new orthodoxies and falling into the same prescriptivist discourse that he so harshly criticizes.

Perhaps the ultimate indicator of *Here Comes the New Photographer!*'s critical legacy—or at least its continued ability to strike a chord with the reading public—was the decision of Walther König, the Cologne-based art publisher and bookseller, to reprint and reissue the German edition in 1978, the same year Graeff died unexpectedly while visiting the United States. Although *Here Comes the New Photographer!* was a commercial success in its own day, its original publisher, Hermann Reckendorf, went out of business before it could release a second edition. Writing in an introduction to the reprint, Graeff seemed flattered. "A new edition now after such a long period

of time?" he mused. "We must no longer follow the obsolete rules for art that until the end of the 1920s had a constraining effect—at least not in German-speaking areas; they have long since become meaningless."[36]

By the year of Graeff's death, the techniques he catalogued and the revolution he so optimistically announced had become so accepted as to seem almost unrecognizable. Indeed, to this day, one can scarcely look at a newspaper, book, television screen, computer monitor, traffic sign, or any other site of the language of the modern world and not see what "the New Photographer" foretold. Even when *Here Comes the New Photographer!* came out, it was in many ways already out of date. By 1929, new deployments of photography and text were not so much on their way as they were already present. With the announcement of this arrival, Graeff not only reported a change—he participated in it.

2

the illustrated press and the photo essay

The Novelty of the Weimar Illustrated Press

In October 1929, the Ullstein publishing company's culture magazine *Uhu* featured a photographically illustrated spread entitled "Eine neue Künstler-Gilde: Der Fotograf erobert Neuland" (A new artists' guild: The photographer conquers new territory) (fig. 5). With a populist tone worthy of Werner Graeff, it begins by presenting an aesthetic polemic as fact: "The question of whether photographs are artworks has been resolved." The blurb-length article then weaves among eight captioned portraits of photographers, grouped in two sets of four. It confidently continues, "Anyone who understands anything about a specific artist's work can recognize it immediately from its personal style, and anyone who understands anything about photography also recognizes at first sight whether a photograph is a 'Hoppé' or a 'Renger-Patzsch' or a 'Munkácsi' or a 'Stone.'"

What stand out most in this piece are its profoundly self-referential qualities. Here, a story about the new uses of photography appears in one of the popular photographically illustrated magazines that epitomized such new uses. Readers would have recognized the names, if not the faces, of the pictured "guild members," especially Erich Salomon, Martin Munkácsi, and André Kertész. Their work and that of other key figures in Weimar Germany's culture of star photojournalists was featured regularly in Illustrierten such as *Uhu*. The article's emphasis on a symmetrical layout and carefully balanced images and its concurrent de-emphasis on text

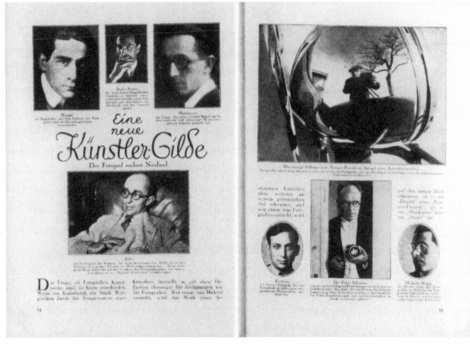

Fig. 5 "Eine neue Künstler-Gilde: Der Fotograf erobert Neuland" (A new artists' guild: The photographer conquers new territory), *Uhu*, October 1929, 34–35.

indicate an interest in shifting the task of signification to photographs. This piece, in other words, does not simply recount an independent phenomenon—the legitimizing of photography as a narrative vehicle through illustrated magazines. Much like *Here Comes the New Photographer!*, it instantiates a phenomenon in the same space in which it reports on it. And it does so with a didactic tone that encourages audiences to look at photographs in new ways. This sort of photo story typified the modus operandi of the Weimar illustrated press. It pointed to the potential of narrative photography as a new way to perceive the dizzying new opportunities of the modern world at the same time that it participated in creating such convolution. The "training" provided by these photo stories, in some cases more explicitly than others, equipped readers with interpretive abilities that would prove important in approaching the abstract and less text-dependent uses of photography in photobooks.

For all of their ambitious aims, however, Illustrierten perpetuated oversimplified views of the complexity of Weimar society. By encouraging an "objective" mode of photographic seeing, Illustrierten standardized and rationalized perception and allowed readers to become the willing consumers of a culture of media voyeurism. To judge from "A New Artists' Guild," photojournalists in Weimar Germany were exclusively men and almost all German Jews or eastern European émigrés who, through photography, found a new way to acculturate.[1] This self-perpetuated image

inflamed nationalist resentment against the media as a left-leaning institution "controlled by Jews." In 1926, for instance, the first issue of *Der Illustrierte Beobachter,* the National Socialists' foray into the illustrated press, juxtaposed reports from mainstream newspapers about poor attendance at Nazi rallies with panoramic images of teeming crowds. One panorama powerfully answers the caption's rhetorical question: "Wer lugt? Die Photographie oder die Judenzeitung?" (Who is lying? Photography or the Jewish newspaper?).[2] Illustrierten across political lines used these same strategies of image organization to frame news according to their own particular biases while maintaining the claim of "objectivity." In this sense, the fate of so many of the guild members after 1933—exile or, in some cases, death in concentration camps—is all the more tragic and ironic. In their profound enthusiasm for photographic objectivity and the power of photographic narratives, they unintentionally helped develop a new and powerful medium that was later mobilized to effect their own social marginalization. Paradoxically, Illustrierten created both complex images of simple phenomena and reductive images of complexity. They thereby embodied both the promise and shortcomings of narrative photography as the technologically inflected means for heightened expression.

On their own, highly structured photo essays such as "A New Artists' Guild" suggest an openness to photography's potential to convey information in new and more revealing ways than text alone. They represent an important moment in which enthusiasm for photography and new technologies in general became so heated in Weimar Germany that, according to art historian Herbert Molderings, technology was effectively the "goddess of an *ersatz* religion."[3] Illustrierten served as laboratories for experimentation and, as Matthew S. Witkovsky has argued, "the principal conduit for image diffusion, no matter what the subject, becoming a vast, extramural school for the new generations of photographers."[4] Yet in the context of a disposable magazine, photo essays undermined their own rhetorical efficacy as but one feature among pages of photographs, essays, stories, puzzles, jokes, and advertisements. This chapter examines this paradox.

Seeing the World Photographically in the Illustrierten

Historian of photography Karl Steinorth rightly stresses that "photo stories and photo sequences are not an innovation of the 1920s; there have been photo stories and photo sequences since the invention of photography."[5] Thus, the inclusion of photo stories in Weimar Illustrierten did not by itself represent anything new. By the 1920s, various European and North American newspapers had been publishing sets of photographs for decades, often in "illustrated supplements."[6] However, several

key differences separated the German illustrated press of the late 1920s and early 1930s from its predecessors. Werner Graeff announced in the penultimate chapter of *Here Comes the New Photographer!*, "The unusual photo will not stay unusual for long. More and more, illustrated newspapers are incorporating them."[7] Graeff then reproduced photo stories excerpted from several well-known Illustrierten. Their headlines are particularly noteworthy, as they point to the magazines' willing embrace of photography: "Wie es unser Photograph sah, oder: Photographiere nie, wenn du einen in der Krone hast" (How our photographer saw it, or Never photograph when you've had one too many); "Gespensterhafte Romantik der Natur: Microaufnahmen aus der Pflanzenwelt" (Nature's ghostly romanticism: Microscopic photographs from the plant world); "Neue Wege der Photographie" (New paths for photography); and "Das Bild liegt auf der Strasse: Entdeckungsreisen mit der Kamera" (The streets are paved with photographs: Journeys of discovery with the camera). Such titles reiterate the major difference between the Weimar illustrated press and earlier newspapers: Illustrierten became the primary means in German society to publicize the new functionalist understanding of photography to mass audiences. They paid special attention to form, most notably in the innovative layout of static images in their one- to four-page filmic short stories, which became a key selling point. Through photo stories (also known as picture stories and photoreportage) about all sorts of topics—and with a notable predilection for stories that in some way referenced photography's unique, technologically enhanced representational capacities—they created equivalencies between written language and photographs.

To a much greater degree than their predecessors, in other words, Weimar Illustrierten actively encouraged audiences to see the world *photographically*. As theorized by a range of photographers and theorists, seeing photographically refers to the notion—to use Susan Sontag's definition—that photography "peel[s] away the dry wrappers of habitual seeing, it creates another habit of seeing: both intense and cool, solicitous and detached; charmed by significant detail, addicted to incongruity." In a comment especially relevant to the workings of weekly photographically illustrated magazines, Sontag adds that "photographic seeing has to be constantly renewed with new shocks, whether of subject matter or technique, so as to produce the impression of violating ordinary vision."[8] Illustrierten were organized as a series of such shocks: they featured a mélange of flashy photographs, photo stories, essays, jokes, and puzzles, with minimal internal logic governing their organization. Week after week, issue after issue, they offered photo stories that encouraged readers to generate narrative readings from static images. Yet despite the new technology's promise of providing "another way of telling" (to quote the title of John Berger and Jean Mohr's meditation on narrative photography), photo stories most often devolved into mere opportunities to gaze voyeuristically into the workings of the far corners of the modern world.[9]

In interwar Germany, the public increasingly welcomed Illustrierten and their photo essays because film (for much of the 1920s still without sound) had newly awakened their visual sensibilities.[10] Following up on this observation, Patrice Petro has described several specifically "filmic" characteristics of photo stories, including the function of composition, camera angles, camera distances, and points of view, in addition to noting that "the majority of photo essays relied upon a degree of visual literacy, or more precisely, upon conventions already established by film viewing."[11] If the first key difference between Weimar Illustrierten and their predecessors lay in their promotion of photographic seeing, this understanding of Illustrierten as a series of constant filmic "shocks" points to a second important way in which they diverged. Contemporaries clearly *perceived* Illustrierten as profoundly different and more significant than their predecessors, often negatively so, on account of what Sontag calls their "addiction to incongruity."[12] In 1925, for instance, Edlef Köppen, a journalist with Funk-Stunde AG, Germany's first radio station, described magazines as a "dubious" sign of the times. He decried the "entertaining mode" of Illustri-erten as typical of Weimar Germany's culture of distraction, chaos, and dilettantism, noting, "The magazine—and not a single one can be completely excepted—pursues complexity with such an emphatic single-mindedness that it cannot but appear suspect."[13] Köppen's attack paralleled critiques by Marxist critics, notably Siegfried Kracauer, who described Illustrierten as capitalism's glossy means to distract and anesthetize an ever-growing army of salaried masses against harsh economic and social realities. Writing in one of the feuilletons later published as part of *Die Ange-stellten* (*The Salaried Masses*), Kracauer argued that illustrated magazines embodied the highly regimented existence of the burgeoning German middle class.[14] In short, such critiques coalesced around the idea that these magazines simply bombarded readers with so many different kinds of material that, in the end, their components seemed to cohere only by virtue of appearing in the same magazine.

Editors such as Stefan Lorant of the *Münchner Illustrierte Presse* (*MIP*) and Kurt Korff and Kurt Szafranski of the *Berliner Illustrirte Zeitung* (*BIZ*)[15] bought heavily into the notion of photographic seeing and the illustrated press as a key space in which to train readers to see photographically. Lorant, like László Moholy-Nagy, was a Hungarian exile in Germany, and the two were longtime friends. Lorant was familiar with Moholy-Nagy's 1923 essay "The New Typography," which stressed that "the objectivity of photography liberates the receptive reader from the crutches of the author's personal idiosyncrasies and forces him into the formation of his own opinions."[16] He also admired Moholy-Nagy's book *Painting Photography Film,* which theorized the concept of the "typophoto": "Photography is highly effective when used as typographical material. It may appear as illustration beside the words, or in the form of 'phototext' in place of words, as a precise form of representation so objective as

to permit of no individual interpretation. The form, the rendering, is constructed out of the optical and associative relationships: into a visual, associative, conceptual, synthetic continuity: into the typophoto as an unambiguous rendering in an optically valid form. The typophoto governs the new tempo of the new visual literature."[17]

Like Werner Graeff's *Here Comes the New Photographer!* or László Moholy-Nagy's *Painting Photography Film,* the Illustrierten of the late Weimar period evince the attempt to apply such concepts as the hybrid text-image "typophoto" to daily life, but in a decidedly more commercial context than a photobook. They sought to impart a new understanding of photography to a receptive audience and to further mold that audience through new uses of photographs. Editors and photographers claimed to be revolutionizing media through these magazines and their signature feature, the photo essay subgenre known as the photo story, which offered substantially more accompanying text intended to encourage specific interpretations than did the lightly captioned or uncaptioned pages of modernist photobooks. As noted earlier, the fact that this revolution in media helped fuel a Nazi propaganda engine mobilized against the people who helped initiate it is both ironic and tragic. But such was the case. The illustrated magazine *Der Illustrierte Beobachter* powerfully testifies to the extreme Right's recognition of the power of photographic propaganda. It was the Nazi Party's third periodical, preceded only by its general newspaper, the *Völkischer Beobachter,* and its student publication, the *Akademischer Beobachter.*[18] The extreme Right learned early on how to use sequenced photographs, particularly those that incorporated avant-garde techniques such as montage, for propaganda purposes.

The claim that photo stories created a media revolution was not entirely false, yet contemporaries inflated its significance or assumed naïvely that new media technology would exclusively serve the cause of human progress.[19] For instance, to Tim Gidal, the German Jewish émigré and Weimar photojournalist and the author of an important history of photojournalism, illustrated magazines marked the dawn of a new age in media because they shifted the primary burden of representation from words to photographs. "With the help of visual media," Gidal wrote, "the new photojournalism . . . has inaugurated a new era of mass communication. Here lies its historical importance, past and present."[20] Such overblown optimism permeated the pages of Illustrierten. They encouraged readers to believe in photography and, more broadly, technology as powerful agents of enlightenment and liberation that could expose, reveal, and otherwise make visible the obscured truths of the modern world.

The enthusiasts who saw Illustrierten as heralding a new age of visual media were not totally wrong, but neither were the detractors who saw these magazines as mere vehicles for giving stimuli-craving audiences the distractions they desired. A nuanced accounting of the phenomena of Illustrierten within the broader history of the Weimar photo essay thus demands that we integrate both viewpoints and

consider the relationship between discourse and society as a two-way street. Peter Fritzsche has compellingly argued in his study of early twentieth-century Berlin and its reading culture that "the city as place and the city as text defined each other in mutually constitutive ways."[21] Following Fritzsche, we might say that in spite of their pretensions to photographic objectivity, the photo essays of Illustrierten demand attention not simply for how they registered and represented the events and desires of Weimar society, but for the very ways they constituted them as well. Examining this proposition is a worthwhile endeavor given that, as Bernhard Fulda rightfully notes, while German movie theaters sold approximately 350 million tickets in 1929, readers consumed about twenty times as many newspapers—a substantial number of them Illustrierten. Even so, Weimar cinema still attracts disproportionate attention as the key space of interwar visual culture.[22] Photo stories helped readers accept images as viable narrative vehicles, but they also encouraged an unsustainable faith in the power and potential of narrative photography.

This chapter traces the translation and reiteration of the ideas of Moholy-Nagy, Graeff, and the New Vision in popular culture by historicizing the photo stories of Weimar Illustrierten and by presenting readings of representative examples. It shows how this photo essay subgenre, like Graeff's *Here Comes the New Photographer!*, occupied an important intermediary space between still photography and book-length photo essays, and how its optimism about photographic technology failed to anticipate how it might be abused. The chapter briefly reviews the origins of the Weimar photo story, examines several layout strategies and aspects of the culture of Weimar photojournalism, and offers readings of the photo stories in a representative issue of Lorant's *MIP*.

The Illustrierten of Weimar Germany

Through sensational cover photographs and heavily stylized narratives constructed from photographs, Illustrierten enticed buyers at crowded urban kiosks. These inexpensive periodicals—in 1929 most weeklies cost around twenty pfennig—secured long-term reader loyalty with serialized novels, advice columns, jokes, puzzles, essays, and other text-based staples from the tradition of nineteenth-century German "family magazines," all packaged in a tabloid format readable on crowded subways.[23] The popularity of Illustrierten is beyond question. In 1929, near the height of the magazines' success, the largest title, the *BIZ*, had a press run of 1,844,130 copies. In 1930 and 1931, the *MIP*'s circulation reached its zenith at 700,000 copies. But even these figures cannot account for the true readership, as many people read the magazines in cafes, bars, hotels, and other public spaces.[24]

Illustrierten achieved popularity quickly. Many were introduced during the so-called period of stabilization, the years following the introduction of the Rentenmark (in November 1923) and the Dawes Plan (in August 1924), which restructured crippling war reparations payments and helped curb traumatic hyperinflation.[25] Several new magazines, including *Uhu* (1924), the *MIP* (1923), and the *Kölnische Illustrierte Zeitung* (1926), flooded the media market during these years of (relative) economic calm, joining preexisting titles such as the *BIZ* (1891) and other popular if more regionally focused magazines, notably the *Frankfurter Illustrierte* (1913) and *Hamburger Illustrierte Zeitung* (1918). The largest and most well-funded titles belonged to prominent media concerns—for instance, the republican-leaning publications of the House of Ullstein (*BIZ* and *Uhu*) and Rudolph Mosse (*Der Welt-Spiegel*, 1899), and the more conservative-leaning titles of the Scherl Publishing Company, part of the media empire of media baron and German National People's Party chair Alfred Hugenberg (*Die Woche*, 1899).[26] Additionally, illustrated magazines such as the National Socialists' *Illustrierter Beobachter* (1926), the Social Democrats' *Volk und Zeit* (1919), and the *Arbeiter Illustrierte Zeitung* (1925) of Willi Münzenberg's communist International Workers' Aid complemented these media-savvy political parties' official newspapers. Regardless of whether they had a party affiliation, all of these titles stoked the fires of an increasingly competitive climate in which magazines were founded, closed, or consolidated with relative frequency.

Partly as a function of the increasing competition among illustrated magazines and partly in response to the rise of film and the avant-garde rethinking of the relationship between text and image, the appearance of Illustrierten changed significantly during this period. They took on the more playful, self-referential, visually striking, and commercial character seen in "A New Artists' Guild" and *Here Comes the New Photographer!* In their pages, editors and star photojournalists experimented and came of age. After they later fled Nazi Germany, many of these journalists played pivotal roles in the development of British and American illustrated media.[27] Kurt Korff, who until his forced emigration in 1933 edited the *BIZ*, saw the new glossy look of photo stories as permitting intensified and efficient expression appropriate to the demands of the fast-paced modern world:

> The public grew increasingly accustomed to receiving a stronger impression of world events from pictures than from written reports. The report was admittedly faster, but the event in its full dimensions, in its total effect—only the picture offered that to the reader. Without a picture the things going on in the world were reproduced incompletely, often implausibly; the picture conveyed the strongest and most lasting impression. . . . The *BIZ* adopted the editorial principle that all events should be presented in pictures with an eye to the

visually dramatic and excluding everything that is visually uninteresting. It was not the importance of the *material* that determined the selection and acceptance of pictures, but solely the allure of the *image* itself. This reorientation is responsible for the change chartered by the *BIZ* in the appearance of illustrated papers, which are no longer directed by text editors, but by those who are capable, like film writers and directors, of seeing life in *pictures*.[28]

Korff's editorial demands for "the strongest and most lasting impression" and images with "allure" had specific implications for photojournalists. Extreme close-ups, photomontage, photograms, X-rays, cutout photographs, and all manner of unusual shooting angles counted among an ever-growing repertory of visual techniques that spoke clearly and loudly through a relatively small number of photographs and, at the same time, encouraged a sense of detached objectivity. Nevertheless, the inclusion of avant-garde imagery did not by itself make a magazine stand out. Rather, as Friedrich Krohner and Arthur Ploch, the respective editors of *Uhu* and *Scherl's Magazin,* stressed in a 1929 article in *Die Literarische Welt* about the behind-the-scenes happenings at an illustrated magazine, "A magazine's uniqueness resides not simply in the images themselves, but in their original and distinctive layout."[29]

One of the key figures—but by no means the only innovator—in the development of these layouts was Stefan Lorant, the so-called godfather of journalism and the editor in chief (at times in function if not in name) of the *MIP*.[30] Born into a Hungarian Jewish family in 1901, the left-leaning Lorant fled Budapest after the rise of the right-wing government of Miklós Horthy at the end of World War I. Lorant eventually found his way to Germany, where he worked in the film industry as a cameraman and director. He traveled in cosmopolitan film circles and had what his biographers describe ambiguously as "close relationships" with stars such as Marlene Dietrich, Greta Garbo, Henny Porten, and even Leni Riefenstahl. Lorant transitioned smoothly from his work in the film business into his work on illustrated magazines. In 1924 and 1925, he worked on a small publication entitled *Das Magazin,* where he experimented with using sensational photographs in extended spreads. His growing reputation led to new opportunities.

One such opportunity presented itself in 1926: the chance to design and publish a special issue of *Ufa Magazin*—the official publication of Germany's largest film studio—to promote Fritz Lang's filmic spectacle *Metropolis.* Lorant's appealing combination of production stills and articles about the making of the movie points to the filmic origins of the journalistic photo story. This work impressed his colleagues, including László Moholy-Nagy, who called the issue "the first modern pictorial magazine."[31] Lorant subsequently edited *Ufa Magazin* for six months in 1927 before

shifting completely to other publications, including *Film Kurier* and eventually the *MIP*. He climbed the ranks to become the *MIP*'s Berlin editor in 1928 and its editor in chief by 1932, although he had already fulfilled the latter role in practice for years.

At the *MIP*, Lorant enjoyed a profound degree of aesthetic autonomy and developed his own signature visual style. In a 1970 interview with historian of photography Beaumont Newhall, he stressed that while some photo editors worked with their photographers on layouts, he never did. Although in some cases Illustrierten purchased prefabricated photo stories from *Bilderdienste* (photo agencies), they often designed their own stories, narratives, and organizational rubrics using images supplied by freelancers. Describing a typical work process, Lorant said, "The editor was the sole arbiter. I usually locked myself into my room with the pictures Bauman [photojournalist Felix H. Man] gave me, put them on the floor, and worked out a layout. . . . We both made our mistakes, but I could always understand his mistakes and I think he could understand mine. Such cooperation is not possible today. Today editing is mostly by consensus of a group."[32] Lorant selected photographs and sketched out his own designs. He then passed them on to a compositor, who in turn transformed them into actual page layouts.[33] According to Tim Gidal, several principles informed these designs; for instance, the pictures had to be published "in as natural, simple and unfalsified a form as possible." In addition to this emphasis on the objective feel of the photographs, Gidal explicitly stressed that Lorant paid enormous attention to the way in which layout could elicit narratives. The varying size of images promoted this role: "Another graphic principle was the reduction and limitation of the pictures to a double-page spread. The key photo was shown large, the rest intentionally smaller and grouped in harmonious sequence."[34] As the examples later in this chapter show, such a hierarchy of images encouraged readers to pay more attention to certain aspects of a story and less to others.

The interest in the narrative or filmic organization of photographs that Lorant helped pioneer was not limited to the large, commercial, and nominally politically unaffiliated Illustrierten. Imitation abounded across existing lines of class, politics, and gender.[35] When, for instance, Max Amann, the director of Franz Eher Nachfolger, the National Socialist German Workers' Party's central publishing house, first suggested that the party publish an illustrated magazine, he stressed that it should imitate the mainstream commercial titles. His words echo Kurt Korff's description of the purpose of the illustrated press: "The more the National Socialist movement grew, the more it proved necessary to teach the general public about it not only through the word, but through the image as well. Thus a plan was devised to publish an *Illustrierter Beobachter* [Illustrated observer] that followed the example of the large illustrated weekly papers, such as the *Berliner Illustrierte* [sic], the *Münchner Illustrierte*, etc. With their enormous press runs, they were extremely effective means of publicity."[36]

To this end, *Der Illustrierte Beobachter* used "unusual" (i.e., avant-garde) images, such as oversized photographic cutouts of Adolf Hitler that literally and figuratively emphasized his stature or wide-angle photographs giving the impression that the crowds at Nazi rallies were larger than numbers alone might suggest. Thus, the very techniques of the New Vision used by photojournalists as tools of enlightenment and entertainment were quickly co-opted for political propaganda.

Along similar lines, the Communists' *Arbeiter Illustrierte Zeitung* (*AIZ*) developed its own signature techniques—most notably photomontage—that encouraged readers to create politically sympathetic narratives from still images. The *AIZ* regularly featured bitingly sarcastic photomontages by John Heartfield on its covers.[37] In the 1920s, photomontage became an effective tool in advertising and, in particular, political propaganda.[38] With their manifestly constructed character, photomontages such as Heartfield's "offer[ed] a kaleidoscopic expanded vision which, by collapsing many views into one, suggest[ed] an experience of unfolding time."[39] His photomontages made for effective propaganda because of their humor and because—unlike more abstract examples by contemporaries such as Hannah Höch or Raoul Hausmann—they more explicitly appropriated the feel of candid newspaper photographs. Dawn Ades notes, "The image fills up the whole page, and, however grotesque, remains curiously uncomposed, almost arbitrary; the immediate impression is almost that of an extraordinarily lucky piece of reporting."[40] Heartfield regularly attacked Hitler with photomontages such as the *AIZ* cover illustration "The Meaning of the Hitler Salute: Motto: Millions Are Behind Me," in which the "millions" represent not voters but money surreptitiously placed from behind into Hitler's waiting hand. As Andres Mario Zervigón justifiably suggests, Heartfield used photomontage both to express his skepticism of photography's claims to evidentiary truth and to criticize the profound enthusiasm for photography evinced in fascist propaganda and the politically mainstream illustrated press. Such iconophobia was pervasive among members of the German communist press.[41]

Lorant's layouts, however, lacked the explicit political charge of the party press. They suggested instead a greater interest in artistry and in arranging photographs to imply narrative progressions. Nevertheless, they still conveyed an implicit politics. Lorant's "variations on a theme" layouts, for instance, juxtaposed identically sized portraits of the same person taken during a relatively short period (often by a star photographer) to suggest animation or the passage of time. His one-page photo story "Bruno Walter Conducts" from an early 1932 issue of the *MIP* consists of four photographs taken by Erich Salomon as Walter conducted an orchestra (fig. 6).[42] In each photograph Walter's facial expressions and hand gestures differ, and each photograph's caption corresponds to a musical tempo (largo, pastorale, andante, and allegro). "Bruno Walter Conducts" invites readers to revise their views of a

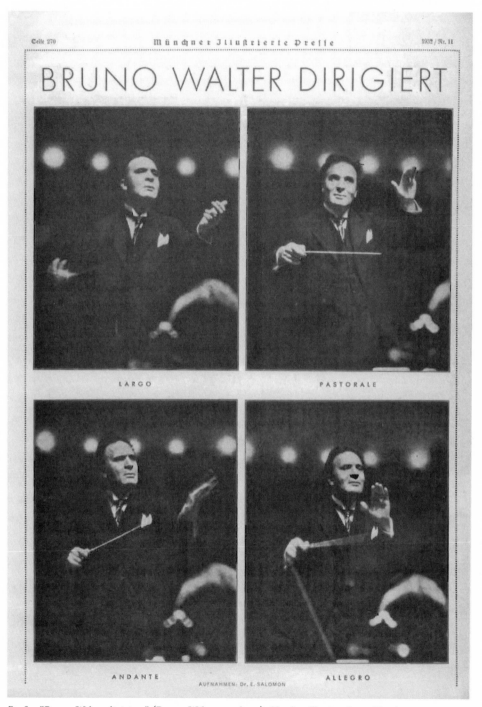

Seite 270 Münchner Illustrierte Presse 1932 / Nr. 11

BRUNO WALTER DIRIGIERT

LARGO

PASTORALE

ANDANTE AUFNAHMEN: Dr. E. SALOMON ALLEGRO

Fig. 6 "Bruno Walter dirigiert" (Bruno Walter conducts), *Münchner Illustrierte Presse,* March 13, 1932, 270.

popular Jewish conductor whom Hitler attacked by name as evidence of Jewish over-representation in the arts. The story implicitly rejects the modern clichéd images of the nervously gesturing Jew and instead presents Walter's movements positively by associating them with harmonious music.[43]

Perhaps the most famous example of Lorant's filmic sensibilities and tragic underestimation of the potential of right-wing politicians is his 1931 photo essay for the *MIP* entitled "Mussolini at Work," with photographs by Felix H. Man (Hans Baumann).[44] This photoreportage conveys a sense of temporal flow through six images of the Italian fascist leader. In a variety of poses, Mussolini reads newspapers, signs documents, issues orders, and the like. The *MIP* took enormous pride in the fact that Man's photo story marked the first time in Mussolini's nine-year tenure that Il Duce had allowed a photographer into his inner sanctum. The magazine prominently reiterated this point, and Man became famous almost overnight, going on to contribute frequently to the *MIP*. For his part, Mussolini cited the populist dimension of Man's "day in the life" photo story as proof that he was a man of the people. In this case, Lorant's interest in form, design, and photography's novelty thus came at the cost of humanizing a fascist dictator.

The emergence of a new class of photographic auteurs such as Felix H. Man and Erich Salomon drew attention to Illustrierten's desire that readers understand photographs as the creation of authors, not technicians. Clever, playful, and self-referential photo stories often stressed that they were the work of these *Bildberichterstatter,* or photojournalists (literally, those who report through images). Salomon, for instance, gained fame for his candid snapshots of trials and politicians, many taken illegally or surreptitiously. Willi Ruge became known for his aviation photographs.[45] Otto Umbehr, the Bauhaus photographer who went by the pseudonym Umbo and co-founded the Dephot photo agency, focused on (in the words of Tim Gidal) "the photographic experience."[46] These members of the new profession of photojournalism and their adventures as "roving reporters"—to use journalist Egon Erwin Kisch's catchphrase—became an important selling point for Illustrierten.[47] Readers could expect to see these photographers' images in many different Illustrierten, just as they might expect to see columns by their favorite commentators in newspapers.

The *Münchner Illustrierte Presse,* October 13, 1929

Stefan Lorant and Kurt Korff are appropriately remembered today as important developers and promoters of photo stories. Their reputations owe much to their work after 1933 with influential British and American illustrated publications,

notably *Picture Post* (Lorant) and *Life* (Korff). They were not the only editors who developed photo stories, nor the sole individuals responsible for the photographs that appeared in them. Nevertheless, it is instructive to examine in closer detail how a sample issue of Lorant's *MIP* creates a montage of photo stories to represent Weimar Germany. In so doing, it tends to reduce the society's complexity so that it fits within the photographic narrative. The various photo stories in the issue highlight several modes of photographic seeing. That is, they elicit from their audiences specific understandings of organized groups of photographic images. They cast photographs as a means to fulfill desires, to penetrate artificially erected societal boundaries, to experience faraway lands, to recognize and appreciate art, and even to gaze into the past as a form of memory. These varieties of perception gleaned from the pages of Illustrierten helped readers develop the interpretive skills necessary to approach book-length photo essays.

Examining systematically how mainstream titles such as the *MIP* promoted modes of seeing photographically is an endeavor fraught with methodological difficulties. For one thing, many of the materials that might have definitively shed light on how and why editors, photographers, designers, and photo agencies constructed specific photo stories were destroyed during the February 3, 1945, bombing raids that devastated Berlin's Friedrichstadt district, the headquarters of Germany's major media companies. And while post-1933 emigration saved the lives of many key figures of the illustrated press, it also meant that they often left behind personal possessions that might have benefited subsequent historians.[48] Aside from these concerns about the availability of archival sources, the ephemeral quality of photo stories presents a very real danger of "overreading." Unlike the photobooks examined in this book's later chapters, these photo stories were intended to be relatively straightforward reports on specific topics, not photographic narratives that in their openness and relative lack of textual mediation invite alternative readings. Clive Scott has suggested in his study on the varieties of photographic language that this sense of narrative constriction ranks high among objections to the photo story's value as an expressive medium. The burdens of excessive text and captions effectively rob photographs of their ability to signify more freely and point toward photographs' traditional role as illustration.[49] Such a claim holds true if one approaches photo stories as isolated texts made particularly interesting by their subject matter and layout—which is precisely the approach taken in many histories of photography or photojournalism.[50] Yet as the criticisms of Edlef Köppen and Siegfried Kracauer suggest, Illustrierten offered a dizzying array of visual and textual materials. That context bears upon how photo stories signified and how they encouraged certain modes of seeing.

To adjudicate between the demands of breadth and depth, the following examines how the photo stories from a forty-page issue of the *MIP* conveyed meaning on

a variety of levels, both in their own time and decades later, and how they sought to evoke certain understandings of the modern world. The analysis considers these photo essays within their immediate and broader contexts. They participated in contemporary discourses about German art, politics, culture, society, and of course photography, but they also told stories on their own and in conjunction with the text-based features in the issue. At times, they complemented or even mimicked these features' topics outright and created false equivalencies of text and image, all of which conferred a false sense of coherence on a disparate mass of material.

The first two pages of the October 13, 1929, issue of the *MIP* speak clearly to a sense of wonder and enthusiasm about photography. The week's most significant news was unquestionably the death of Gustav Stresemann, Germany's politically centrist, intellectually gifted, and highly pragmatic foreign minister (and, for a brief period in 1923, its chancellor). Yet unlike, for instance, that week's *BIZ*, which featured a multipage layout with photographs by Erich Salomon—and unlike the full-page photograph of Stresemann's funeral on the cover of the *Kölnische Illustrierte Zeitung* (*KIZ*)—the cover of the *MIP* does not mention Stresemann at all. It instead features a formally novel and visually striking image by the English photographer Cecil Beaton. The caption reads "A New Path for Portrait Photography," followed by "This is how Cecil Beaton, the English society photographer, sees his sisters" (fig. 7). The photograph and caption are a teaser for the issue's one-page photo story "Noteworthy Portraits by the English Society Photographer Cecil Beaton," written by the Austrian journalist and travel writer Paul Cohen-Portheim. The cover image depicts Beaton's sisters (and frequent models) Nancy and Baba, photographed from above.[51] The young women lie on their backs cheek to cheek amid a pile of large plastic balls and a plastic ground cloth that reveals only their heads. With their short, stylish haircuts and beautifully made-up faces, the girls were surely a glamorous and attractive enticement to potential buyers of the magazine. This cover emphasizes both the extent to which Illustriertren relied on photography's formal novelty and sex appeal to sell copies and how they promoted photography as a means to represent and fulfill libidinal desire. One Beaton sister is positioned upside down, such that spinning the photograph 180 degrees produces almost the same photograph. The balls echo this circular composition. One of them extends beyond the photograph's frame to obscure the *P* of *Presse* in the masthead, as if to stress the centrality of photography to the magazine. The photo story that the cover announces appears only six pages before the end of the issue, forcing readers to thumb through advertisements to reach it.

The *MIP* did not ignore the big news of Gustav Stresemann's death. But the way in which the magazine reported it on its second page speaks as much to an interest in the *media* of presentation as to the news itself (fig. 8). Like the cover photograph

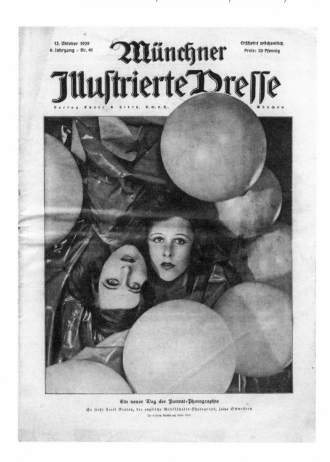

13. Oktober 1929
6. Jahrgang / Nr. 41

**Münchner
Illustrierte Presse**

Erscheint wöchentlich
Preis: 20 Pfennig

Verlag Knorr & Hirth, G. m. b. H.　　München

Fig. 7 "Ein neuer Weg der Porträt Photographie" (A new path for portrait photography), *Münchner Illustrierte Presse*, October 13, 1929, cover.

by Cecil Beaton, an image of Stresemann covers almost three-quarters of the page. Even in a context known for its oversized pictures, this photograph is exceptionally large. The accompanying text makes clear that this enlargement is in part a visual pun: "The name Stresemann is first of all associated with the locales of Locarno and Thoiry, which themselves have become independent concepts. It is possible that Stresemann overestimated the successes he achieved there, and that the parliamentary system, of which additionally he was the most sovereign ruler, forced the minister, who always remained his party's leader, to produce a somewhat radically enlarged picture of these accomplishments."

Gustav Stresemann's work to reintegrate his people economically and politically into Europe and the world after World War I earned him a Nobel Peace Prize in 1926. In hindsight, he embodied the unrealized possibilities of the failed Weimar Republic. He was a strong and capable politician in an era in which decisive leaders who were not fascist were sometimes scarce. When the U.S. stock market crash plunged the world economy into depression just three weeks after Stresemann died from a stroke on October 3, 1929, at only fifty-one years old, the absence of such hard-nosed pragmatic democrats became painfully obvious.[52] As with the

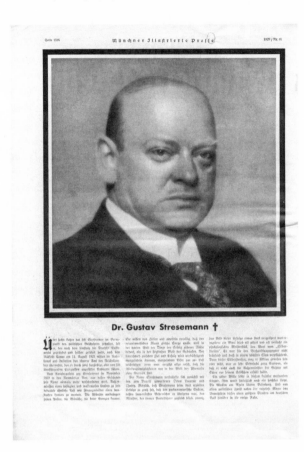

Fig. 8 "Dr. Gustav Strese-
mann †," *Münchner Illustrierte
Presse*, October 13, 1929, 1346.

Cecil Beaton cover image, the *MIP*'s coverage of Stresemann's death self-consciously draws as much attention to form (the fact that the magazine is using photography to present news) as to content (namely, the specifics of the story). The phrase "etwas stark vergrößert" (somewhat radically enlarged) in the caption refers not only to Stresemann's tragic overestimation of his accomplishments—the diplomatic work he undertook at Locarno in 1925 and Thoiry in 1926 was far from complete when he died—but also quite literally to the enormous, grainy image above it. This sort of wordplay, even in a news story of such gravity, was typical of the Weimar illustrated press across ideological lines. It drew as much attention to the act of looking at events as to the events themselves.

By way of comparison, that same week *Der Illustrierte Beobachter* reported on Stresemann's death on its back page.[53] The headline above a photograph of Stresemann's corpse reads "The End . . . , " referring not only to the end of Stresemann's life but also to the article's location at the end of the issue. Such punning underscores the extent to which the editors of illustrated magazines took on the self-appointed mission to train people to see the world as a sequence of images to be viewed in accordance with certain ideological norms, even though the powerful rhetoric of

truth embodied in photography allowed them to lay claim to unbiased presentation. For its part, the *AIZ* ran a picture of Stresemann's corpse above a caption laden with leftist political jargon: "The most clever and talented leader of the German bourgeoisie is no more. Raised in a petty-bourgeois family, he soon developed into the lawyer for a large business. After [Ernst] Bassermann's death he became the leader of the National Liberal Party and thereby the spokesman for the imperialist politics of imperial Germany."[54]

Unlike the illustrated press affiliated with parties on the far Left or far Right, the *MIP, BIZ,* and *KIZ* generally sided with the rule of law and democratic institutions, and the photo story on the next three pages of the *MIP*'s October 13 issue speaks to these sympathies (figs. 9a–c). The photoreportage recognizes the fiftieth anniversary of the Reichsgericht, Germany's highest court. The Reichsgericht came into existence on October 1, 1879, but its proceedings remained closed to the public—at least until the publication of this essay. The photo story points to another mode of seeing promoted by Illustrierten: readers could rely on photo stories as a way to penetrate the inaccessible. The court's ornate calligraphic seal, which reads "Im Namen des Reichs" (In the name of the Empire), doubles as the story's headline. Following the subtitle "50 Years of the Court of the German Empire," a summary line adds that "for the first time since its founding, a photographer was allowed to take pictures in session." A brief history of the court snakes through the subsequent images and reaches its conclusion in a half-page of text continued twenty-five pages later amid advertisements.

In serving as the article's headline, the court's seal is a "typophoto" of the sort advocated by László Moholy-Nagy; it unifies form and content. It speaks to the pretense that the illustrated press used photography merely to facilitate the modern world's "speaking for itself." This photo essay's appeal lies as much in what it connotes about photography as in what it says about the court. The photographs were taken by Erich Salomon, who used his personal connections to access and photograph government proceedings and high-society functions closed to the general public. Salomon's images are banal, showing judges in legal robes deliberating around a table. To enliven these fundamentally static scenes, all three pages of the photo story employ Lorant's design strategy of one large focal image with smaller images grouped in harmonious sequence. A sense of formal symmetry governs the layout. The second and third pages of the photo story form a spread in which the figures on either page face the fold, creating a sense of enclosure and unity. The smaller images at the top of the third page compose a filmic sequence that depicts the chronological succession of the court's presidents. As a whole, this photo story claims to create a historical narrative about something previously hidden: the inner workings of Germany's highest court. It portrays photography as a tool of liberation, as a way to gain a privileged view into behind-the-scenes happenings.

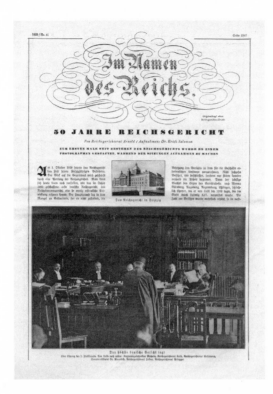

(a)

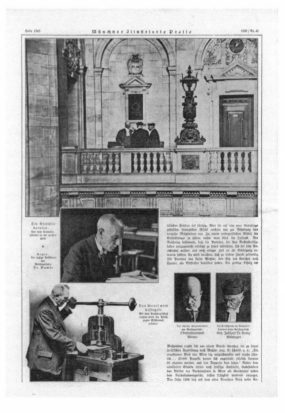

(b)

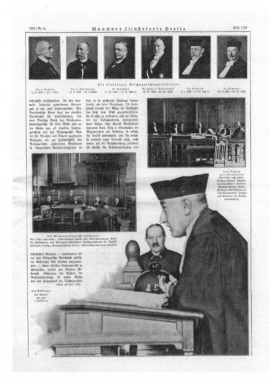

Figs. 9a–c "Im Namen des Reichs:
50 Jahre Reichsgericht" (In the name
of the Empire: 50 years of the court of
the German Empire), *Münchner Illustrierte
Presse*, October 13, 1929, 1347–49.

(c)

Whereas the Salomon photoreportage speaks these magazines' mission to promote "intensive" seeing, the next two pages of the *MIP* shift their focus outward. They feature short, one-page photo stories that introduce the notion of seeing "extensively" into distant lands. The first consists of five photographs (and one drawing) of the Marché aux Oiseaux, the Parisian flower market, which on Sundays becomes a market for birds and other pets. The headline "Amsel, Drossel, Fink und Star, und die ganze Vogelschaar" (Blackbird, thrush, finch, and starling and the whole flock of birds) comes from a children's song, playfully introducing an aural dimension to the photo story. Unlike a story about an anniversary, this sort of feature could have been published to fill space at any time. It indeed reads like filler. The facing page presents three high-contrast, stop-motion images taken by the star photojournalist Umbo of the famous juggler, acrobat, and vaudeville performer Enrico Rastelli. Like the summary line in the Reichsgericht photo story, the headline emphasizes the novelty of the medium: "Rastelli: The Lord of the Jugglers: Snapshots [*Momentaufnahmen*] from the Artist's Guest Appearance in Munich." Photographing judges in their dimly lit chambers or rubber balls moving at high speed between a juggler's hands required the use of high-speed cameras. Although this photo story's significance as a discrete text lies in its technological optimism about snapshots and the way it affords readers the chance to see events occurring far away, it also reiterates

the notion that technology enhances human perception. And it fulfills another role within the proximate context of this particular issue: it forms a thematic segue to the *MIP*'s essay section.

Beginning with their names, "illustrated" magazines touted themselves as media that represented news visually, but, in fact, the majority of their pages were filled not with photographs but with text and advertisements. Many decades after the decline of Weimar Illustrierten, Kurt Szafranski, the publisher of the *BIZ*, stressed to Tim Gidal that even though we remember Illustrierten for their contributions to visual culture (photography, photo stories, and photomontage), what made them commercially viable were the serial novels, crossword puzzles, and jokes.[55] Like the *BIZ*, the *MIP* clustered photo stories toward the beginning and end of issues to stress their visual character. These essays bracketed the "moneymaking" (if less visually appealing) features. Of the eight photo stories in the forty-page October 13, 1929, issue of the *MIP*, all began on either the first seven or last six pages. That week's forty-eight-page *BIZ* and thirty-six-page *KIZ* also concentrated their photo stories in either the first dozen or last half-dozen pages. This organizational pattern limited costs by limiting the number of pages with photomechanically reproduced images. In so doing, it produced roughly symmetrical magazines: photo essays followed by text followed by photo essays, with advertisements interspersed throughout, and, in some cases, a two-page photo essay in the center spread. This typical structure of an Illustrierte makes the segue between Umbo's photographs of Rastelli and the subsequent feature almost seamless, at least considering their content.

This next feature is the third installment of *Bux: The Circus Novel*. *Bux* was a work of popular fiction by Hans Possendorf, the pseudonym of the novelist and detective story writer Hans Mahner-Mons. The story tells of the adventures of a circus performer named Willibald "Bux" Buchsbaum, episodically recounting his exploits, travels, love affairs, and possible involvement in a murder. It notably teems with modern tropes such as train travel, America, "exotic" peoples and locations, and, of course, the mass spectacle of the circus. In transitioning from a photo story about a real circus performer to a serialized novel chapter about a fictional one, the *MIP* suggests a formal equivalency between two distinct orders of representation. In context, this equation legitimizes the use of photography in the photo essay. The third installment of *Bux* inaugurates a roughly twenty-page section of text features, including a short story by Bruno Walter, essays by Erika Mann and Arthur Silbergleit, jokes, anecdotes, and, most of all, advertisements. The concentration of advertisements in this section of the magazine adds further weight to Szafranski's claim that text features kept Illustrierten afloat, even if the photo essays were their signature feature.

Although this part of the issue lacks photo stories, its material reiterates the thematic interest in modern technology, photography, exotic cultures, and popular

spectacle. For instance, Erika Mann's essay "7 Minutes Before 10" concerns an actress in the legal drama *Haben Sie Mut* (Take heart), and in tandem with another essay, "50 Years of the Electric Light Bulb" by Carl Graf Klinckowstroem, it subtly echoes the subject matter of the preceding fifty-year anniversary feature about the Reichsgericht. The two essays reemphasize the logic of the segue between the Rastelli photo story and the *Bux* installment, again implying a false formal equivalency between these features. In the essay "The Robot," Arthur Silbergleit reflects on automatons and the mechanization of modern life, a curious subject considering its location across from an advertisement for a Mercedes Benz, the modern invention par excellence.

Only in the final six pages of the issue do the photo stories return, providing the closing bracket around the text features. These pages begin with the photo essay about Cecil Beaton announced on the *MIP*'s cover. The four symmetrically laid-out photographs in "Noteworthy Portraits by the English Society Photographer Cecil Beaton" accompany a biographical sketch by Paul Cohen-Portheim (fig. 10). The "noteworthy" images form an inverted *T,* with the photographs on the bottom sides depicting Beaton and his sisters in formal dress. At center top is a photograph shot from above (much like the issue's cover photograph) of the poet Edith Sitwell lying as though dead under two cherubs. The image beneath it, "Six Images of Mrs. Harrison Williams: An Interesting Photograph of the American Millionairess," consists of six identical exposures of Mrs. Williams (née Mona Travis Strader) composite printed within the same frame, creating a kaleidoscopic sense of sextuple vision. Mrs. Williams was a well-known fashion icon and socialite with a proclivity for marrying and divorcing wealthy older gentlemen—the New Jersey utility company magnate Harrison Williams was her third husband. The multiple exposures of her made-up face and bobbed hair accordingly construct her appeal as a celebrity. In spite of the interesting formal aspects of Beaton's photographs and their sense of high-society glamour—especially the photograph of Mrs. Williams—the article counterintuitively describes him as *not* being a photographer: "He started photographing for fun as an amateur, with an inexpensive camera. He photographed both of his sisters, their girlfriends, and other important society ladies. He succeeded through the originality of his photographs. But Cecil Beaton did not become a 'photographer' and is not one today. He photographs only the people who interest him, but these he photographs over and over." For Cohen-Portheim to write in the context of an illustrated magazine that Beaton is not a photographer says as much about the attempt to create a hierarchy of modes of photographic seeing as it does about Beaton. The comment is not intended as an insult. To the contrary, distinguishing among different kinds of photography is part of the mission of legitimizing photography. Cohen-Portheim seems to mean that Beaton is not simply a

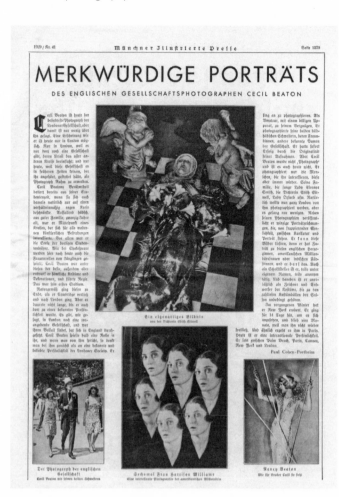

Fig. 10 "Merkwürdige Porträts des Englischen Gesellschaftsphotographen Cecil Beaton" (Noteworthy portraits by the English society photographer Cecil Beaton), *Münchner Illustrierte Presse*, October 13, 1929, 1379.

photographer who produces stock photographs, but rather a photographic "artist" who sees and registers his unique subject matters in keeping with his own individual style. For Beaton, these subjects are attractive society women photographed in fashionable clothing, and his style accords with the tenets of the New Vision.

The next page features another one-page photo story that, thematically, again reads like filler because it lacks any connection to a specific current event or personality. The headline reads, "The Spanish Street Between 6 and 7 O'Clock: Characteristically Negligible Moments [*Nebensächlichkeiten*] from Barcelona and Madrid" (fig. 11). Aside from this title and the story's short captions, the images look like tourist snapshots from Spain's largest cities. The spread of six equally sized photographs is the work of Emery Kelen, who—like Stefan Lorant, André Kertész, and Martin Munkácsi—was one of the many Hungarian exiles working as editors and photojournalists in the Weimar illustrated press. In Kelen's somewhat stereotyped vision, Spain is a slow-paced and poor country. "The man is neither dead nor injured," one caption begins. "He is simply taking a nap in the middle of the sidewalk." Another

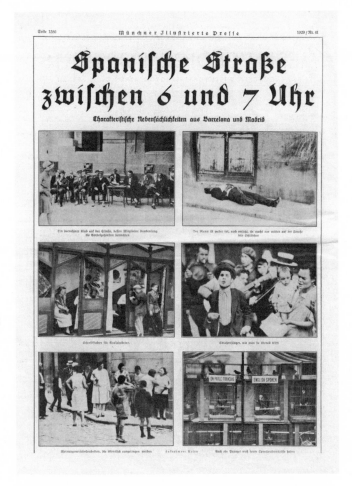

Fig. 11 "Spanische Strasse
zwischen 6 und 7 Uhr"
(The Spanish street between
6 and 7 o'clock), *Münchner
Illustrierte Presse,* October 13,
1929, 1380.

describes "street singers, whom one sees everywhere," and another, beneath a pic-
ture of squabbling señoras, "a difference of opinion, dealt with in public." This
story, along with a photo essay featured two pages later about an upcoming British
expedition to the South Pole, not only speaks to the long tradition of photography
as a form of prosthetic vision—that is, as a way to see spaces and cultures beyond
one's own. It also encourages a mode of typological seeing. That is, these snapshots
are presented as "typical" moments of Spanish life and invite readers to construct
larger narratives from a limited cross section, even if Spanish life obviously cannot
be reduced to six photographs. By promoting photography as a tool for constructing
typologies, Illustrierten encouraged a mode of perception that, as we shall see in
chapter 4, became an important strategy used by photographers to construct models
of German identity in photobooks.

The dissonant rhythm and subject matter of the final pages of the October 13
issue continue with a thematically wide-ranging photo story about another con-
tested art form at pains to legitimize itself: modern dance. The text of the story

"The Duncan School in Salzburg" boldly states, "A cultural history of the twentieth century without the name Duncan would be incomplete."[56] "Duncan" here refers not only to Isadora Duncan, the foundational figure of modern dance who had died in September 1927 in a freak automobile accident, but also to her sister, Elisabeth Duncan. The latter had recently opened a new dance school at Schloss Klessheim, a baroque castle in Salzburg. In his study on modern German dance, Karl Toepfer describes the motivations behind the school's founding: "Elisabeth Duncan wanted a school that was independent of her sister's chaotic personality. With the help of Max Merz (1874–1964), whom she married, she sought to infuse some discipline into Isadora's improvisatory, Grecian approach to bodily movement by incorporating into the curriculum ideas from German body culture (including Merz's enthusiasm for race hygiene)."[57] As relevant as these dubious racial policies seem in historical retrospect, the photo story lacks any allusions to them. It focuses instead on modern dance as a discipline that promotes, in the words of the caption, "harmony of body and soul." In so doing, the essay plays into the various Weimar discourses about sports, dance, body culture, and a return to nature as alternatives to the chaos of the urbanized modern world.[58] The photographs in the spread capture young girls in simple dresses, some with garlands on their heads, dancing outside on the grass like forest nymphs. The slightly off-focus quality of the largest images may derive in part from the capturing of action, but it still evokes the pictorialist style of art photography and pictorialists' penchant for pastoral scenes. Pictorialist soft focus served the aesthetic mission of equating photography with painting, and the soft-focus images in this photo story perform a similar function.[59] The images suggest an ethereal, otherworldly tone, as though the young girls dancing in the baroque castle and in nature are mythological nymphs. The photo story thus draws on readers' familiarity with an older, "artistic" style of photography to stress the aesthetic significance of Duncan's work. Photography becomes a way to "see" an art form that, due to its dynamic nature, eludes representation in still images.

This interest in modern dance as an art form segues into another photo essay about aesthetic legitimization. The final full-page photo story, "The Bob Haircut Paid Off!," focuses on two trends in modern culture: the breakdown of traditional aesthetic boundaries through the emergence of "applied arts" and the bob haircut as a signature trait of the cosmopolitan, liberated, androgynous figure of *die Neue Frau* (the New Woman) (fig. 12). The story concerns Antoine—he has no last name—a French hairstylist who "invented" the *Bubikopf*, or bob haircut (literally, boy head), one of the signature aspects of the New Woman that in its very name suggests androgyny. The spread consists of three images of Antoine and four of his "original sketches" of the bob haircut. The top-left photograph shows Antoine (who is also an actor) in eighteenth-century period costume, while the lower-left image captures

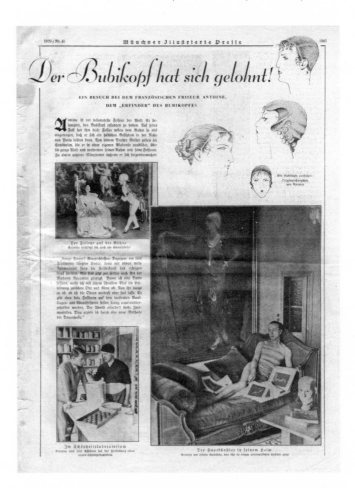

Fig. 12 "Der Bubikopf hat sich gelohnt!" (The bob haircut paid off!), *Münchner Illustrierte Presse,* October 13, 1929, 1383.

him "Im Schönheitslaboratorium" (in the beauty laboratory). The largest image, which fills the right side of the page, depicts the "Haarkünstler" (hair artist) in his home. The caption reads, "Antoine in front of a painting that shows him in an oriental costume." He lies on a couch like Manet's Olympia amid a pile of photographs, possibly of dancers. A sculpture of a head sits on the coffee table in front of him, and the enormous painting hangs behind the couch. Together, by referencing craftsmanship, drama, sketching, sculpture, and photography, these photographs cast Antoine's work as a form of applied art. At the same time, Antoine is cast as a profoundly effeminate figure; but for the caption that identifies the painting as an image of him in costume, one could easily mistake it for a picture of a woman. In this photo story, art, the French, and modern fashion are portrayed as effete, a common set of stereotypes that provided grist for right-wing propagandists.

 The top half of the last page of the October 13, 1929, issue of the *MIP* completes the photo story about Elisabeth Duncan and modern dance. An irregularly shaped, four-image photo story fills out the rest of the page. One intentionally

slanted image, captioned "A Memento of the Meadow," depicts a festive moment from the Theresienwiese, the site of Munich's annual Oktoberfest. The position of the image causes it to overlap with another photograph, evoking a pile of postcards from Oktoberfest or the kind of layout one might find in a private scrapbook. The tilt also expands the size of the image to fill in what would otherwise be an empty text column. The two photographs beneath it, captioned "Memories of Oktoberfest," likewise show familiar scenes from the beer festival and construe photography as a technology of memory—as a way to "see the past." Photography not only registers what happened at Oktoberfest. It offers a way to relive the experience later on.

Photo Stories and Photobooks

Whatever their differences as commercial or ideological rivals, Illustrierten were united in their enthrallment with photography and in their conviction that carefully organized photographs could convey information objectively with an added visceral punch. As these readings have shown, however, Illustrierten did not simply report information. On account of spatial limitations, they organized text and images in ways that created blank spaces for readers to fill. Different subject matters and different layouts elicited certain narratives and encouraged readers to look at culture in certain ways. The subject matters of the eight photo stories in the October 13, 1929, issue of the *MIP* are thematically diverse and incongruent, and yet they typify the Illustrierten of the day. To read the photo stories in this issue is to travel around the world to France, Spain, and the South Pole, and to learn about a politician's death, the anniversary of a court, a new coif, and the founding of a dance school. By way of comparison, that same week, photo stories in the *KIZ* took readers to Japan, Greece, and the United States, while the *BIZ* included photo stories about women's fashion, the "marriage market of Sarajevo," the statistically large number of twins in the town of Horn in Westphalia, and other wide-ranging themes.

The tragic irony of the enthusiasm with which the "new guild" of photographers and editors of illustrated magazines pursued enhanced expression through photography is that the visual techniques they pioneered and the reading strategies and modes of seeing they encouraged were soon mobilized against them. In mid-March 1933, Stefan Lorant and other non-Nazi editors were arrested in Munich. According to a report in the *Völkischer Beobachter*, "The arrested man [Lorant] is a Hungarian Jew and does not possess German citizenship."[60] Regardless of their achievements, Lorant and many other photographers and writers simply could not escape the "Jewish" label. In July 1933, scarcely three months after Lorant's ouster, the *MIP* published an ominous photo essay entitled "The Truth About Dachau" about the newly

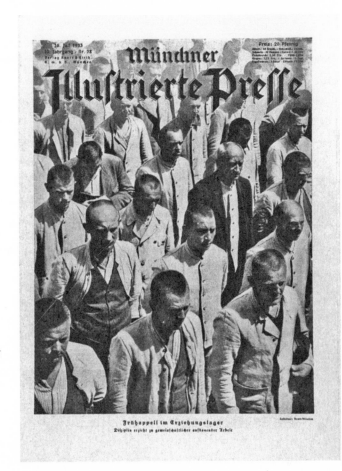

Fig. 13 "Frühappell im Erziehungslager" (Morning roll call in the education camp), *Münchner Illustrierte Presse*, July 16, 1933, cover.

established concentration camp outside of Munich. This decidedly propagandistic photo story used the same techniques with which the *MIP*'s readers had grown familiar during the Weimar Republic's final years. A full-page cover photograph depicts rows of inmates at roll call, and its cropping suggests that there are many more at the camp who do not fit into the picture (fig. 13). The story's close-ups of prisoners mimic mug shots or photographic documents of the mentally ill. The creative use of typography is evident in the caption beside a picture of casually chatting inmates with crossed legs: "Hours of Relaxation in the Education Camp."[61] By describing incarceration camps as more humane than they actually were and by using photographs as "proof," this photo story helped readers "look the other way" even as they looked straight at these injustices.[62] While it is a gross oversimplification to suggest that the editors and photojournalists in any way "caused" the new state of affairs, the formal techniques and faith in photography and technology that they so loudly professed conferred an air of truth and authenticity to such reports, which appeared in the *BIZ* until the mid-1940s.

Even if their professed goal was to inform and entertain, the key by-product of Illustrierten was their creation of a new faith in photography and in modes of photographic seeing. They effectively acclimated audiences to narrative photography. This enthusiasm for photography brought with it a well-intended but overly naïve faith in photography's ability to represent complexity. Edlef Köppen wrote that the unstated motto of Illustrierten was "to be informed about everything, but know nothing thoroughly."[63] To judge by photo stories that reduced Spanish street life to six photographs or the history of a symbolically loaded hairstyle to one page, he was correct. From the clear position of hindsight, Illustrierten seem to have been politically naïve. For all of their failings in this regard, however, their advocacy of photography played a key role in the subsequent popularity and commercial viability of the extended book-length photo essays examined in the following chapters. Erich Salomon's readers, for instance, would have been attracted to his photobook *Famous Contemporaries in Unguarded Moments* because they already knew his work from its regular appearance in Illustrierten. And the same sort of typological method used in "The Spanish Street Between 6 and 7 O'Clock" informed August Sander's thinking about how to represent German identity. After frequently encountering photo stories such as this one, readers would have had a better sense of how to approach longer photobooks, if only at a subconscious level.

Aside from their role in training the senses, Illustrierten promoted the work of specific photographers responsible for photobooks and, in turn, used those photographers' images in additional photo stories. For instance, Thomas Mann wrote a glowing review of Albert Renger-Patzsch's *The World Is Beautiful* in the December 23, 1928, issue of the *BIZ*, illustrated with images from the book. It appeared just in time to help last-minute Christmas sales.[64] In its June 1926 issue, *Uhu* published a photo essay about Karl Blossfeldt's microscopic photographs of plants and, in so doing, helped create a market for his 1928 photobook *Originary Forms of Art: Photographic Images of Plants*.[65] And in 1930 August Sander sold *Uhu* editor Peter Surhkamp images from his archive of portraits after Sander's photobook *Face of Our Time* was brought to Suhrkamp's attention. In sum, the traffic between Illustrierten and photobooks went both ways. Understanding the history of the diverse manifestations of the photo essay in Weimar Germany demands that one go beyond photobooks. One must also recognize the pivotal role that the photo story played in making them both possible and popular.

3

the modernist photobook: the nature of nature

As is the gardener, so is the garden.
—Thomas Fuller (1732)

Photo Essays, Feuilletons, and Responses to German Modernity

Germany's rapid modernization brought with it many unanticipated side effects on the collective psyche. Neologisms and popular terms such as *Zerissenheit* (tornness), *Amerikanismus* (Americanism), *Chock* (shock), and *Großstadt* (metropolis, or the big city)—to name just a few—point to the diverse range of experiences that accompanied the country's hasty transformation from a politically fragmented agricultural backwater in the late nineteenth and early twentieth centuries into one of Europe's dominant powers. Whereas almost two-thirds of the population lived in towns with no more than five thousand inhabitants in 1871, less than half did by 1925. Countless writers, thinkers, and artists were provoked to ask some difficult questions: Does one find the exemplary moments of this new age in higher living standards, parliamentary democracy, greater social mobility, and the steel and concrete of the metropolis? Or do politically motivated street fights, hyperinflation, and the decay of traditional values more accurately capture the essence of modern experience? Has modernity torn mankind away from nature, or was the idealized agricultural past itself a form of false consciousness?

To be sure, no single movement, fad, or phenomenon exemplifies the many responses to the rapidly changing world in the early twentieth century. Nor can

one categorize these responses with simple dichotomies. Even though much of the received historical wisdom about return-to-nature movements has stressed their connections to *völkisch* elements and nationalism, in point of fact no single ideological bent held a monopoly on seeking to reconnect with the natural world. To the contrary, historians such as Michael Hau have shown that Germans concerned with modern civilization's adverse consequences sought various new ways of "living as nature intended" (*naturgemäße Lebensweise*).[1] Vegetarianism, nudism, alternative medicine, and other dietary, hygienic, and recreational practices gained popularity as an increasing number of people came to believe that rationalization, urbanization, and industrialization had led human beings astray from their natural state. John A. Williams, moreover, points out that movements such as *Freikörperkultur* (free body culture) and the *Wandervogel* (youth scouting) found widespread support among social democratic and left-leaning workers' groups.[2] These responses were not specific to Germany. For instance, the *Naturfreunde* (friends of nature) hiking movement—with its ties to democratic socialism—found adherents not just in Germany but in Austria, France (*les amis de la nature*), and elsewhere.

Although a changed and changing relationship with the natural world was clearly a central social concern in Weimar Germany, the contribution of photographic narratives and sequences to articulating, framing, and participating in this discourse has received short shrift. This oversight is particularly glaring for several reasons. For one, nature photography was quite popular, and nature books were popular across class lines. At thirty-six marks, Karl Blossfeldt's *Urformen der Kunst* (*Originary Forms of Art*) was intended for an audience with more disposable income than the readership of inexpensive paperbacks, such as the titles in Karl Robert Langwiesche's series Die Blauen Bücher (The blue books) or the four volumes in Auriga Press's series Die Welt der Pflanze (The world of the plant).

Aside from their obvious commercial popularity in Weimar Germany, books of nature photography demand attention because photography itself inhabits a strange space between nature and culture. The title of one of the earliest photographically illustrated books, William Henry Fox Talbot's *The Pencil of Nature* (1844–46), underscores this ambivalence. Is it the case, as Geoffrey Batchen asks, that photography is a pencil provided by nature that humans use to inscribe nature? Or is photography nature's pencil, the means by which the external world inscribes itself? If by depressing the shutter release the photographer merely allows light to do what it would anyway—that is, penetrate the aperture and inscribe the back of the camera obscura with an inverted image of the outside world—then photography's status as fundamentally "cultural" or "natural" is in doubt. As Batchen describes it, photography seems both artificial and natural—and concurrently neither. "Indeed," he writes, "photography gives neither the resolution of a third term suspended 'between' nature

and culture nor the equally convenient irresolution of a perpetual undecidability."[3] Ontological questions about photography are, in other words, often similar to the questions posed about relationships to nature. To what extent have technology and rationalization separated us from the natural world, on the one hand, and how have they created new ways to interpret and interact with it, on the other?

Weimar photo essayists were very much aware of photography's ambivalent relationship to the forces of modernization. They had witnessed the radical transformation firsthand. In one of the more empirical moments of his radio lectures on the history of photography, August Sander drew attention to this change with the relevant statistics: "In the period from 1875 to 1895, the number of photography businesses increased by 71.4 percent, whereas the number of commercial businesses as a whole increased by 13.2 percent. The number of people employed in photographic industries increased by 160.2 percent, whereas the number of people employed in commercial businesses as a whole increased by 58.7 percent."[4] Given this widespread consciousness of how photography developed parallel to modern German society, it is no surprise that landscapes, animals, plants, and other archetypically "natural" phenomena became popular subjects for photographers. Albert Renger-Patzsch's 1928 *Die Welt ist schön* (*The World Is Beautiful*) and Paul Dobe's 1929 *Wilde Blumen der deutschen Flora* (Wildflowers of German flora) stand out as two works that, in the form of extended image sequences with unique structures, participate in the discourse about the changing "nature of nature." These photo essays are not simply collections of "natural" images, even if all of Dobe's photographs depict flowers and half of Renger-Patzsch's show flowers, plants, and animals. To the contrary, they exemplify another popular photo essay subgenre: the nature photobook. Each work is structured with greater or lesser degrees of narrative rigor, and each can be read as its author's contribution to a broad-based public discussion about modernization and its effects. Renger-Patzsch uses a photographic series that establishes a narrative rhythm and then contrapuntally interrupts it. This strategy produces a text that questions clean divisions of the "natural" and the "cultural." The photographs of wildflowers in Dobe's book appear in roughly the same order in which the plants blossom in the wild. With its xenophobic introductory text and a narrative rhythm that replicates the blossoming of flowers across the seasons of the year, *Wildflowers of German Flora* seeks to convince its readers of the value of Germany's own natural resources.

For further evidence of these photo essays' organizational structures and arguments, it helps to read them alongside similarly themed literary and cultural essays, specifically feuilletons. These popular, mass-produced works were also used by writers to participate in the return-to-nature discourse. Like the photo essay, the feuilleton prospered in Weimar Germany as a commercialized form directed at a wide

audience. A fixture of the "arts and leisure" sections of newspapers, this short essay form was designed to entertain, inform, and enlighten the general educated reader. It became an important form for many key philosophers and literati of the Weimar period, including Walter Benjamin, Siegfried Kracauer, Alfred Döblin, Ernst Jünger, Robert Walser, Ricarda Huch, and countless others who exploited it as a vehicle for expression, analysis, and cultural criticism. In his introduction to Kracauer's *The Mass Ornament,* Thomas Y. Levin even stressed that "during the Weimar era the feuilleton took on an avant-garde function as the locus of a concerted effort to articulate the crisis of modernity."[5]

Photography and the feuilleton faced similar prejudices. At the same time that photographers resisted the urge to define their medium against traditional visual arts, the feuilleton also came under fire as—in Paul Reitter's phrasing—"a particularly vivid agent of the very crisis [of modernity] in question."[6] Like nature photography, the feuilleton was often criticized as frivolous, trivial, and ornamental. More ominously, cultural conservatives such as Richard Wagner and Heinrich von Treitschke had cast feuilletonism and its practitioners as cosmopolitan, decadent, and "Jewish" since the nineteenth century.[7] Frustrated by this marginality, the noted feuilletonist Joseph Roth complained, "Must I apologize for the fact that a feuilletonist decides to become a politician? One cannot write feuilletons with one's left hand. One *may* not write feuilletons as an afterthought. It is a terrible underestimation of the whole activity. The feuilleton is as important as politics for the newspaper and for the reader, even *more* important."[8] Roth's protest suggests that the feuilleton's significance lies in how and where it addressed readers' concerns and interests. As the section of a newspaper that was "under the line" (i.e., physically segregated from "objective" news stories), feuilletons implied a unique subject position. The author's voice represented a moment of individuality that broke through the anonymity and homogenizing tendencies of the rationalized world, despite the fact that these same forces of modernization were responsible for the urban mass-media context in which the feuilleton flourished. For this reason, "feuilleton" has also come to mean the self-consciously subjective style of this short, belletristic form, even if, strictly speaking, the rubric of the text physically "under the line" no longer applies. Whether criticizing the technologized modern world or affirming it, the feuilleton, like the photo essay, was always enmeshed in and completely reliant upon it.

It thus comes as little surprise that late Weimar photo essays and feuilletons shared a common interest in the shifting boundaries of nature and culture in modern life. Some photo essays, such as Dobe's *Wildflowers of German Flora,* advocated a xenophobic, *völkisch,* and *Heimat*-mythologizing worldview. Others, like Renger-Patzsch's *The World Is Beautiful,* presented more abstract narratives that suggested the interconnectedness and irreducibility of the nominally separate "natural" and "artificial" spheres.

But in both cases, photo essays and feuilletons demonstrated that a rose is never just a rose—especially in the age of its mechanical reproducibility.

To better appreciate the role of photographic narratives in Weimar discourses of modernization and rationalization, it is useful to read Dobe's politically tendentious *Wildflowers* against Renger-Patzsch's *The World Is Beautiful*. With its closed, cyclical structure, scientific annotations, and politically one-sided introduction, *Wildflowers* produces an unambiguous and in many ways shallow statement of conservative, *völkisch* nationalism. But in eliminating ambiguity so thoroughly, it raises the question of whether it is even a valid object of interpretation. As a popular, commercially oriented, and in many respects trivial flower book, *Wildflowers* is exactly the kind of mass-cultural text that is susceptible to "overreading." One can easily read texts such as this one as exhibiting, in Janet Ward's phrasing, "proto-Nazi illness or just plain old capitalist 'false consciousness,' the manifestations of which are thus eternally in error." Yet it is precisely this photobook's status as an ephemeral "surface phenomenon" of a popular conservative nationalist intellectual strain of Weimar culture that warrants attention. As Ward also notes, such texts are valuable in historical retrospect in part for their role as "a cultural blueprint of visual life that shows us where our images today have come from."[9] Weimar photo essays about nature offer more than just the opportunity to reaffirm a (contested) historiography that would cleanly trace back-to-nature movements to the political Right. They also testify to the diversity and complexity of nature/culture discourses. At the same time, in their shared embrace of photographic sequences and books as the media through which to address these issues, these photo essays speak to the emergence of narrative photography and its acceptance across the cultural and political spectrum.

Wildflowers of German Flora and Animosity Toward Urban Life

Paul Dobe's *Wildflowers of German Flora: One Hundred Nature Photographs* was published in 1929 as part of the popular Blue Books series of the Langwiesche Verlag. Although this series included other plant books, such as Karl Otte Bartel's 1930 *Blüte und Frucht im Leben der Bäume* (Blossom and fruit in the life of the tree) and the 1931 *Formen des Lebens: Botanische Lichtbildstudien von Dr. Paul Wolff* (Forms of life: Botanical photo studies by Dr. Paul Wolff), it clearly emphasized flower books as a desired consumer object and intellectually valid subject matter for the *Bildungsbürgertum*, the educated German middle class. The dust jacket for the first printing of *Wildflowers*, for instance, advertised two popular books on "family" subjects: the 1908 *Die Seele deines Kindes* (The soul of your child) and the 1911 *Das Buch der Ehe* (The book of marriage), both by the conservative and anti-Semitic theologian Heinrich Lhotzky. In grouping nature

photography and family photography in the same series, the Blue Books demonstrate photography's value as a useful medium for reaffirming mythologies not only of nature but also of childhood, marriage, and other aspects of the human world. The mission of such books was at once aesthetic—as they allowed readers to appreciate natural beauty—and pedagogic. In Pepper Stetler's reading, the mission of flower books echoed the pedagogic mission of Werner Graeff's *Here Comes the New Photographer!* Stetler views flower books as a "form of training, a way of seeing elemental structures that are invisible without the camera's guidance."[10]

The title of Dobe's introduction, "Die Stellung des Menschen zur Blumenwelt" (Mankind's position toward the world of flowers), reiterates the notion that a close study of nature offers not only a mirror for understanding modern life but also a way to reconnect it to the natural world from which it has been alienated by inorganic asphalt and cosmopolitan decadence. In this introductory essay, Dobe argues that to photograph flowers is to embrace a political and spiritual cause of utmost importance to the renewal of the German nation: "The pull of the time has drawn our view far beyond the borders of our land . . . and has brought us to the point that we scarcely pay attention to that which is 'not far away.'" *Wildflowers* takes on the mission of redirecting the German gaze toward German soil and its natural products. In so doing, it allows readers to see that "what is outside cannot be separated from what is inside."[11]

To transform photographs of German wildflowers into a narrative, Dobe arranges them roughly "nach dem Laufe des Jahres" (according to the flow of the year)—that is, in the order in which the flowers blossom in the wild. Reading *Wildflowers* becomes a proxy for a nature walk around Germany and a temporal voyage through the different seasons when wildflowers blossom. Within this broader narrative structure, Dobe annotates each flower with its Linnean genus and species, the months and seasons when it blossoms, and, when applicable, information about the image's degree of magnification. Because the photographs are relatively low-quality, grayscale reproductions, the flower's colors are also listed. A black border surrounds each image and its symmetrically laid-out annotations, and additional dotted black lines bound each page. The flower's German name appears in calligraphic Fraktur beneath the photograph's bottom-left corner, while the genus and species names appear to the right in Latin script. The page number is located just below the dotted line at the bottom, and the photographer's name (usually Dobe) is placed just above it at the top. Because the images are arranged cyclically, where one begins the narrative is basically irrelevant. As with the passage of the seasons, as soon as one reaches the end, the cycle begins anew.

Although *Wildflowers'* scientific pretensions render the images "legible," this same scientific language limits their connotative possibilities. Four photographs in

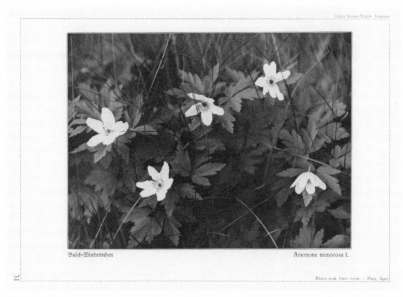

Fig. 14 Albert Renger-Patzsch, "Busch-Windröschen" (Wood anemone), in Paul Dobe,
Wilde Blumen der deutschen Flora: Hundert Naturaufnahmen mit Vorbemerkung (Königstein im Taunus:
Langewiesche, 1929), 31. © 2011 Albert Renger-Patzsch Archiv/Ann u. Jürgen Wilde,
Zülpich/Artists Rights Society (ARS), N.Y.

particular demonstrate how framing and sequencing circumscribe photographic sig-
nification. "Busch-Windröschen" (Wood anemone, page 31; fig. 14), "Holonder"
(Elder, page 51), "Hainbuch—Weißbuche" (Hornbeam, page 104), and
"Büschel-Glockenblume" (Clustered bellflower, page 107) were taken not by Dobe
but by Albert Renger-Patzsch. They nevertheless signify differently than the flow-
ers in *The World Is Beautiful*. There, photographic meaning is obscured by a variety of
strategies: the division of the photo essay into discrete sections, the separation of
captions from the images, the absence of discernible reference points within the
space of the photograph, the pronounced tendency toward abstraction, the fore-
grounded surface textures, the complex play of light and shadow, and, in general,
the materiality of the object qua object. This catalogue of modernist visual tech-
niques opens up a wide range of connotative possibilities. Sometimes even the very
subject of Renger-Patzsch's photographs is not immediately evident.

But *Wildflowers* lacks such ambiguity. Dobe recontextualizes Renger-Patzsch's
images such that they reinforce the cultural agenda introduced by *Wildflowers*' book
jacket and preface. In its entirety, the blurb on the jacket reads:

This volume unites one hundred botanical photographs of nature into a work
whose meaning for the German world can easily be more than it might seem at
first glance. In its restriction to German wildflowers, that is, flowers that are in

general construed, indeed misconstrued, as weeds, and that clothe our home-
land with the immeasurableness of unknown life and unknown beauty, there
lies a particular living value for German people. The person to whose eyes
these photographs do not open a world of life and beauty that he has passed
by inattentively, his eyes will indeed never be opened. Entirely extraordinary
photographic skill performs here its duties as a leader.[12]

Germans, Dobe argues, are too absorbed with the fast pace of modern life. They
have scorned their native soil and have erroneously labeled German flowers *Unkraut*
(weeds). Technology, specifically photography and the mass production of illustrated
books, can help Germany reclaim what it has lost touch with through urbaniza-
tion. In fulfilling this role, it executes its *Führerdienste*—literally, its duties as a leader.
The use of *Führer,* already a politically laden word by the early 1930s, points clearly to
the book's right-wing political sympathies.

The volume's acknowledged intention is to represent the natural world's purity
and wholeness to an urban audience that has been alienated from it. To this end, it
rehearses common tropes of antiurban discourse. The introduction begins, "All of
the images of this book present *German* plants. These plants have grown wild from
their very beginnings in our fatherland or close by in German-speaking areas. Plants
that appear wildly in Germany from [other] cultures or that appear on the streets
of our transportation systems from foreign lands are not included in this collec-
tion."[13] This opening paragraph equates flowers and humans almost as if flowers are
cognizant of nationalities. Dobe explicitly excludes urban flowers (those that grow
in cracks on streets and sidewalks) and nonindigenous species from his German
flower kingdom. From the very first lines, then, he speaks in reactionary, xenopho-
bic cliché.

To oppose the alien elements that he perceives as threatening, Dobe tries to
reestablish a primal link with nature, even if this reunification must paradoxically
appeal to the same technology that initially generated the break. Because of the
photographs' relatively low quality in this mass-produced volume (the first edition
numbered fifteen thousand copies), most of the backgrounds are black or blurry.
Technology generates formal standardization. Furthermore, as Dobe admits in his
introduction, most of the photographs were taken in studios, not in the wild. Some-
times the flowers did not survive transport to the photo studio. In other cases, floral
beauty becomes evident only through enlargement.[14] To reclaim nature, one must
paradoxically distort and destroy it.

What emerges is a book-length lamentation of the modern world's chaos and
separation from nature and the suggestion that "the natural" possesses the seeds of
Germany's spiritual renewal. Unsurprisingly, the conservative critic Wilhelm Stapel,

known for his antiurban, anticosmopolitan, and anti-Semitic polemics, heaped praise upon *Wildflowers* and its companion volumes in essays, reviews, and feuilletons. Reaffirming Dobe's implication that the natural coexists as a separate sphere with distinctly human characteristics, he noted in a review of recent photobooks about plants and animals that "complicated life complexes express themselves in plants."[15] Whereas Dobe projects his antimodern critiques onto flowers using photographs, Stapel does so with words, notably in the short essays that appeared in the pages of his journal, *Deutsches Volkstum*.

This parallel tendency becomes particularly evident in Stapel's "Der Geistige und sein Volk" ("The Intellectual and His People"), an essay written in the subjective feuilleton style typical of many conservative nationalist reflections about urban life.[16] In this text, Stapel rehearses the litany of right-wing stereotypes about Berlin. This quintessential metropolis, he claims, is an "intellectual cloaca" overpopulated by avant-garde artists, writers, and intellectuals who share the same propensity toward irony and cynicism. These urban types unjustly ridicule and attack the German countryside, as evinced by "know-it-all" novels such as Alfred Döblin's *Berlin Alexanderplatz*. To make matters worse, the big city teems with corrupt foreign elements. Slavs and Eastern Jews have "penetrated" Berlin and created a "peinliche Mischung" (embarrassing mix). In an interesting moment of historical revisionism, Stapel even claims that the decadence of the big city is a long-standing phenomenon: Prussia's Hohenzollern dynasty took up residence at Sanssouci in Potsdam, just outside of Berlin, because "Neu-Berlin fiel ihnen auf die Nerven" (New Berlin got on their nerves). The answer to Germany's problems and to the problems of modern life, he writes in the final sentence, is an "Aufstand der Landschaft gegen Berlin" (uprising of the landscape against Berlin).[17]

In addition to its aphoristic conclusion, which posits rural and urban values as antagonists in a cultural struggle, "The Intellectual and His People" incorporates several botanical metaphors as it criticizes Berlin. Unlike the *Volk* who live organically and close to nature outside of city limits, the people of Berlin suffer from "Entwurzelung" (uprooting). Berlin has, furthermore, corrupted the countryside. Provincial cities have grown "eigenwüchsig" (spontaneously) like weeds on the sidewalk and have, Stapel laments, tried to copy Berlin. They have become "berlinoid" (Berlinified). "Pomuchelsberg is organizing a week of light," he notes, alluding to the Berlin im Licht (Berlin in Light) project of October 1928, in which the tourism and lighting industries commissioned famous photographers to capture Berlin's buildings, trains, and monuments at night.[18] To Stapel, such projects exemplify the spiritual and intellectual deprivation of the day. He argues, "All of these slurred ironies, all of these 'New Objectivities,' all of these reportages—this excited *Cri de Berlin* is indeed nothing but the inability to overcome the problems of our time."[19]

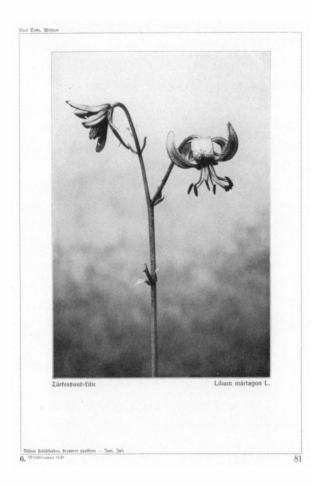

Fig. 15 Paul Dobe,
"Türkenbund-Lilie"
(Turk's cap lily), in *Wilde
Blumen der deutschen Flora*, 81.

Like Stapel and Oswald Spengler before him, Dobe views nature as the source of national cultures.[20] Within its hierarchy, he claims, German flowers—and by extension Germans—occupy a superior position. That this thinly veiled political message replicates the politics of cultural reaction becomes particularly clear in light of the praise Dobe's *Wildflowers* garnered from Stapel. Stapel's distaste for cosmopolitan Berlin, foreigners, and New Objectivity—a movement in which Albert Renger-Patzsch and Karl Blossfeldt were the most important photographers—did not turn him against *Wildflowers* (nor against foreign phrases such as *Cri de Berlin*). To the contrary, in the same issue of *Deutsches Volkstum* in which "The Intellectual and His People" appeared, Stapel wrote a laudatory review of a companion volume to *Wildflowers* entitled *Aus zoologischen Gärten* (From the zoological gardens). Stapel calls this nature-themed book (also part of the Blue Books series) a "philosophy of nature in images" and cites his own review of *Wildflowers* from several issues earlier.[21] In this earlier review, Stapel projects his own romantic fantasies about the city onto Dobe's photographs, which he burdens with deep meanings that mere black-and-white

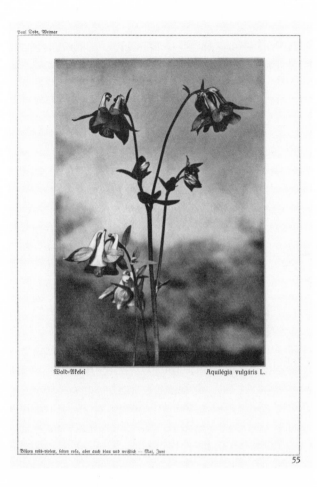

Paul Dobe, Weimar

Wald=Akelei Aquilégia vulgáris L.

Blüten trüb-violett, selten rosa, aber auch blau und weißlich — Mai, Juni

55

Fig. 16 Paul Dobe, "Wald-
Akelei" (Granny's bonnet),
in *Wilde Blumen der deutschen
Flora*, 55.

images of flowers might not seem capable of sustaining. For instance, foreshadowing the "sarcastic intellectuals" satirized six months later in "The Intellectual and His People," he calls the *Frauenschuh* (lady slipper) on page 66 "dummfrech" (insolent). Flowers that even suggest the foreign, such as the *Türkenbund-Lilie* (Turk's cap lily) on page 81 (fig. 15), are deemed untrustworthy.[22]

As a whole, Stapel argues, *Wildflowers* serves as a wake-up call for the organic components of the soul, which have atrophied in the rationalized world. He reads each photograph and the entire sequence as a romantic symbol of longing. The *Wald-Akelei* (granny's bonnet) on page 55 (fig. 16) "awakens in us with one glance all of romanticism. This is Philipp Otto Runge to a T."[23] Runge counted among the most important painters of north German romanticism besides Caspar David Friedrich, and he is notable for his mystical, symbolic, and highly evocative images of flowers, animals, and landscapes.[24] The *Weiße Seerose* (white sea rose) two pages later "awakens a Storm-like mood," Stapel claims, invoking the gloomy realism of Theodor Storm's novellas, many of which are set in the dreary environs of the author's North

Frisian home.[25] Stapel thus appreciates *Wildflowers* not simply as a set of photographs but also as a metaphorical attempt to intervene in a cultural controversy through photography.

Blurring the Boundaries: Victor Auburtin's First Impressions in Berlin

Whereas the pairing of Paul Dobe and Wilhelm Stapel shows how conservative nationalists used photobooks about flowers to express their ideas about the natural roots of national identity, a juxtaposition of the work of Albert Renger-Patzsch and Victor Auburtin suggests a different and in some ways more politically moderate approach. Renger-Patzsch's *The World Is Beautiful*—arguably Weimar Germany's most popular book-length photo essay—and Auburtin's feuilleton "Erste Eindrücke in Berlin: Von einem Auslandsdeutschen" (First impressions in Berlin by a German from abroad")—which appeared in the *Berliner Tageblatt* on October 16, 1927—allegorize modernity as a complex, irreducible mixture of the traditionally "natural" and the traditionally "artificial." Renger-Patzsch's sequenced photographs and Auburtin's ironically unfolding paragraphs are both symptoms of changing perceptions. Like *The World Is Beautiful*, Auburtin's report on his first impressions in the metropolis is filled with twists, some humorous and ironic, others surprising and shocking. Unlike the Dobe-Stapel pairing, however, Renger-Patzsch and Auburtin demonstrate a more complex role for photography in the discourse of modernization.

Auburtin's feuilleton assumes that first impressions of a new environment yield an authentic picture of it. The urban neophyte in "First Impressions in Berlin" has yet to develop the coldness, insensitivity, cynicism, and moral flexibility necessary to thrive in the metropolis's chaotic mass of sense perceptions.[26] Berlin's onslaught of stimuli consequently overwhelms him. Auburtin conflates the undifferentiated manifold of natural and artificial influences through irony and metaphor. His urban newcomer assumes the role of the naïve, rural outsider who records his arrival in the metropolis through a series of snapshot-like impressions: "Is it known that Berlin has the most beautiful flower shops in the world? With orchids of blue porcelain and mayflowers in October? And nowhere are there so many windows decorated with flowers, not even in Vienna."[27]

Auburtin inverts the reader's expectations in this passage. He invests "natural" categories such as flowers with man-made attributes and materials. Berlin's flower shops are beautiful not because their wares provide an escape from the city's pollution and grime in a microcosm of nature, but because they provide an "artificial paradise" replete with fake flowers that create the illusion of escape. Auburtin pokes fun at floral beauty, be it in kitsch or advertising, because he is not truly

talking about flowers but rather the commercially oriented representations of them. For the newcomer to the big city, nature and culture merge into a chaotic mass of representations.

In recording his first impressions of a new environment, Auburtin speaks to a broader aesthetic concern of *Neue Sachlichkeit* (New Objectivity)—namely, how to represent encounters with the newness of modernity. His feuilleton replicates the structure and assumptions of the arrival scene, an important trope of popular fiction that often thematized this same issue. Arrival scenes in popular novels, some of which were serialized in Illustrierten, frequently relied on a fundamental (if at times overly reductive) set of dichotomies, including urban/rural, naïve/street smart, and uncorrupt/jaded. The neophyte has not yet developed the blasé, indifferent attitude that forms a kind of psychic armor against the modern city's sensory onslaught.[28] Three Weimar novels with notable arrival scenes are M. I. Breme's 1927 *Vom Leben getötet* (Killed by life), Rudolf Braune's 1929 *Das Mädchen an der Orga Privat* (The girl at the Orga Privat typewriter), and Irmgard Keun's 1932 *Das kunstseidene Mädchen* (*The Artificial Silk Girl*).[29] In each text, as in Auburtin's feuilleton, the conventional dichotomies often collapse. Keun's novel, published when its author was only twenty-two, describes the mixed feelings of Doris, a provincial secretary who arrives in the metropolis dreaming of celebrity: "I'm in Berlin. Since a few days ago. After an all-night train ride and with ninety marks left. That's what I have to live on until I come into some money. What I have since experienced is just incredible. Berlin descended on me like a comforter with a flaming floral design. The Westside is very elegant with bright lights—like fabulous stones, really expensive and in an ornate setting."[30] This scene depicts the experience of modernity not with the straightforward metaphors used by Dobe and Stapel, but rather by conflating urban and natural imagery. Berlin envelops Doris like a quilt of flowers that both comforts and smothers her. Its lights tantalize her like precious stones, but she remains unemployed and cannot partake of the city's charms. She experiences modernity as *maßlos* (boundless), at once intense, seductive, and liberating, yet concurrently chaotic, formless, and oppressive. One can only speculate as to whether Auburtin's narrator, like Doris, arrived in Berlin at the Zoological Garden train station, whose name describes the herds of commuters as aptly as it describes the herds of animals at the neighboring zoo.

The exemplary arrival scene in *The Artificial Silk Girl* suggests that a complex mixture of uniquely modern challenges and optimism was a central concern in the popular literature of Weimar Germany. Some literary forms, particularly those categorized as *Heimatliteratur* (homeland literature), took on conservative, anticosmopolitan, antiurban, and protofascist tones. The Norwegian Nobel laureate Knut Hamsun and the German writers Ludwig Ganghofer and Gustav Frenssen, among others, developed prototypes for Weimar novels of *Zerissenheit* (tornness) with books that rejected the city

and its modern, rationalized ways.[31] In the Weimar era, authors such as Ernst Wiechert, Ina Seidel, Friedrich Griese, Josef Martin Bauer, and Richard Billinger sought not merely to stop the trends toward modernization but to turn back the clock entirely.[32] Their works are filled with transparently symbolic characters—typically honest, hard-working country types who overcome the machinations of lying, immoral urbanites.

Reactionary sentiments were not, however, limited to lowbrow *Heimatliteratur*. In countless essays and feuilletons, Stapel's conservative comrades in arms attacked urban modernity as an affront to the cherished values, traditions, and rituals of a mythic, organic, "natural" past. In April 1931, antiurban critique reached something of a climax. Wilhelm Ritter von Schramm called Berlin a "geistiger Kriegsschau-platz" (scene of intellectual war) where Americanism meets Bolshevism, a city that lies on the line connecting New York to Moscow.[33] Progressives, meanwhile, used mass-media essay forms to articulate a more affirmative view of the metropolis. Kurt Tucholsky alluded to the same fascination with city lights that triggered criticisms of the Berlin in Light exhibit. Under the pseudonym Ignaz Wrobel, he wrote, "To the outcry of the provinces against their own capital, there is only one answer: Speak with the power of Berlin, which is light, to the provinces, where it is dark."[34] Tucholsky notably published this essay just over a week after pseudonymously reviewing the 1927 edition of the German photography annual *Das deutsche Lichtbild* (The German photo-graph), this time as Peter Panter. In the review, Tucholsky praised Renger-Patzsch's images, both those of flowers and those of industrial objects, for their diversity.[35] These writings suggest that controversies about urbanization permeated all spheres of cultural production, including written essays and photo essays, even if in some cases the debate was framed as "nature versus culture" and at other times camou-flaged in dichotomies such as urban/rural, American/European, *Gesellschaft/Gemein-schaft,* or German/Jew.

As Auburtin's feuilleton addresses this central debate of Weimar Germany, it demonstrates in language what a photo essay such as Renger-Patzsch's *The World Is Beautiful* conveys through sequenced photography. In both forms, clear-cut bound-aries between nature and culture collapse. But whereas the feuilleton must rely on irony and unexpected rhetorical twists to conflate these categories, *The World Is Beautiful* represents the nature/culture collapse spatially in important transitional moments between the book's sections. Auburtin establishes a narrative rhythm but then unex-pectedly diverges from it, whereas Renger-Patzsch lets the space between the pictures serve the role of narrative caesura. In the passage that begins "The Bellevue Garden is beautiful," for instance, Auburtin arouses the expectation that a sketch of natural beauty will follow. But in its entirety, the paragraph reads, "The Bellevue Garden is beautiful, and a slender student wanders alone through it, reading in Spengler's *The Decline of the West,* as a retired official sits quietly on the bench and ponders. Only

for God's sake, don't tear down the iron gate around the park, as is planned. There would be no more wandering and pondering."[36] Oswald Spengler's *The Decline of the West* is an odd choice for an afternoon read, and not only because its gravity and pessimism contrast ironically with the frivolity of a young student's afternoon stroll in the park. In this magnum opus of Weimar cultural pessimism, Spengler examined world cultures with an approach derived from comparative morphology, a discipline that, like horticulture, imposes artificial classificatory structures on vegetation. Spengler theorized history as organic in two volumes teeming with botanical metaphors. The reader would only have to reach the fourth section of the introduction to read that "nature is the shape in which the man of higher cultures synthesizes and interprets the immediate impressions of his senses."[37] Throughout the work, similar botanical metaphors regularly resurface, as in this exemplary moment: "[A culture] blooms on the soil of an exactly definable landscape, to which plant-wise it remains bound. It dies when this soul has actualized the full sum of its possibilities in the shape of peoples, languages, dogmas, arts, states, sciences, and reverts into the proto-soul."[38] Culture, like the flower, goes through cycles. It spreads its petals, blossoms, withers, and dies. The disjuncture between *what* the student reads and *where* she reads conflates the natural and the artificial. The park's efflorescence contrasts starkly with the culture of those who pass through it. This culture blossomed but is now dying.

Finally, Auburtin reminds the reader of modernity's paradoxical duality through the figure of the retired *Rat* daydreaming on the bench and the *eiserne Gitter* (iron garden fence). A *Rat* is a privy councillor, a high-level bureaucrat, but since this man has retired, he is now the government's pensioned ward and can relax with casual strolls through the park. The former bureaucrat, together with the fence that surrounds him, is almost a comic literalization of Max Weber's famous definition of modern bureaucracy in *The Protestant Ethic and the Spirit of Capitalism* as an "iron cage."[39] Yet this iron cage is not a prison; it is the figurative good fence that makes good neighbors. Although it circumscribes life and curtails nature, this very act of segregation produces culture. The iron fence around the park is a framing device that evokes the paradox of nature photography in its very form. It makes nature autonomous but, in so doing, threatens it.

Albert Renger-Patzsch's *The World Is Beautiful*

Within a year of Auburtin's feuilleton, the most important flower photo essay of Weimar Germany—and indeed one of the most important photo essays in general—was published: Albert Renger-Patzsch's *The World Is Beautiful: One Hundred Photographs*. Rhetorically, it functions much like Auburtin's "First Impressions in Berlin,"

particularly in that it sets up readers' expectations only to undercut them. Unlike other flower photo essays of the late Weimar period, *The World Is Beautiful* does not consist entirely of photographs of flowers. Although plants, animals, and landscapes are the subject of well over a third of the volume, it also includes images of man-made objects. Their exclusion would have misrepresented both Renger-Patzsch's conception of photography and the implicit narrative about the arbitrariness of the nature/culture dichotomy, at least as manifested in tendentious works such as Dobe's *Wildflowers of German Flora.*

Through a series of layered structures, the sharply focused, highly detailed photographs of *The World Is Beautiful* build an argument. Renger-Patzsch's photobook shows that an object's social function, "naturalness," or "artificiality" is of secondary importance in understanding its essence. Instead, an object's key trait is its fundamental status qua object, which its form renders accessible. The ability to reproduce an object's form with unprecedented detail is, according to Renger-Patzsch, photography's defining feature. As Renger-Patzsch stressed throughout his career in numerous essays, the master photographer is one who manages the camera skillfully and precisely enough to recreate each object's idiosyncratic materiality or "thingness" in the eye of the beholder.

Consequently, Renger-Patzsch segregates his photographs from their descriptive captions, which are listed in the back of the book, presumably because their inclusion next to the images would only prejudice the viewer. When one reads the caption before seeing the photograph, as one is forced to do with most reprints of *The World Is Beautiful,* the object's materiality yields to its instrumentality—that is, one focuses on what an object does rather than on what it fundamentally is. One immediately subsumes the object into conceptual categories such as function, genus, and style. What for Renger-Patzsch was primarily the phenomenal interplay of shapes, surfaces, textures, and contrasts becomes—with a caption—a tree, an animal, a raw material, or a building. To recognize how an object functions within human society is to change its aesthetic status.

Renger-Patzsch consistently reaffirmed his purist aesthetics throughout his career, from the 1920s until his death in 1966. As early as 1925, he argued in "Ketzergedanken über künstlerische Photographie" ("Heretical Thoughts on Artistic Photography") that "the photographer must cling, true to his equipment, to that which is related to form."[40] At the end of his career, in the last essay published in his lifetime, he reiterated these views: "When I speak to you about my conception of photography, I am completely clear about the following facts: first, that my conception is only one among very many, and secondly, it is not as personally conditioned as many others, but it is indeed dated—it was in fact conceived over forty years ago, or to put it bluntly, it is regarded today as antiquated."[41] According to Renger-Patzsch,

photographers should not compete with painters, because photography and painting are fundamentally different. In a master's hands, the camera's unrivalled reproductive capacities reveal everything as an object to the human mind. Formal consistencies level out the historically conditioned traits and superimposed discourses that pigeonhole objects as "natural" or "artificial." These categories arise less from the object's intrinsic qualities than from the observer's mind.

For all of the uniqueness and individual expressiveness of his photography, Renger-Patzsch's photo essay is not just a set of one hundred sharply focused, highly detailed images that independently support his argument about the importance of form. Nevertheless, the volume's overly optimistic title has negated its narrative dimension and argumentative thrust. Renger-Patzsch's publisher changed the book's original title, *Die Dinge* (Things), to the ostensibly "catchier" *Die Welt ist schön* (*The World Is Beautiful*), a strictly commercial move that troubled Renger-Patzsch.[42] The new title very likely alluded to the highly successful series that included Dobe's *Wildflowers of German Flora,* the Blue Books, which was also called Die Welt des Schönen (The world of the beautiful).[43] The publisher's scheme to boost the holiday sales of Renger-Patzsch's book by making reference to another series has produced several unfortunate side effects for interpreters. Under the new title, each photograph— rather than being an exploration of form—becomes isolated "proof" of the affirmative thesis that the world is indeed beautiful. Critical readings typically ignore evidence of extended narrative organization and instead stress the intrinsic detail, craftsmanship, and beauty of the individual images.

Walter Benjamin's famous—but ultimately misguided—lambasting of New Objectivity photography in "The Author as Producer" exemplifies this kind of critique.[44] Benjamin argued that the images of flowers and factories in *The World Is Beautiful* aestheticize exploitative conditions. According to Benjamin, Renger-Patzsch's photography reifies and perpetuates social injustice. Because of the change to the photo essay's title, the photographs relate to one another, at most, thematically. Benjamin's claim that Renger-Patzsch fails to exploit the camera's revolutionary potential applies more to the book *The World Is Beautiful* than to the original photo essay, *Things*.

The naïve and pretentious title *The World Is Beautiful* and the uncritical affirmation it implies negate the book's narrative dimension. A closer inspection of the sequencing reveals an extended argument that, like Auburtin's "First Impressions in Berlin," arouses and undermines expectations as it blurs assumptions about the boundaries between nature and culture. To understand this argument, one must attend to the complex formal and thematic mechanisms by which Renger-Patzsch unifies images in short narrative sequences and creates ruptures among them. These mechanisms are the rhetorical analogues to Auburtin's metaphors and irony and the means by which *The World Is Beautiful* operates like conventional language.

Throughout *The World Is Beautiful,* extreme close-ups and careful cropping transform everyday objects into abstractions. There are, however, other unities that transcend individual photographs. Explicit subject matter (such as wood) or implicit themes (such as entrapment and trauma) reappear in various guises. Such thematic constants unify eight otherwise disparate sections named explicitly in the book's introduction: "Plants," "Animals and People," "Landscape," "Material," "Architecture," "Technology," "The Colorful World," and "Symbol." For all of their differences, these thematic units divide *The World Is Beautiful* into two symmetrical halves, with roughly fifty images of the ostensibly "natural" world and fifty of the "artificial," or human, sphere. A cryptic emblem on the book's cover that is half agave plant, half industrial tower symbolically reiterates this organizational structure.

Yet the symmetry is deceptive. *The World Is Beautiful* generates an anthropological or evolutionary narrative that starts in the natural world and progresses to the human world and eventually to the spiritual world, only to undercut it in individual photographs that invert readers' expectations and the ideological assumptions out of which they arose. Images of lower life forms begin the photo essay, but midway through it the narrative shifts to the realm of *Homo sapiens,* man the tool user. Images of raw materials, factories, churches, cities, and art replace the plants and animals. *The World Is Beautiful*'s overall structure thus suggests a narrative progression. One is reminded of an animation in which a fish crawls out of water and evolves first into a reptile, then a mammal, then a bipedal primate, and finally a human being. Nevertheless, photographs of actual human beings are scarce. Only three images in *The World Is Beautiful* depict living human beings, and two others, "Maori Head" (image 35) and "Hands" (image 100), show body parts. Renger-Patzsch concentrates on mankind's environments and creations, not on the people who use them. The only photograph of an entire human being in an environment is "Crab Fisherwoman" (image 32), in which a fisherwoman is literally tangled in her surroundings. Her net, like the iron fence in Auburtin's park scene, is the marker of a culture that both entraps her and provides her with a means of sustenance.

Ultimately, however, *The World Is Beautiful* renounces any deterministic suggestions of progress, grand historical narrative, or seamless "nature to culture" evolution. The most convincing proof thereof arises from the two transitional images that appear at the end of one section and the beginning of the next. These segues both link and separate the eight sections. Although the first photograph in each transitional pair often reiterates preestablished themes and motifs, the second image frequently repudiates, ruptures, or otherwise undercuts expectations. Although specific "micronarratives" emerge from the larger sections, they are abruptly arrested. The result of this contrapuntal rhythm is a photo essay that criticizes easy dichotomies such as "nature versus culture."

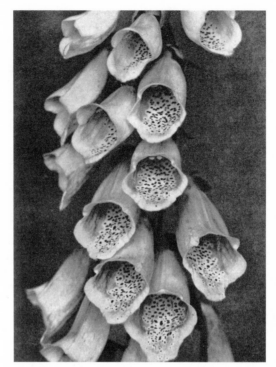

Fig. 17 Albert Renger-Patzsch, "Fingerhut" (Foxglove), in *Die Welt ist schön: Einhundert photographische Aufnahmen,* edited with an introduction by Carl Georg Heise (Munich: Kurt Wolff Verlag, 1928), 1. © 2011 Albert Renger-Patzsch Archiv/Ann u. Jürgen Wilde, Zülpich/Artists Rights Society (ARS), N.Y.

The World Is Beautiful's first photograph, "Fingerhut" (Foxglove), sets the tone for the photo essay (fig. 17). It repeats the gesture of the cover emblem by suggesting that the artificial is always already latent in the ostensibly natural. At first glance, "Foxglove" merely depicts a bouquet of foxgloves (*Digitalis purpurea*). The image appears to prove that "the world is beautiful" and thereby distracts alienated urban readers from modernity, this beauty's "other." However, upon closer inspection, other possible readings emerge. "Foxglove" might be understood as echoing modern capitalism's downside as much as it suggests escape from it. The bulbs lack individuality, and their innards spew forth like liquid waste in sewer pipes. Bundled, they look like a torn electrical cable, its frayed ends pointing in every direction. Because foxgloves have long been used in pharmaceutical manufacture, the photograph might well be understood as a subtle echo of the cover emblem. This emblem suggests that nature and culture are inextricably linked—or that "nature versus culture" is a false dichotomy in the first place.

Just as "Foxglove" injects connotations of industry and urban decay into what otherwise appears to be a superficial depiction of flowers, the transition between the first section, "Plants," and the second section, "Animals and People," blurs the accepted boundaries between the natural and the artificial. On one level, images 20 and 21, "Queller im Schlick eines Priels" (Glasswort in the mud of a tidal gully; fig. 18) and "Mantelpavian" (Hamadryas baboon; fig. 19), simply represent the

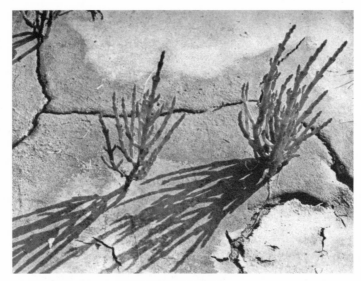

Fig. 18 Albert Renger-Patzsch, "Queller im Schlick eines Priels" (Glass-
wort in the mud of a tidal gully), in *Die Welt ist schön*, 20. © 2011 Albert
Renger-Patzsch Archiv/Ann u. Jürgen Wilde, Zülpich/Artists Rights Society
(ARS), N.Y.

plants and animals of the natural world. Yet each of the sharply focused images draws
parallels between the human and nonhuman worlds. Each photograph represents
objects or ideological conventions that bridge the natural and artificial spheres.

The glasswort (also called a saltwort) in the cracked mud of a tidal gully nota-
bly derives its name from the plant's industrial application. The high percentage of
alkalis in this coastal plant makes it useful for glass production. Although this pho-
tograph looks different from later images in *The World Is Beautiful* that show stacks of
wood and other raw materials, its function is similar. Plants again contain the literal
and figurative seeds of the artificial, in this case the glass necessary for the camera
lens. Formally, the image's abstract quality suggests aerial photography, specifically
the bird's-eye views of László Moholy-Nagy, Alexander Rodchenko, Werner Graeff,
and other avant-garde photographers of the New Vision. They argued that images
that lack horizon lines or break with the conventions of single-point perspective
force one into new ways of seeing the quotidian. Such images thereby reveal the pro-
gressive potential of forms that look at everyday objects, such as plants, in new ways.

Like "Glasswort in the Mud of a Tidal Gully," the photograph on the other side
of the sectional transition destabilizes the nature/culture dichotomy. It does so by
parodying aesthetic conventions. Formally, the image resembles a portrait with its
three-quarter view. The model turns slightly to the side and avoids the camera. Like
a middle-aged man, his graying hair is nicely groomed, but he seems to be balding.
He clenches his jaw with stubborn dignity like a patriarch posing for an image that

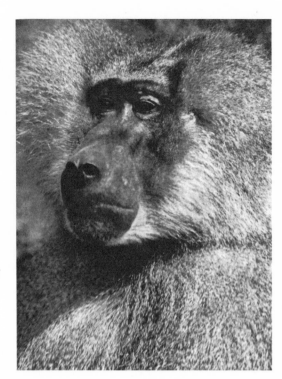

Fig. 19 Albert Renger-
Patzsch, "Mantelpavian"
(Hamadryas baboon), in
Die Welt ist schön, 21. © 2011
Albert Renger-Patzsch Archiv/
Ann u. Jürgen Wilde, Zülpich/
Artists Rights Society (ARS),
N.Y.

will hang for centuries on a manor wall. There is but one small problem: the model
is a hamadryas baboon. Portraiture is a distinctly human endeavor, and, historically,
family portraits have played an important role in the construction and affirmation
of the bourgeois family.[45] They are meant to be displayed prominently on the hearth
as proof of familial unity. Renger-Patzsch's baboon, the evolutionary precursor to
human beings in fascist bastardizations of Darwinism, is thus not only amusing but
also provocative. "Hamadryas Baboon" questions the vain separation of the human
and animal worlds while also revealing the artifice of photography's most common
use: in portraiture, we present ourselves not as we are but as we want ourselves to
appear.

 Like the transition from the first to the second section, the shift from the second
to the third continues Renger-Patzsch's implicit attack on the nature/culture dichot-
omy. "Kopf eines Maori" (Maori head), the final image in the section "Animals and
People," serves as a shocking punch line to the narrative in the preceding photo-
graphs (fig. 20). In the course of "Animals and People," Renger-Patzsch has created
an allegory of reproduction, but he subverts it with this final image. The reproduc-
tion narrative begins straightforwardly. "Kranke Äffchen" (Sick baby monkeys), the
first image after "Hamadryas Baboon," portrays not one but multiple chimpanzees,
presumably siblings, who appear small and weak. Viewed sequentially, the two images
of primates create a consistent narrative rhythm. The portrait of an individual from

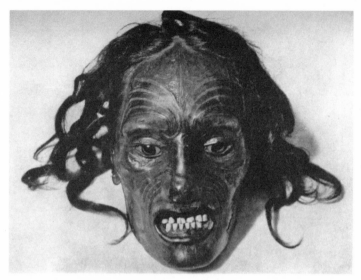

Fig. 20 Albert Renger-Patzsch, "Kopf eines Maori" (Maori head), in
Die Welt ist schön, 35. © 2011 Albert Renger-Patzsch Archiv/Ann u. Jürgen
Wilde, Zülpich/Artists Rights Society (ARS), N.Y.

an older generation precedes a group photo of members of a younger generation.
The next six photographs and an ensuing set of three reproduce the grouping
rhythm and the pattern of generational movement from older to younger. Following
individual pictures of an ostrich, a Brazilian bittern, a horse, a steer, a snake, and a
lioness, the narrative returns to groups of animals—several reclining camels, a herd
of sheep, and the clearest indication yet of family ties, a mother horse with her foal.

Humans are included in this pattern. Images 33 and 34, "Bildnis" (Portrait)
and "Somalikind" (Somali child), appear to extend the paradigm established in the
preceding animal pictures to the human realm. Having just seen images of individ-
ual human family members, readers expect family groups to follow, in accordance
with the logic of the animal images. The similar poses of the white woman in "Por-
trait" and the baboon heighten this expectation. However, the section's final image
ruptures the pattern. Groups do not follow the individuals, and the reproduction
allegory is shattered. The severed Maori head resembles both the white woman and
the black Somali child. The woman and the head both avoid direct eye contact with
the camera, display their teeth, and have their hair parted down the middle. Like the
child, the head is not European, and both subjects have significant bald patches. The
child wears a necklace of some totemic value, while the head in its entirety serves as
a ritual object. The woman, for her part, wears earrings, her own ornamental fetish
object.

Ultimately, one cannot overlook the Maori head's profound uncanniness.
Unlike the vast majority of photographs since that of the baboon, the dismembered

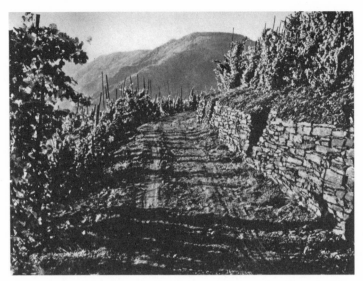

Fig. 21 Albert Renger-Patzsch, "Weinbergweg" (Vineyard path), in *Die Welt ist schön*, 36. © 2011 Albert Renger-Patzsch Archiv/Ann u. Jürgen Wilde, Zülpich/Artists Rights Society (ARS), N.Y.

head almost seems to celebrate death and chaos with its mocking grin—not the sacred values of nature, fertility, and family. The narrative paradigm disintegrates. The holy bourgeois family has collapsed because the artificial boundaries of race and class that quietly but profoundly circumscribe family formation have been transgressed. This micronarrative's conclusion forces one to reread the earlier images and reconsider the expectations with which one approaches them. Families are not, as the animal narrative initially suggests, purely natural. Rather, strict social norms control who can form families with whom and what happens if these borders are transgressed. Renger-Patzsch's tackling of miscegenation is entirely appropriate. In the Weimar Republic, racial theories and enormous demographic changes subjected traditional institutions such as marriage, the family, and sexuality to new scrutiny.[46]

The image following the jarring Maori head, "Weinbergweg" (Vineyard path), initiates a second motif that reappears later in the photo essay: paths that lead nowhere (fig. 21). The photograph depicts a road on the side of a mountain vineyard that leads into the unknown. A black cut in the side of the mountain repeats the suggestion of an abyss, as do the shadows that obstruct the way. Michael W. Jennings has convincingly argued that this blockage recurs throughout *The World Is Beautiful* as proof that nature and the man-made serve equally to block and frustrate vision in the modern world.[47]

"Kaimauer" (Quay wall; fig. 22) and "Musterzimmer" (Shoe lasts; fig. 23), the transitional photographs at the exact center of the volume, again allegorize the concurrent division and unity of the natural and artificial spheres. Their location

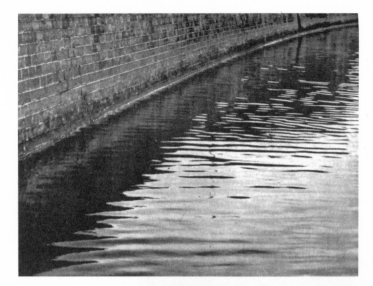

Fig. 22 Albert Renger-
Patzsch, "Kaimauer"
(Quay wall), in *Die Welt
ist schön*, 49. © 2011
Albert Renger-Patzsch
Archiv/Ann u. Jürgen
Wilde, Zülpich/Artists
Rights Society (ARS),
N.Y.

Fig. 23 Albert Renger-
Patzsch, "Musterzim-
mer" (Shoe lasts), in
Die Welt ist schön, 50.
© 2011 Albert Renger-
Patzsch Archiv/Ann u.
Jürgen Wilde, Zülpich/
Artists Rights Society
(ARS), N.Y.

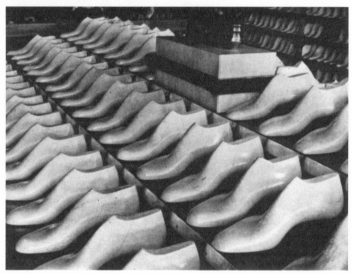

is particularly strategic. The first forty-eight images are divided into the sections
"Plants," "Animals and People," and "Landscape." "Quay Wall" precedes ten photo-
graphs in "Material" portraying raw materials that will soon be transformed into con-
sumer goods and subsequent depictions of the "artificial" human world in "Architec-
ture," "Technology," "The Colorful World," and "Symbol." The cropping of "Quay
Wall" eliminates everything except the water and the brick wall and thereby accentuates
the sharp dividing line between them.[48] But the division is deceptive. The buildings,
people, and other aspects of the urban landscape outside the frame still cast reflections
onto the water, creating black and white strips on its surface. Although the photograph
depicts a separation, these shadows subtly undercut the unanimity of this gesture.

Fig. 24 Albert Renger-Patzsch, "Eingangsmauer" (Entry wall), in *Die Welt ist schön*, 64. © 2011 Albert Renger-Patzsch Archiv/Ann u. Jürgen Wilde, Zülpich/Artists Rights Society (ARS), N.Y.

Historically informed viewers assume—correctly—that the shoe lasts of the photograph by that name come from the Fagus-Werk (Fagus Factory) shown in image 64, "Eingangsmauer" (Entry wall; fig. 24), even though there is no direct evidence of this in *The World Is Beautiful*. It is known that sometime between 1926 and 1928, Fagus commissioned Albert Renger-Patzsch to take photographs for use in advertising and public relations materials.[49] Although the entry wall, which looks strikingly similar to the quay wall, obscures the factory, the sign "Schuhleisten-und Stanzmesserfabrik" (Shoe last and awl factory) atop the building remains visible. In spite of the obviously industrial and artificial associations of a warehouse full of shoe lasts, these objects still retain links to the earlier section of flower and plant photography. The shoe lasts are made of beechwood, of the genus *Fagus*, which is depicted earlier in the book and reappears later. Beechwood crops up not only in the raw materials section ("Pieces of Beechwood," image 52) and in the Fagus Factory photographs of the architecture section but also in the preceding landscape images ("Beech Forest," image 43; "Hornbeam," image 44). Whether in the wild, in stacks as raw material ("Lumberyard," image 59), or in finished industrial products, beechwood unites the disparate spheres of nature and industry even as it changes form.

Images 89 and 90, "Brücke" (Bridge; fig. 25) and "Pietà des 15. Jahrhunderts: Marienkirche in Zwickau" (Fifteenth-century pietà in the Marienkirche in Zwickau; fig. 26), constitute the penultimate set of transitional photographs. They further support the thesis of the elision of the natural and artificial in that they are the mirror images of "Maori Head" and "Vineyard Path." These photographs invert the

Fig. 25 Albert Renger-Patzsch, "Brücke" (Bridge), in *Die Welt ist schön*, 89. © 2011 Albert Renger-Patzsch Archiv/Ann u. Jürgen Wilde, Zülpich/Artists Rights Society (ARS), N.Y.

Fig. 26 Albert Renger-Patzsch, "Pietà des 15. Jahrhunderts: Marien-kirche in Zwickau" (Fifteenth-century pietà in the Marien-kirche in Zwickau), in *Die Welt ist schön*, 90. © 2011 Albert Renger-Patzsch Archiv/Ann u. Jürgen Wilde, Zülpich/ Artists Rights Society (ARS), N.Y.

paradigm of an image of trauma followed by an image of a path leading nowhere. Insofar as *The World Is Beautiful* provides no explicit instructions about how to view this or any other image, one first encounters "Brücke" on its side, rotated 90 degrees. In this orientation, the bridge's slats resemble a wooden fence, an obvious symbol of entrapment. Like the road in "Vineyard Path," the bridge leads not to a specific goal but rather into the unknown, indicated here by clouds and a sharp horizon line. "Bridge" ends the section "The Colorful World" and may well be understood as providing a literal bridge to the next section.

As with "Maori Head," however, the transitional images are not comforting. They are traumatic, disjointed, and disruptive to preestablished narrative rhythms.

Fig. 27 Albert Renger-
Patzsch, "Hände" (Hands),
in *Die Welt ist schön*, 100. © 2011
Albert Renger-Patzsch Archiv/
Ann u. Jürgen Wilde, Zülpich/
Artists Rights Society (ARS),
N.Y.

The close-up detail tears the pietà out of its sacred context, just as the close-up of the baboon removes it from its indigenous habitat. Christ's bloodied body does not appear in a cathedral setting, such as that of image 60, "Blick in den Chor des Lübecker Doms" (A glance into the choir of the Lübeck Cathedral), the architecture section's first image. Nor does it appear as part of an altarpiece. Instead, Christ is radically decontextualized. Torn from the sculpture, his body loses its holy connotations and becomes merely bloodied flesh. One eye is closed, and the other bulges awkwardly out of its socket. An unknown figure clothed in an ominous black robe clasps the grotesque corpse of Christ, which is hardly distinguishable from a real corpse. As in the earlier transitions from natural realms to artificial ones, trauma and death dominate this segue, not hope and beauty. The images stand in stark contrast to the book's title and pound home its message of the merging of nature and artifice.

The book's final image, "Hände" (Hands), offers a coda that is far more complicated than it initially appears (fig. 27). In the context of the section "Symbol" in a book entitled *The World Is Beautiful*, a pair of clasped hands begs to be interpreted as a redemptive gesture of hope or prayer. Nevertheless, after so many suggestions of trauma, entrapment, and the uncanny, this conclusion is out of character. Here, Renger-Patzsch's own writings about hands in portraiture open the door to a more nuanced perspective on the image's meaning. In an article that appeared in

the popular magazine *Photographie für Alle* (Photography for everyone) just over a year before the publication of *The World Is Beautiful,* Renger-Patzsch stressed the importance of hands in photography: "The hands play a special role among artists and craftsmen. Here, in a certain sense, the hands lead their own existence. The pronounced individuality of such hands gave me the idea many years ago to isolate hands from the body as though for an image and to let them represent themselves in the photograph. Without doubt, such shots are a little alienating when we first see them, as is everything that is somewhat different from the norm." For Renger-Patzsch, hands are no less objects than flowers, animals, and factories. They are to be photographed with the same attention to texture and detail. Separated from the body, however, they arouse the same uncanny feelings as other images of trauma. "The photographs have not been retouched," Renger-Patzsch wrote, describing the pictures that accompanied the article. "The photos were not retouched so that the magic of their material effect might not be sacrificed for the sake of any false aesthetic principles."[50] In a fitting finale, even the implication of prayer in a picture of clasped hands disturbingly suggests dismemberment and alienation.

With this double-edged ending, *The World Is Beautiful* concludes its nuanced contribution to Weimar discourse about modernization and urbanism. To divide the world into natural and artificial spheres and—like Dobe and Stapel—to embrace one side enthusiastically is to fall prey to an illusion. Back-to-nature movements or Ludditism cannot resolve our discontent with the modern world, but neither can technological utopianism. Renger-Patzsch suggests to the very end that the familiar nature/culture dichotomy that generates a bipolar scale of possible solutions is itself artificial, tenuous, and even illusory. Neither category would exist but for the other. As such, *The World Is Beautiful* ultimately implies a course of political moderation. But as a photographic intervention in the modernization debate, it does something different from essays and feuilletons. It performs the complexity that it represents. We are consistently pushed to ask whether Renger-Patzsch has created culture with nature's tool or whether he simply represents nature through art.

Why Politicized Plants Matter

The Weimar Right yearned for a long-lost, romantic past, like Novalis's Heinrich von Ofterdingen, who sought an elusive blue flower bearing the face of his beloved.[51] Walter Benjamin summarized the left-wing response when he wrote that "no one really dreams any longer of the Blue Flower. Whoever awakes as Heinrich von Ofterdingen today must have overslept."[52] As they document attempts to come to terms with the rapid changes of the modern world, *Wildflowers of German Flora, The World Is Beautiful,*

and other similarly themed essays and feuilletons demonstrate the photo essay's emergence as a viable discursive form. Like conventional written forms, these photographic sequences organize arguments and facilitate their creators' participation in important cultural and philosophical debates. While Dobe uses sequenced flower photography to argue that flowers are symbols of an organic past, Renger-Patzsch implies in *The World Is Beautiful* that such a past never existed.

4

photographic physiognomies: diagnosing germanness

The Physiognomic Revival in Weimar Germany

The broad scope of the Weimar debate about the "nature of nature" paralleled a more geographically specific but equally vexed conversation about what it meant to be German in a time of crisis. The absence of firm political and economic foundations sparked frequent public reflection on questions of personal and national self-definition. Whether they used text, image, or some combination of the two, these meditations on the meaning of "Germanness" regularly invoked an age-old discipline that experienced a noticeable revival in the interwar period: physiognomy, the study of external bodily characteristics in the belief that they reflect unseen psychological and spiritual truths.[1] According to scholar Richard Gray, physiognomy became in Weimar Germany a "super-discipline," a "universal theory of knowledge, perception, and instinctual understanding that present[ed] a powerful counter-model to the Enlightenment narrative of a rationally endowed, historically progressive humanity."[2]

The National Socialists' later abuse of physiognomy, phrenology, and related biometric pseudosciences has understandably rendered these disciplines synonymous with bigotry and intolerance. To establish racial hierarchies with Germanic types firmly at the top, Nazi *Rassenforscher* (race researchers) such as Ludwig Ferdinand

Clauss and Hans F. K. Günther invoked a German physiognomic tradition dating back to Enlightenment thinker Johann Caspar Lavater and even to antiquity.[3] The work of such *Rassenforscher* helped establish the infrastructure, rationale, and pretensions to ethnic virtue that Claudia Koonz terms the "Nazi conscience."[4] When scholars endorsed and popularized scientific racism, they implicitly and sometimes even explicitly legitimized subsequent genocidal policies. However, while one should not minimize physiognomy's tainted history, it is important to recall that the stigma surrounding it is of relatively recent vintage.[5] Today physiognomy may seem merely a misguided and bigoted basis for "proving" racial hierarchies, but in early twentieth-century Europe, many thinkers—even those later victimized by the misappropriation of its conclusions—recognized it as an analytical tool of self-reflective *Kulturkritik* used to deconstruct essentialized notions of identity.[6] In interwar Germany literally hundreds of physiognomy-themed publications appeared, and in many of them portrait photography played a central role.[7]

This physiognomic revival offered thinkers and photographers a powerful means by which to probe the roots of the chaos lurking beneath Weimar Germany's fragile façade of stability. With their focus on the tangible human body, physiognomic analyses implicitly rejected the psychologistic Freudian explanations of the psyche based on dreams or sublimated feelings that had grown in popularity since the end of the nineteenth century.[8] At least in comparison with the surrounding political turmoil, social upheaval, and hyperinflation, the body represented a relatively finite, tangible, and stable object of study. This interest in concreteness coincided with similar phenomena during the period of stabilization between 1924 and 1929, including the growth of fascism, the rise of Taylorism in industry, and the turn toward *Sachlichkeit* (matter-of-factness or objectivity) in the arts. Each of these trends sought to establish a semblance of economic, political, or aesthetic order. In Weimar Germany, physiognomy became, as Sabine Hake argues, "a new/old way to test the discursive and disciplinary boundaries—boundaries between the visible and the hidden, between tradition and innovation, between the self and the other."[9] Whether deployed in the service of progressive or reactionary goals, or something altogether different, the act of reading surfaces for deeper meanings became a popular approach to the question of national self-diagnosis. It permeated disciplines as varied as medicine, criminology, film theory, and philosophy.

Photography, especially portraiture, played a particularly significant role in Weimar Germany's physiognomic revival.[10] As sociologists approached the question of national identity systematically by constructing "representative types" from social or demographic data, physiognomic photographers represented German identity through book-length mosaics of German types. They regularly undertook this project by creating series of images. In these works, many of which included the words

Gesicht (face) or *Antlitz* (face, countenance) in their titles, photographers did more than just offer nonfictional accounts of Germanness; they created their own metaphors, models, and even fictions of German identity.[11] Consider, for instance, the formally similar work of two well-known photographers: the *völkisch* nationalist Erna Lendvai-Dircksen and the avant-garde portraitist and film cameraman Helmar Lerski. Lendvai-Dircksen began her book series Das germanische Volksgesicht (The face of the Germanic folk) during the Weimar era and continued it well into the 1940s. Through close-ups of human faces, many shot from slightly below, she aestheticized, idealized, and romanticized traditionally *völkisch* aspects of German culture.[12] And yet her photographs still strangely resemble Helmar Lerski's *Köpfe des Alltags* (Everyday heads), a set of eighty close-ups of darkly shadowed faces, many also shot from below. Lendvai-Dircksen found unity in race, whereas Lerski stressed the importance of social class by including photographs of beggars, the unemployed, cleaning women, and other socially marginal types in his photo essay.[13]

This brief comparison shows, schematically, how the rhetoric of "the camera does not lie" ostensibly let Germany's literal and figurative body politic "speak for itself" through portraiture. In point of fact, however, the photographers' mediating roles were second to none. Each left his or her own imprint on photographs through individual style, framing devices, and narrative sequencing. Whereas for some on the Right, physiognomic photography offered empirical "proof" of Germanic superiority and non-Aryan degeneracy, leftists read the calluses on workers' hands and their deeply furrowed brows as evidence of a lifetime of hard work and capitalist injustice. In short, physiognomy was highly politicized, but it also permeated worldviews well beyond simple Left/Right dichotomies. This chapter analyzes two physiognomic contributions to Weimar debates about German identity: August Sander's photo essay Antlitz der Zeit: Sechzig Aufnahmen deutscher Menschen des 20. Jahrhunderts (Face of Our Time: Sixty Photographs of German People of the Twentieth Century) and Walter Benjamin's letter sequence Deutsche Menschen (German Men and Women).

First published in 1929 by the Kurt Wolff Verlag (which had just been taken over by the Transmare Verlag), Sander's photo essay consists of sixty portraits excerpted from a larger project entitled People of the Twentieth Century, which occupied Sander throughout his life. This larger endeavor was originally to consist of forty-five portfolios of twelve photographs each. However, the rapid demographic changes taking place in German society caused the nature of Sander's material to change. Sander in turn frequently reconceptualized his project's initially rigid structure, and a "completed" version of the full project never appeared during his lifetime. It remained a work in progress. Sander divided his portfolios into seven groups: "The Farmer," "The Skilled Tradesman," "The Woman," "The Classes and Professions," "The Artists," "The City," and "The Last People."[14] Stylistically, his physiognomic portraiture

is remarkably consistent. Each photograph depicts a representative "type" of a particular group, whether country farmers, master craftsmen, or urban artists of the utmost urbanity. In contrast to the soft-focus pictorialist style that many photographers of Sander's generation embraced, the images in *Face of Our Time* are all sharply focused and vividly detailed, and they instantly identify themselves as products of a mechanical medium.[15] The subjects' willingness to be photographed readily reveals itself through direct frontal poses that leave them fully exposed to the camera's penetrating gaze.

In spite of the universalizing pretensions of the title *Face of Our Time,* many of Sander's models were merely citizens from Cologne or nearby Rhineland villages. Others were friends, family members, and colleagues from the Gruppe progressiver Künstler (Progressive Artists' Group), a circle of politically committed artists, writers, musicians, and others who worked primarily in a figurative style of constructivism and *Neue Sachlichkeit* (New Objectivity).[16] The painter Franz Wilhelm Seiwert, a member of the group, described both its approach and his own as "attempting to depict a reality stripped of any sentimental and accidental element, attempting to render visible its function, its legitimacy, its relations and tensions within the picture frame and its regularity."[17] *Face of Our Time* embodies this functional aesthetic, which has distinguished Sander's portraiture as one of the standard-bearing moments of New Objectivity photography.[18] Sander remains to this day a profoundly influential figure in the history of photography. An entire generation of photographers—including Diane Arbus, Irving Penn, Walker Evans, and the "Düsseldorf school" of Bernd and Hilla Becher, Andreas Gursky, Candida Höfer, Axel Hütte, Thomas Ruff, and Thomas Struth—has drawn inspiration from Sander's "variations on a theme" or "typological" photography.[19]

Yet Sander was also influential among his own contemporaries. With its interest in diagnosing present and future German identity, *Face of Our Time* invites comparisons to a second moment of the physiognomic revival that at once pays homage to Sander and powerfully critiques the limits of physiognomic and typological thinking: Walter Benjamin's *German Men and Women.* It is a series of twenty-five private letters by German intellectuals and cultural figures that Benjamin annotated and published first as feuilletons in the *Frankfurter Zeitung* from April 1931 to May 1932.[20] Each installment consisted of a handwritten letter by the likes of Johann Wolfgang von Goethe, Friedrich Hölderlin, Johann Heinrich Pestalozzi, Justus Liebig, Gottfried Keller, Annette von Droste-Hülshoff, and the Brothers Grimm, accompanied by a short introduction (or, in some cases, an afterword) by Benjamin. Both a Marxist and a Jew, Benjamin left Germany after the National Socialists assumed power in 1933. In 1936, while in exile, he compiled and republished the letters in Switzerland under the "Aryan" pseudonym Detlef Holz. Benjamin's publisher chose the title

Deutsche Menschen (*German Men and Women*) to help sales in Germany, where nationalism had reached a fever pitch.[21] *German Men and Women* is a chronologically ordered series spanning almost exactly fifty years before and after 1832, the year in which the standard bearer of German culture, Johann Wolfgang von Goethe, died. The letters date from 1783 to 1883, a period that, according to Benjamin, corresponds with the decline of the bourgeoisie from the zenith of its power in the late eighteenth century to its demise during the *Gründerzeit,* the "boom years" of rapid industrialization and modernization that followed German unification in 1871. In *German Men and Women,* Benjamin creates a dynamic narrative of German identity in the nineteenth century that focuses not on the physical surfaces (e.g., faces) of famous Germans but on the emotions and virtues that reveal themselves in the private letters they wrote.

Both *Face of Our Time* and *German Men and Women* represent relatively understudied works by well-known (and well-researched) cultural figures. When Sander scholars analyze *Face of Our Time* as a discrete text, they generally focus on its genesis, themes, and narrative trajectory in relation to the larger cross-sectional survey, *People of the Twentieth Century,* from which it stemmed. These approaches to the work as a "preview" are entirely reasonable, and Sander's own letters corroborate such readings.[22] Nevertheless, scholarship on *Face of Our Time* as a photo essay per se is relatively scarce.[23] One must differentiate between the larger sociological survey that readers could not access and *Face of Our Time,* which they could purchase. Sander did excerpt the individual photographs for *Face of Our Time* from the larger portfolio series, but his arrangement of the images in the photo essay does not correspond exactly to the portfolio organization in *People of the Twentieth Century.* For these reasons, *Face of Our Time* demands to be read on its own terms and not to be understood exclusively as a "preview" or "excerpt" of a larger project.

Benjamin's *German Men and Women* is also an understudied work by an otherwise well-examined figure. Only one volume of essays dedicated explicitly to *German Men and Women* exists.[24] Scholarship tends to focus disproportionately on Benjamin's media theory, especially his influential essays "The Work of Art in the Age of Its Mechanical Reproducibility" and "The Author as Producer." Moreover, *German Men and Women* consists more of other writers' letters than of Benjamin's own original writings, calling his role as a full-fledged "author" into question. Rather, he serves as a commentator, arranger, and editor of an extended montage of letters, which introduces myriad methodological concerns to the study of *German Men and Women.* Like Sander, his role is to structure fragments from a preexisting archive and let them "speak for themselves" to generate broader, transhistorical meanings. And just as Sander's photographs served different purposes when printed in illustrated magazines than when included in a modernist photobook, the individual annotated letters that Benjamin published in the *Frankfurter Zeitung* in 1931–32 must be distinguished from

the chronologically sequenced compilation of these texts that he published in 1936, by which time the political situation in Germany had changed dramatically.

There are compelling historical reasons to consider these works as a dialogue, and not only because anecdotal evidence suggests that Sander was a fan of Benjamin's work.[25] Aside from their similar titles, both of which mention the German people whose essence they probe, Benjamin explicitly praised *Face of Our Time* in his famous essay "Little History of Photography." Yet to the extent that scholarship has examined the Benjamin-Sander relationship at all, it fixates overwhelmingly on this essay, and even though Benjamin published it at the same time that he was working on *German Men and Women,* his project scarcely receives mention.[26] There are conceptual reasons to consider these works together as well. Even though *German Men and Women* lacks literal photographs, Benjamin's preferred prose form in this book is the fragmentary *Denkbild,* or thought figure, which derives much of its structure and effect from photographic concepts.[27] Both in his selection of letters and in his introductions to them, Benjamin creates written photographs, sudden moments of historical insight whose redemptive moments burst like the camera's flashbulb as fragments of the past. In other texts, such as his "Theses on the Philosophy of History," Benjamin repeatedly stressed that his theory of history relies on photographic concepts.

For all of the formal, thematic, conceptual, and historical affinities that link August Sander and Walter Benjamin, *Face of Our Time* and *German Men and Women* nevertheless differ in their conclusions about German identity in a time of crisis. Both works broadly engage the late nineteenth- and early twentieth-century tradition of *Kulturpessimismus* (cultural pessimism), a term most often associated with the historical and philosophical writing about cultural decay that reached its apotheosis in Oswald Spengler's widely read magnum opus from 1918, *Der Untergang des Abendlandes* (*The Decline of the West*). By approaching Sander's and Benjamin's works against the background of Spengler's well-known philosophical text—which derives much of its methodology from physiognomy—we can better understand how they debate the notion that outward surfaces reveal deeper secrets and the idea that by reading individual surfaces one can draw larger conclusions about broader classes of people. Although both Sander and Benjamin approach German identity with cross sections, Benjamin ultimately rejects typology as a valid way of reaching conclusions about people and nations.

Sander's sixty photographs convey a more specific message when read in order as a photo essay. *Face of Our Time* unfolds as a Spenglerian "rise and fall" narrative of civilizational decline with a distinctly pessimistic take on the fate of modern civilization.[28] Through transitions, ruptures, and exclusions, the organization of the photographs in *Face of Our Time* subtly questions narratives of progress and their consequences. Whereas Sander reads (and constructs) the state of contemporary German society

from German faces, Benjamin does similar work, albeit more historical and philological, in introducing and arranging the material traces of language left by famous Germans in private letters. Like *Face of Our Time, German Men and Women* acknowledges the dark sides of modernity. This acknowledgment is subtle but particularly powerful in light of the fact that a German Jew published the book in 1936, at a time when National Socialism was well established and the end of its terror was nowhere in sight. But unlike Sander's portrait series, Benjamin's text montage ultimately suggests the possibility of redemption for Germans and Germany through an allegory. *German Men and Women* traces core values that have persisted since the late eighteenth century even as Germany endured rapid industrialization, wars, national unification, and other growing pains. Benjamin's cultural physiognomy reveals and, as a kind of "ark," stores the traces of a humane, tolerant, enlightened Germany that persisted in German culture from 1783 to 1883 and that can endure, in Benjamin's wording, the *Sintflut* (deluge) of fascism.[29]

When read together, these two works help us understand narrative photography's significance as part of the physiognomic revival during the interwar period and beyond. Sander's typological method—taking specific examples and using them to divine deeper social structures—was popular yet readily susceptible to abuse. And while Benjamin clearly appreciated the novelty and power of Sander's approach, he also found much to criticize in it. By evoking the visual discursively in *German Men and Women,* Benjamin critiques the interplay of text and image in photo essays in general and Sander's in particular. The dialogue between these works underscores the need to understand photo essays not simply as isolated objects for study by art historians, nor letter collections as the exclusive purview of literary scholarship. When we compare a photo essay with a similar work that nevertheless lacks the visual referents of literal photographs, we can see the photo essay's rhetorical powers and limitations vis-à-vis other forms of modernist literature and cultural criticism. The implicit conversation between these texts reveals the full-blown participation of the photo essay in the intellectual debates of German modernism. Through photo essays, photographers used photographs to accomplish tasks hitherto restricted more to the written word, and contemporaries recognized the importance of these works.

Oswald Spengler, August Sander, and the Physiognomy of Culture

Oswald Spengler's *The Decline of the West* stands out as one of the most influential texts in the intellectual culture of Weimar Germany.[30] In this widely discussed work, Spengler posited a cyclical model of the rise and fall of world civilizations—a model from which August Sander drew inspiration, at least in part. In Spengler's model,

all civilizations course through a series of predictable phases, named after the cycli-
cal seasons, that repeat across cultures, time, and space. Spengler's claim earned
widespread attention not least because it boldly challenged Enlightenment notions
of individual freedom and agency. Describing this concept of history, John Farren-
kopf has argued that "for Spengler, man is less the autonomous creator of his his-
tory and more the vehicle for its expression."[31] Spengler challenged those who would
claim that modern Western—or, as he called it, "Faustian"—civilization represents
the culmination of human existence. Rather, he provocatively characterized mod-
ern culture as the hallmark of the "winter" of Faustian civilization. Like the other
Hochkulturen (great cultures) that he analyzes, Western civilization will decline, and in
the early twentieth-century world around him, Spengler saw that decline under way.
With its pessimistic outlook, *The Decline of the West* clearly resonated with the philosophy
of decadence and cultural decay, the thread of so-called cultural pessimism that runs
through the works of Friedrich Nietzsche, Arthur Schopenhauer, Paul de Lagarde,
Julius Langbehn, Georg Hansen, and even Arthur Moeller van den Bruck, the
writer credited with coining the term "the Third Reich." Although Spengler's own
relationship to Hitler and National Socialism was complex, historians can and do
legitimately read his work and the tradition of cultural pessimism as a key conceptual
forerunner to National Socialism.[32] In Eric D. Weitz's words, *The Decline of the West* was
"one of the foundational texts of the Right, established and radical, and its great
popularity extended even far beyond those circles."[33]

As it pertains to Sander's *Face of Our Time,* however, Spengler's influence is much
more specific. As we shall see, this influence manifests itself in the photo essay's
cyclical structure. Spengler's own physiognomic method also informs Sander's
approach of interpreting the German condition through a relatively small number
of images—sixty. Spengler accorded physiognomy a particularly significant place as
a theory of knowledge and understanding. He rejected "systematic" approaches to
knowledge, by which he meant the quantitative, positivistic methods of the social
sciences. He advocated instead a method of cultural diagnosis oriented around read-
ing surfaces. In *The Decline of the West*'s third chapter, "The Problem of World History,"
in the section entitled "Physiognomic and Systematic," Spengler wrote,

> The visible foregrounds of history . . . have the same significance as the out-
> ward phenomena of the individual man (his stature, his bearing, his air, his
> stride, his way of speaking and writing), as distinct from what he says or writes.
> In the "knowledge of men" these things exist and matter. The body and all its
> elaborations—defined, "become" [*werden*] and *mortal* as they are—are an expres-
> sion of the soul. But henceforth "knowledge of men" implies also knowledge
> of those superlative human organisms that I call cultures, and of their mien,

their speech, their acts—these terms being meant as we mean them already in the case of the individual.[34]

Spengler claimed that physiognomy does not work through the application of mathematical laws to static objects. Rather, it functions analogically, through the transfer of knowledge about one dynamic object (an individual's face, speech, and acts) onto another (an entire class of people). Spengler saw this method as the wave of the future, and he predicted that "in a hundred years, all sciences that are still possible on this soil will be parts of a single vast Physiognomic of all things human."[35] To Spengler, knowledge requires that one peruse surfaces as much as, if not more than, depths. He felt justified in making broad claims about cultures on the basis of a relatively scant amount of data. On account of this radical epistemology, critical opinion about *The Decline of the West* has always been polarized. Whereas some have seen Spengler as a brilliant historical theorist on par with Hegel, others have derided him as a charlatan and dilettante whose interest in the "big picture" provided him with all manner of excuses to focus on surface characteristics and ignore any details that might complicate or contradict his hypotheses.[36]

Although Sander's exact degree of interest in *The Decline of the West* is unknown, he clearly belonged to the camp of Spengler's admirers. According to Sander's son Gunther, August Sander "was a passionate reader of all kinds of theoretical writings," and he "familiarized himself thoroughly with this voluminous study [*The Decline of the West*]."[37] Like Spengler, Sander valued physiognomy as a model of historical under-standing. He found it particularly suited to the study of dynamically changing objects in a period of rapid social change. In Spengler's phrasing, a physiognomic method allows an analysis "nicht des Gewordenen, sondern des Werdens" (not of that which has become but of that which is becoming).[38] Not coincidentally, Sander used this distinctively Spenglerian vocabulary of "becoming" or "development" in the title of a series of six lectures on the history of photography that he delivered in 1931 for the Cologne-based Westdeutscher Rundfunk (West German Radio): Das Wesen und Werden der Photographie (The nature and growth of photography).[39]

In "Die Photographie als Weltsprache" ("Photography as a Universal Language"), the fifth installment of this lecture series, Sander argued for the universality and superiority of a *Bildersprache* (language of images) over the spoken or written word, thus explaining why he chose it for *Face of Our Time*.[40] With the proliferation of mechan-ically (re)produced images through photography, he claimed, mankind's attention has again been directed to the preliterate, primal medium of the visual. *Bildersprache* does not depend on sound, the basis of spoken and written language, and thus it succeeds where conventional language fails. It transcends national boundaries where text cannot, and as a visual Esperanto, it harbors unique, universal, and utopian

possibilities. One could, Sander claimed in an exoticizing example, show an African Bushman images of the sun, moon, stars, and animals, and he would instantly recognize all of them. By contrast, textual descriptions of the same natural phenomena would mean nothing, unless the Bushman could read German.[41]

Sander argued that a photographic cross section of German society would provide an effective way to grasp Germanness at a particular historical moment. He believed that photography's efficiency, universality, and expressive power facilitated analogical relationships between specific examples, in this case between German types and Germany and Western civilization as a whole: "The individual does not make the history of his time, but he both impresses himself on it and expresses its meaning. It is possible to record the historical physiognomic image of a whole generation and—with enough knowledge about physiognomy—to make that image speak in photographs. The historical image will become even clearer if we join together pictures typical of many different groups that make up human society."[42]

Soon thereafter Sander adds, "The photographer who has the ability and understands physiognomy can bring the image of his time to speaking expression."[43] Photographs compress personality, meaning, and movement into a highly cogent, highly detailed, and highly evocative mark or stamp. This singular image, or *Einbild,* as Sander also calls it, represents both a static, spatial continuum and a temporal flux. Each image implies both before and after. The *Einbild* accurately conveys the meaning of an era because, as Sander also claims, history leaves its stamp on individuals' *Ausdruck und Gesinnung* (expressions and sensibilities); this accords with his Spenglerian belief that mankind is not so much an agent in history as a pawn in its broader cycles. As an image with spatial, temporal, and even allegorical dimensions, the *Einbild* offers insight into something greater—in this case, the "face of our time."

In this fifth lecture, Sander also explained the importance of sequencing to his physiognomic project. In so doing, he pointed to the broader structure of *Face of Our Time* and what he sought to do with it: "With photography the popular expression—'someone can see the grass grow'—has become a reality. By means of photography we have already begun to record all phases of human growth—from germinating cell to death." Sander reiterated this faith in the ability of a sequence of still photographs to "capture the development of mankind" when he noted, "Today with photography we can communicate our thoughts, conceptions, and realities to all the people on earth; if we add the date of the year we have the power to fix the history of the world."[44] In making reference to life cycles, the development of mankind, and the broader scope of world history, Sander not only recognizes the fact that images, when montaged, sequenced, or otherwise creatively organized, can be used to create arguments. He also alludes to the Spenglerian developmental model that *Face of Our Time* parallels.

August Sander's Physiognomic Photography and *Face of Our Time*

Oswald Spengler's thinking deeply impressed August Sander, and the traces of his model are evident as a structuring principle in *Face of Our Time*. This structure makes Sander's photobook more than just an assorted cross section of German types, each presented in an *Einbild*. In his foreword to *Face of Our Time*, Alfred Döblin, the well-known Weimar-era essayist and author of the modernist classic *Berlin Alexanderplatz*, stresses the fact that Sander's work is a photo essay. Döblin repeatedly emphasizes both its didactic purpose and argument. At the same time, however, he acknowledges a key feature of the photo essay genre—namely, that this relatively slim volume resists straightforward interpretation and opens itself up to multiple readings. Döblin defines *Face of Our Time* not simply as an anthology of loosely arranged images but as a unified yet fragmentary modernist "open text" that rewards rereading with different interpretations. "Entire stories could be told about many of these photographs," he writes. "They are asking for it, they are raw material for writers, material that is more stimulating and more productive than many a newspaper report. Those who know how to look will learn more quickly than they could from lectures or theories."[45]

Döblin then offers his own reading of *Face of Our Time*. He understands it broadly as a general "philosophy" about the question of human identity in the modern era and specifically as a text that documents how Germany has changed in that era. On this broader level, Döblin claims that Sander's portraiture reveals human society as the one source (along with death) that transforms individuals into an anonymous, faceless mass. When individuals become mere statistics, they lose their collective power and become the featureless, faceless cogs of a societal machine. Döblin praises *Face of Our Time* as a progressive work that both challenges this leveling and hints at the possibility of radical social change by juxtaposing photographs of revolutionaries and workers' councils with industrialists, teachers, and other authority figures who represent the status quo.[46] As Ulrich Keller notes in his seminal work on Sander, *Face of Our Time* garnered praise from leftist critics for this very reason, which may have contributed to the banning of the work (and the destruction of the original printing plates) during the Third Reich.[47] Through its sharply focused images of social types, the photobook vividly reminds its readers that the masses consist of unique individuals from many different social strata. Individual Germans—and not a unified, monolithic, faceless mass—form the basis of the German nation and any concept of "Germanness" that one seeks to divine from it. The faces of farmers, businessmen, students, artists, revolutionaries, and even societal outcasts reveal diverse feelings, thoughts, and personalities. Their *Kollektivkraft* (collective power), as Döblin calls it, arises not only from their power as a group united in a photographic series but also from the details of their idiosyncratic physiognomies.

Döblin concludes the foreword with a reading of the specific photographs of *Face of Our Time.* His interpretations situate the photo essay within the proximate context of German modernity and stress the sense of sociocultural development that takes place through the movement between different milieus. In images such as "Three Generations of a Farming Family," he sees in the farmers' faces a people worn down by a lifetime of hard, monotonous work. "We then move on to the type seen in the small town," he adds, describing the photographs of city craftsmen and the urban proletariat as providing "a quick overview of economic development during recent decades." From there, Döblin shows how the tensions of the time "become clear when we compare the photograph of the working students with that of the professor and his so peaceful family, nestling contentedly and still unsuspectingly." After tracing the "progression in moral attitudes that has taken place during recent decades" through the images of clergymen, teachers, and pupils, he writes that Sander goes on to survey "newer types." He explains, "Society is in the midst of a revolution, the cities have grown to gigantic proportions, and while occasional original figures remain, new types are already developing." Döblin sees in Sander's work a dynamic picture of Germany's transformation from a traditional, provincial, and agriculturally oriented nineteenth-century society to the cosmopolitanism and urbanity of the twentieth century and its metropolises. "Taken as a whole," he writes, "[*Face of Our Time*] provide[s] superb material for the cultural, class, and economic history of the last thirty years."[48]

Like many progressive critics, Döblin reads Sander's photographs as images of individual uniqueness and agency in the face of oppressive societal forces. Nevertheless, he gives short shrift to the concluding images of *Face of Our Time,* which depict service workers and the unemployed. This omission, as well as Sander's interest in Spengler's deterministic model of history, opens the door to a radically different interpretation. *Face of Our Time* moves metaphorically across Germany and German history in the course of just sixty photographs. But Sander not only creates images of the social classes and professional types of his time. He also provides an outline of the development of modern "Faustian" civilization that largely accords with Spengler's macrohistorical model, especially in its pessimistic conclusion about the decline of Western civilization. Sander's narrative begins with farmers and rural types, progresses to representatives of medieval guilds, and ultimately moves to industrialized, modern society and its intellectual and spiritual accomplishments. But true to the Spenglerian paradigm—and in a departure from Döblin's reading—it culminates with poignant photographs of the destitution, abjection, and economic servitude all too familiar to members of Weimar society.

Spengler schematized his cyclical model of the course of civilizations as a set of fold-out charts in the definitive 1931 edition of *The Decline of the West.* In these graphic

Fig. 28 August Sander, "Westerwälder Bauer" (Farmer, Westerwald), in *Antlitz der Zeit: Sechzig Aufnahmen deutscher Menschen des 20. Jahrhunderts* (Munich: Transmare Verlag/Kurt Wolff, 1929), 1. © 2011 Die Photographische Sammlung/ SK Stiftung Kultur—August Sander Archiv, Cologne/Artists Rights Society (ARS), N.Y.

depictions of the rise and fall of the "great cultures," he presents his comparative morphology of different civilizations and traces them through their various phases. The arrangement of the photographs in *Face of Our Time* accords, if not exactly then at least quite consistently, with Spengler's system. Employing the metaphor of the seasons, Spengler summarizes his model in the "Tables Illustrating the Comparative Morphology of History," which fold out from his book. The first table, "'Gleichzeitige' Geistesepochen" ("Contemporary" spiritual epochs) summarizes the calendar structure of Spengler's model. It begins with the "spring" of civilizations, which he describes as "landschaftlich-intuitiv. Mächtige Schöpfungen einer erwachenden traumschweren Seele. Überpersönliche Einheit und Fülle" (rural-intuitive. Great creations of the newly awakened dream-heavy soul. Super-personal unity and fullness).[49] This romanticized notion of the origins of civilization in an agricultural paradise was a familiar trope to right-leaning social theorists of modernity, many of whom—as we have seen in the case of Albert Renger-Patzsch and Paul Dobe— juxtaposed an organically united and pure "nature" with the corrupt, fragmented metropolis.

The first photograph in *Face of Our Time* depicts a farmer from the Westerwald region (fig. 28). The well-dressed, bearded, and somewhat elderly man is seated slightly off-center in a full frontal pose and gazes directly into the camera. Only his clothes, chair, glasses, and book (presumably a Bible) mark his individuality.

Yet these material possessions do not identify him as a farmer from Westerwald—only the caption does. If one glances at the image first, one might think him a clergyman or a teacher based on his serious demeanor and book. The absence of obvious indices of "farmerness" (a plow, scythe, oxen, overalls, straw hat, or other equally stereotypical props) might induce the reader to look even harder for more subtle ones. The caption and photograph thus undermine each other. Together, they imply that historical context determines photographic meaning and personal identity. They draw attention to the fact that Sander is not simply presenting a picture of a farmer. Rather, he is merging his own concept of "farmer" with a specific German context and encouraging readers to create their own analogies. The next nine photographs of *Face of Our Time* further explore the trope of the German farmer. They show a shepherd, farming women, farming families, and farmers' children, and include perhaps Sander's best-known image, "Young Farmers." In most of these images, the sitters cling tightly to family members or to symbolic objects such as Bibles and flowers. The photographs of farmers, their families, and their life cycles are images of purity, wholeness, and organic unity. They depict what was, in rapidly urbanizing Weimar Germany, an increasingly lost world.

Although one cannot map the movement between the stages of civilizational evolution (Spengler's "seasons") exactly onto specific photographs, *Face of Our Time* clearly shifts into new subject matters in a manner that corresponds to Spengler's seasonal model. Sander bridges the "seasons" with clusters of transitional images that could belong in either category. Summer, Spengler's next phase, is characterized by "reifende Bewußtheit. Früheste städtisch-bürgerliche und kritische Regungen" (ripening consciousness. Earliest urban and critical stirrings). Having just surveyed agricultural types, Sander shifts to such figures as the landowner, the teacher, and the "small-town citizens of Monschau, near Aachen." Many of the photographs in this phase depict small-town professional types. Ulrich Keller notes that Sander's images of what the photographer calls *Handwerker* (craftsmen) do not fully acknowledge the extent to which traditional guild structures found themselves in a profound state of crisis and decline.[50] Rather, they nostalgically depict the world in which Sander grew up and reflect Sander's own understanding of photography as a craft.

Notable examples of Sander's photographs of craftsmen are those of a locksmith (fig. 29) and a wallpaper hanger, as well as his famous portrait of a barrel-chested pastry chef. But Sander also includes more modern "professions" in photographs such as "Boxers," an allusion to the new popularity of the sport in the 1920s.[51] Like the farmers, the various craftsmen often hold the props of their respective professions: boxing gloves, a keychain, a mixing bowl, and so forth. They are defined by what they do. Unlike the preceding farmers, however, these subjects belong more to small-town and urban settings. They correspond to the *Bürger,* the specifically

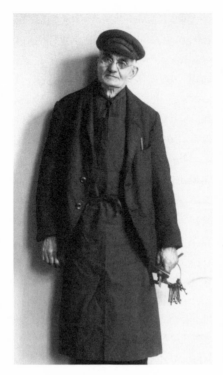

Fig. 29 August Sander, "Schlossermeister"
(Master locksmith), in *Antlitz der Zeit*, 14.
© 2011 Die Photographische Sammlung/
SK Stiftung Kultur—August Sander Archiv,
Cologne/Artists Rights Society (ARS), N.Y.

Fig. 30 August Sander, "Kommunistischer
Führer" (Communist leader), in *Antlitz der Zeit*,
24. © 2011 Die Photographische Sammlung/SK
Stiftung Kultur—August Sander Archiv, Cologne/
Artists Rights Society (ARS), N.Y.

defined class of medieval urban citizens (as opposed to serfs). The shift from
ancient/rural to medieval/urban also affords Sander the opportunity to introduce
photographs of members of the working class. As *Face of Our Time* moves to its next
phase, Sander employs transitional photographs that link summer's "ripening con-
sciousness" and "earliest urban and critical stirrings" to autumn, the civilizational
stage marked by the "großstädtische Intelligenz. Höhepunkte strenggeistiger Gestal-
tungskraft" (intelligence of the big city. Zenith of strict intellectual creativeness).
The key transitional photographs depict ripening class consciousness in the form
of workers' councils and, ultimately, political revolutionaries. "Kommunistischer
Führer" (Communist leader) is a portrait of Paul Frölich, a member of the German
Communist Party who served in the Reichstag (fig. 30). Frölich poses against a blank
background wearing a goatee and a simple suit, both of which make him uncannily
resemble the standard-bearing figure of world communism at the time, the then
recently deceased V. I. Lenin. He is, like Lenin, a "type" that readers can use to cre-
ate larger analogies.

Sander represents the urban intelligence and intellectual creativity of autumn through a wide variety of social types. These figures are all distinctively urban figures—white-collar workers who perform "mental labor" rather than blue-collar laborers. They include clergymen, government officials, students, working women, doctors, scholars, industrialists, and tycoons, as well as significant cultural figures of Weimar society: the architect Hans Poelzig, the painter Jankel Adler, the sculptress Ingeborg von Rath, the composer Paul Hindemith, the tenor Leonardo Aramesco, and others. The clothes these figures wear and the few (if any) props that surround them distinguish them as members of higher social classes than the sitters in previous photographs. Nevertheless, this phase of civilization has departed significantly from the purity of the agricultural past. However much cosmopolitan intellectuals and professionals might see themselves as the vanguard of civilization, Sander appears to have bought into the Spenglerian rhetoric. His sequencing presents them not only as masters of their respective arts but also as representing the final stage before the impending decline of winter.

Nowhere is the decadence of modern civilization more evident than in the pictures of two teenaged high school students—the literal "future" of Germany. Neither looks particularly childlike, and neither conforms to gender norms. With her short hair and stylish contemporary clothing, the sitter in "Lyzealschülerin" (High school girl) epitomizes the androgynous figure of the "New Woman" (fig. 31).[52] The young man in the following photograph, "Gymnasiast" (Male high school student), appears profoundly effeminate with his sunken cheeks, full lips, dandyish clothing, and half-smoked cigarette between his thin fingers (fig. 32). Such figures of modern decadence already point to the winter of Faustian civilization. They contrast profoundly with the subsequent photograph of a much more traditional student type: a member of the student dueling society whose facial scars graphically testify to his membership. The androgynous, decadent, cosmopolitan student types recur in "Bohemia," a transitional image of two cigarette-smoking, disheveled artist types who, unlike almost all of Sander's other sitters, do not look directly into the camera. These figures appear before a concluding set of four images representing winter.

Spengler describes winter as the "Anbruch der weltstädtischen Zivilisation. Erlöschen der seelischen Gestaltungskraft. Das Leben selbst wird problematisch. Ethisch-praktische Tendenzen eines irreligiösen und unmetaphysischen Weltstädtertums" (dawn of megalopolitan civilization. Extinction of spiritual creative force. Life itself becomes problematical. Ethical-practical tendencies of an irreligious and unmetaphysical cosmopolitanism). Whereas only pages before, Sander shows (and implicitly critiques) the breadth of artistic creativity, the final four images in *Face of Our Time* depict the "extinction" of creative energies and the instrumentalization of existence

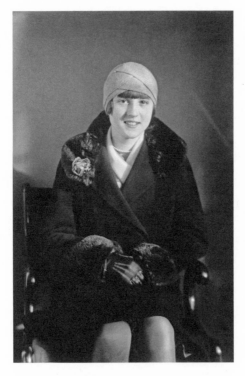

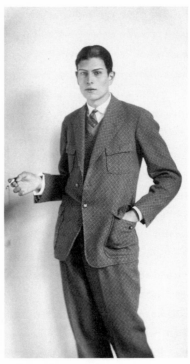

Fig. 31 August Sander, "Lyzealschülerin" (High school girl), in *Antlitz der Zeit*, 39. © 2011 Die Photographische Sammlung/SK Stiftung Kultur— August Sander Archiv, Cologne/Artists Rights Society (ARS), N.Y.

Fig. 32 August Sander, "Gymnasiast" (High school student), in *Antlitz der Zeit*, 40. © 2011 Die Photographische Sammlung/SK Stiftung Kultur—August Sander Archiv, Cologne/Artists Rights Society (ARS), N.Y.

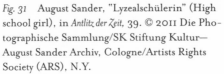

in the metropolis. These photographs of a barman, an out-of-work sailor, a cleaning lady, and a jobless man are all images of service workers or those who have fallen prey to the modern world's economic cycles. The subjects look tired, as though they have spent their lives serving others. The sailor, whose caption identifies him as "abgebaut" (downsized), stands crookedly beneath a cage-like lattice of steel beams. He appears ready to pull out his pockets and reveal them as empty. The barman's tired face and the maid's powerful hands and soiled smock likewise betray lifetimes of servitude.

"Arbeitslos" (Jobless), *Face of Our Time*'s sixtieth and final image, suggests a dire trajectory for civilization, offering a damning conclusion to Sander's narrative of his time (fig. 33). The image connotes the hopelessness, fear, loneliness, and oppression of physiognomic police photography. The unemployed man looks away from the camera, and his semiprofiled posture is reminiscent of a mug shot. His nondescript clothing resembles a prisoner's uniform or a monk's tunic. His head shorn, he stands against a brick wall whose lines make him appear like a suspect in a police lineup. He is a figure of silence and isolation.

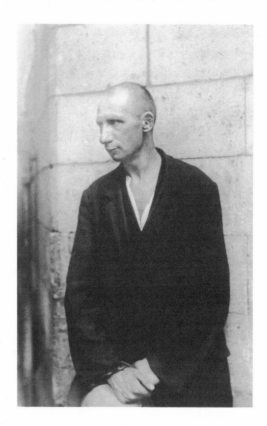

Fig. 33 August Sander, "Arbeitslos" (Jobless), in *Antlitz der Zeit*, 60. © 2011 Die Photographische Sammlung/ SK Stiftung Kultur—August Sander Archiv, Cologne/ Artists Rights Society (ARS), N.Y.

Walter Benjamin's *German Men and Women*

Walter Benjamin appreciated August Sander's photo essay for many reasons, not least because it complemented his own studies of the dynamic nature of German identity and the means by which it expressed itself. In October 1931, concurrent with the *Frankfurter Zeitung*'s publication of the annotated letters that eventually became *German Men and Women,* Benjamin publicly praised Sander in his essay "Little History of Photography."[53] He assigned Sander an important place in the history of photography and described *Face of Our Time* not as a mere portrait collection but as a structured work, a photo essay that actively involved its readers in the construction of meaning. "Whether one is of the Left or the Right," Benjamin wrote, "one will have to get used to being looked at in terms of one's provenance. And one will have to look at others the same way. Sander's work is more than a picture book. It is a training manual [*Übungsatlas*]."[54]

After encountering not only Sander's photo essay but also projects such as Hugo von Hofmannsthal's *Deutsches Lesebuch* (German reader), Rudolf Borchardt's *Der Deutsche in der Landschaft* (The German in the landscape), and other contemporary letter collections and text anthologies, Benjamin was inspired to embark on his own

cross-sectional survey of German identity in the modern era.[55] His project began as the series of letters that appeared in the *Frankfurter Zeitung* between April 1, 1931, and May 31, 1932. Benjamin had hoped to publish a book of sixty letters in 1932 to coincide with the centennial of Goethe's death. But he found no takers among publishing houses, and political exigencies, including his own forced exile, introduced lengthy delays. In Parisian exile, however, he came into contact with the Swiss publisher Rudolf Roessler through a mutual friend, the theologian Karl Otto Thieme. Roessler's Vita Nova Verlag took on the manuscript, and it was in print by the end of October 1936. Benjamin originally considered calling the book *Das unterschlagene Deutschland: Briefe* (Germany, suppressed: Letters), employing an adjective that would have variously suggested that Fascists had suppressed, misappropriated, and defrauded Germany. This potential title reveals how the radical changes in the political situation between 1931 and 1936 cast the project in an entirely different light and gave it new resonances.[56] Such a title would have made the work much more explicitly political. Nevertheless, commercial considerations ultimately triumphed and resulted in the choice of a title much more palatable for sales in National Socialist Germany: *Deutsche Menschen: Eine Folge von Briefen* (*German Men and Women: A Sequence of Letters*). The title's hagiographic implications and the "Germanic" Fraktur typeface used on the book jacket made *German Men and Women* seem less like a critical reflection on German identity. Instead, they made it look like one of Emil Ludwig's many popular biographies, which Benjamin derided as "slick and cheap," or the text anthologies about "great Germans" that were published in Weimar Germany and throughout the Third Reich.[57]

But the book *German Men and Women* is hardly an uncritical celebration of German nationalism, just as *Face of Our Time* is not simply an anthology of random German types. The two works share many similarities that only begin with their common participation in Weimar Germany's physiognomic revival and their shared interest in understanding the nature of "Germanness" in modernity. For one, both works' full titles include the word "German," even if *German Men and Women* was not Benjamin's original choice for a title. And although the final version of *German Men and Women* included only twenty-five images, Benjamin had originally planned to present sixty—the same number of photographs in *Face of Our Time*. Both texts survey a wide range of social and professional types selected from much larger corpuses, and they create cross-sectional images of specific centuries (the late eighteenth and nineteenth for Benjamin, the twentieth for Sander). Sander photographed men and women from diverse backgrounds and classes, while Benjamin compiled letters from men and women in a similarly wide range of occupations, including scientists, theologians, salesmen, pedagogues, professors, writers, and even a composer.[58] But perhaps the most significant similarity that unites the works is their

shared methodology. Each author sought to limit his own presence and instead let the time "speak for itself." Art historian Michael Diers argues that Sander leaves his critical imprint—and yet maintains a "hands-off" approach—through the distanced, objectifying techniques of New Objectivity photography: sharply focused, unmanipulated, unsentimental photographs. Benjamin's mediating presence appears solely in his choice and organization of the letters and his critical introductions to them, all of which are cast as the work of an "appropriately German" editor by the name of Detlef Holz.[59] This method results in an open, essayistic form. Although larger rise-and-fall narratives organize *Face of Our Time* and *German Men and Women,* both works move from photograph to photograph or letter to letter in a manner that does not strictly formalize or structure how one should read.

Benjamin allows the time to "speak for itself" through a series of letters that span fifty years before and after the first selection, dated March 31, 1832, written by the composer Karl Friedrich Zelter to Chancellor von Müller. Zelter reports that his close friend Johann Wolfgang von Goethe finally died the previous week. "Stretched on his back," Zelter writes, "lies the man who bestrode the universe on pillars of Hercules, while the powers that rule the globe vied for the dust beneath their feet." However, considering Goethe's overwhelming significance in his own time and Benjamin's profound intellectual interest in Goethe's life and works, the death of German culture's most important public face in 1832 was not simply an end, but a beginning. Zelter asks a favor of the chancellor: "Now I have one request: do not cease to honor me with your kind messages. You will discern what I am given to know, since you are aware of this ever-cloudless relationship between two intimate friends, always at one in their natures, if far apart in their daily lives. I am like a widow who loses her husband, her lord and provider. Yet I must not mourn; I must marvel at the riches he brought me. Such a treasure I must needs preserve, and make its interest my capital."[60] Zelter's words encapsulate the project of *German Men and Women*: whereas Sander maps twentieth-century types with a narrative of sociocultural development and decline, Benjamin presents letters that echo this decline and yet leave open space for hope. Those redemptive moments take the form of cherished humanistic values, emotions, friendships, and familial bonds, and they are expressed in a medium not yet standardized by cold modern technology. Rather, the letters demonstrate the perseverance of charity, generosity, empathy, sacrifice, humor, love, and other such "treasures" (as Zelter calls them) in a period that, in Benjamin's description, witnessed the bourgeoisie's decline from a position of eminence in the late eighteenth century to its "unlovely end" during the "boom years" of the *Gründerzeit,* a period of accelerated industrial development and economic expansion following German unification in 1871.[61] The nineteenth century brought vast social and economic changes, but core humanistic values persisted. Nevertheless,

modernity's impact on human experience and emotion—important themes in Benjamin's oeuvre—was very real.

As Goethe himself protested, such changes were not necessarily positive in spite of the rhetoric of progress that surrounds them. In the critical introduction to the first letter from Zelter to Chancellor von Müller, Benjamin cites another prescient note that Goethe had written to Zelter in June 1825. In it, the poet complained that "wealth and speed are what the world admires, and what all are bent on. Railways, express mail coaches, steamboats, and every possible means of communication—that's what the civilized people of today strive for. So they grow overcivilized, but never get beyond mediocrity." Goethe then added that "we may be the last representatives—with a few others perhaps—of an era that will not easily come again."[62] In Goethe's plaint one can clearly discern an additional allegorical dimension of *German Men and Women* that transcends national geography. It refers not only to the time of a "free Germany" but also to a past in which individuals were not (yet) overwhelmed by the shock-inducing experiences of modernity nor rendered mediocre and "overcivilized" by naïve optimism about technological "advances." The sense of tradition for which Goethe longs persists in the very fact that his letter is not mechanically produced but handwritten. As this strategically cited letter suggests, *German Men and Women*, like *Face of Our Time*, does not simply investigate what it means to be "German" in a time of crisis. Rather, it is additionally concerned with the larger question about the fate of civilization in the modern age.

In the face of modernity's challenges and changes, treasured humanistic values and emotions persisted. The evidence is in the written word. Benjamin describes both the meaning of handwritten letters as "treasures" and their relevance for his project's narrative structure in an unpublished introduction to *German Men and Women*:

> The series of German letters that is inaugurated here is not to be thought of as an anthology. However much the attentive reader may learn from it about the value and honor of the German language, and however clearly some of these letters enable him to glimpse a human being where previously he had perceived only an achievement, this is not the intention of the present writer—any more than he wishes to advance the general education of the reader. The intention of this series is, rather, to reveal the lineaments [*Antlitz*] of a "secret Germany" that people nowadays would much prefer to shroud in heavy mist.[63]

Benjamin refers to his time as having a "face" or "countenance" (*Antlitz*), phrasing that invariably suggests Sander's *Face of Our Time* (*Antlitz der Zeit*) and other contemporary attempts to diagnose the *Zeitgeist* that incorporated such loaded words in their titles.[64] Benjamin nevertheless stresses that a chronicle of accomplishments by

German history's "great men" does not reveal the true portrait of a people. Rather, the contours of this countenance emerge as a necessarily incomplete set of images. In his introductions to the letters, Benjamin frequently describes the subsequent texts with visual metaphors. They are "portraits," "pictures," "glances," and "miniatures." The introduction to Friedrich Hölderlin's December 1802 letter to Casimir Böhlendorf even characterizes letter writing as a kind of photography in itself. Hölderlin's letters provide "the look inside Hölderlin's workshop" (*den Blick ins innere*) and reveal "the image of the restless, wandering Hölderlin."[65] The project of *German Men and Women,* like that of *Face of Our Time,* is to present these individual images both as isolated moments and as components of a larger mosaic. Meaning emerges from the nuances of individual texts as well as from the cumulative pictures they create.

Photography, Physiognomy, Graphology

To find the meaning(s) of German identity, August Sander photographed his countrymen. Walter Benjamin, however, sought clues not in the literal wrinkles, folds, and tics of German faces but in the idiosyncrasies of the German language. Describing the value of old letters as diagnostic tools, Benjamin wrote that the minute, daily interactions that spark correspondences "are often focal points in which the determining powers of a time collect."[66] The "determining powers of a time" (*Bestimmungskräfte einer Zeit*) manifest themselves differently in private, handwritten letters than in literary works, scientific treatises, histories, and other genres written for public audiences. Private letters are candid snapshots—not formal portraits—of a time. To create an album of the humanistic values and emotions revealed in letters, Benjamin separates them from their original context within correspondences. Günter Oesterle argues that this act of isolation foregrounds the particular emotional or linguistic gesture of each letter.[67] It draws attention to the medium—language—and its power as a repository for affect.

Yet Benjamin's interest in letters and their rich palettes of language went deeper than just the words themselves. He was especially interested in the physical act of inscription—handwriting. Although Benjamin explains the years that bookend his letter series (1783 and 1883) as being fifty years before and after Goethe's death, it is notable that the years 1882–83 also coincided with the appearance of the first German-made typewriter on the market, the Hammonia *Typenschreibapparat* of the Guhl & Harbeck company of Hamburg.[68] Handwriting thus takes on special significance as a key dimension of personal written expression. Benjamin points to the intertwined relationship of handwriting and identity in his introduction to Samuel Collenbusch's letter to Immanuel Kant dated January 23, 1795: "[Collenbusch's]

spiritual influence was manifested not only in speech but also in an extensive corre-
spondence, whose masterful style is shot through with whimsical details. For example,
in his letters . . . he would draw special lines to link certain underlined words and
phrases to other words, also underlined, without there being the slightest connection
between them."[69] This interest not only in what Collenbusch's letter says but also in
what the letter actually looked like speaks to Benjamin's keen interest in graphology,
the study of handwriting for clues about moral character. Particularly on account of
the work of the philosopher and psychologist (and anti-Semite) Ludwig Klages, gra-
phology thrived in Germany and Europe after World War I as an important subdis-
cipline of physiognomy.[70] Benjamin wrote extensively on the subject during the late
1920s and early 1930s. Several essays, book reviews, and even a radio lecture testify to
his belief that handwriting reveals a unique image of its writer, much like the subjects
of photographs leave indelible impressions on a negative plate.

In his August 1928 review of Anja and Georg Mendelssohn's *Der Mensch in der Hand-
schrift* (Man in his handwriting), for instance, Benjamin agreed with the Mendels-
sohns' claim that "writing is determined by gesture," which is in turn determined by
the "*inner* image." Benjamin saw in handwriting a "plastische Tiefe" (plastic depth)
that hides behind the impressions on paper. He further noted in this review that
"moral character is a thing without expression [*ein Ausdrucksloses*]; it emerges, invisibly
or dazzlingly, from the concrete situation. It can be confirmed, but never has any
predictive force."[71] In other words, handwritten letters, like portrait photographs,
carry the mark of a particular moment. Both suggest specific eras but also distinct,
arrested instants or frozen flashes that stand out from the flux of time and the grand
narratives of the age. In another work, "On the Mimetic Faculty" (1933), Benja-
min further argued that "the nexus of meaning of words or sentences is the bearer
through which, like a flash, similarity appears." In this same text, he noted, "Gra-
phology teaches that handwriting contains images that the writer's unconscious con-
ceals in it." Benjamin then added, "If we are to consider history as a text, then what is
true for literary texts . . . is also true for history: the past has left images comparable
to those that light leaves on a photosensitive plate."[72] Zooming in on these details
reveals redeeming qualities that might otherwise escape attention. Whereas Sander
scrutinized facial expressions in his study of German identity, Benjamin looked for
clues in handwritten traces of the German language.

Throughout *German Men and Women,* Benjamin periodically returns to this interest
in the images that handwritten language both conceals and expresses. Language itself
becomes a thematic concern in his introductions to letters and in the letters them-
selves. The April 14, 1858, letter from the famous German philologist (and name-
sake of the fairy-tale collection) Jacob Grimm to the historian and politician Fried-
rich Christoph Dahlmann begins, "Dear Dahlmann, Though I seldom see your

handwriting, I recognized it at first. Perhaps you did not recognize mine, which has become somewhat shrunken and irregular because of all the writing I have done."[73] In his critical remarks on this letter, Benjamin cites a crucial passage from Grimm's introduction to the *Deutsches Wörterbuch* (*German Dictionary*), a foundational text of German philology and a model for the *Oxford English Dictionary*. Benjamin reads the introduction to the dictionary as further evidence of the link between language, history, and national identity. He quotes Grimm: "Beloved German compatriots, whatever your empire or your faith, enter the hall of your ancient, native language, which is open to you all. Learn it, hallow it, and hold fast to it, for on it the strength and longevity of your nation depend."[74] Grimm suggests that the act of speaking or writing in German defines Germanness. Identity emerges from history and transcends sectarian and regional boundaries. It is constantly reshaped and redefined through acts of writing in the present. Nazism may have falsified the German tongue with its clichés and political catchphrases, but a different German language—and a different Germany—persist in the written traces of the past, and in the age before typewriters, these traces of private expression were invariably handwritten.[75]

German Men and Women and the Fate of German Identity

For all of their methodological, formal, and thematic similarities, August Sander's *Face of Our Time* and Walter Benjamin's *German Men and Women* point to different conclusions about the nature of and prospects for modern German civilization. *Face of Our Time* traces a pessimistic macrohistorical trajectory that ends in decline. However, given that the book appeared in 1929 before the world financial crisis, the National Socialists' 1930 electoral success, and Adolf Hitler's ascension to the chancellorship in 1933, any reading of this photo essay that designates it as a specific protest against fascism is anachronistic. Although its structure does not foreclose the possibility of multiple interpretations, it lends itself well to readings that situate it within the broader context of German modernity, rationalization, and urbanization and what those changes meant to people in Weimar Germany.[76] In that Benjamin opens his letter series with Goethe's complaint about the changes that accompany the modern world, it also makes sense to understand the letters Benjamin published in the *Frankfurter Zeitung* in 1931 and 1932—as opposed to the book *German Men and Women* of 1936— as a broad-based meditation on the fate of the individual experience in the modern world. Like Sander, Benjamin knew Oswald Spengler's work. He cited *The Decline of the West* explicitly several times in his unfinished *Arcades Project,* and in his 1935 essay "Brecht's *Threepenny Novel*," he described Spengler as "show[ing] how useless the humanitarian and philanthropic ideologies from the early days of the bourgeoisie

have become for present-day entrepreneurs."[77] But while contemporary discourse about the cycles of civilization definitely (if subtly) informs Benjamin's work, specific references to Spengler are, on account of its nineteenth-century focus, absent.

Even so, it is important to recognize that the very same historical traumas that *Face of Our Time* antedated fundamentally changed the nature and significance of the project, as well as how we should interpret it. James McFarland notes in an essay about *German Men and Women* as a political project that Benjamin's serialized letters took on a greater sense of urgency when they finally appeared in book form in 1936.[78] Just as there are reasons to consider *Face of Our Time* independently of *People of the Twentieth Century*, it is worth interpreting the 1936 book *German Men and Women* as fundamentally different from the 1931–32 letter series. As feuilletons in the *Frankfurter Zeitung*, the letters appeared individually, removed not only from their original contexts in correspondences but also from the broader chronological arc that the book traces. In the context of a newspaper's culture section, private letters by key historical personages spoke more to readers' broad interest in German culture and history. But between 1931 and 1936, much changed in Germany, and with it the very status of Benjamin's project.

During these years, the National Socialists solidified their hold on power, expunged Jews from vast sectors of public life, criminalized Judaism through the Nuremberg Laws in 1935, and forced Benjamin and countless other German Jews into exile. Those who dismissed National Socialism as an ephemeral fad or Hitler as a raving lunatic soon found that they had sorely underestimated the movement's broad-based appeal and potency. Within this proximate context, the book *German Men and Women* reads very differently. For all of its ostensible concern with the nineteenth century and modernity's "overcivilizing" tendencies, the letter series speaks more directly to political events. To informed readers, Benjamin's framing of statements about the need to preserve humanistic values clearly criticized National Socialism's rise and the long-term threats that it posed to Germany and its culture. Through their energy, passion, and sheer linguistic richness, the letters trace the existence of a German community unlike the "racial community" of Nazi Germany.[79] This secret Germany, Gerd Mattenklott has argued, is based on genuine human compassion and emotion—not (like Nazi Germany) on spectacles, platitudes, and kitsch.[80]

Benjamin's handwritten dedications in copies that he presented to friends, family, and colleagues offer ample evidence for a reading of *German Men and Women* as literary resistance to Nazism and as an attempt to preserve the valuable aspects of German culture during a catastrophe. To fellow cultural critic Siegfried Kracauer, he wrote, "For S Kracauer / this ark / which I built / as the fascist deluge / began to rise." In the copy he inscribed for his sister Dora Benjamin, he wrote, "This ark / built on the basis of the Jewish model / for Dora / from Walter / NOVEMBER 1936."[81] In light of such religious allusions to Noah's ark and the flood, the "Menschen" of *Deutsche*

Menschen takes on a decidedly more Jewish cast, possibly punning on the Yiddish word *mentsh,* a decent person of honor and integrity. The book's cryptic opening epigram is in fact a recipe for what it takes to be a *mentsh*: "Of honor without fame / Of greatness without glory / Of dignity without pay." This motto again stresses the persistence of a different Germany that might someday return but that, in the meantime, can persist only in silent dignity, frozen in letters.[82] Nationalists, however, could simply pass over the motto as a platitudinous, honorific statement about the letter writers' nobility, humility, and greatness.

Ultimately, the political message of Benjamin's project comes through most strongly in several letters about loss and mourning that embody, in Theodor W. Adorno's words, the "expression of grief which [*German Men and Women*] exudes."[83] Of the many moving texts in the collection, some of the most powerful painfully report on personal losses, often the deaths of friends, family, the defining *Dichter und Denker* of humanistic German culture (Goethe), or some combination of all three. David Friedrich Strauss's November 15, 1831, letter to fellow theologian Christian Märklin, for instance, reports on Georg Wilhelm Friedrich Hegel's sudden and unexpected death (during the cholera epidemic of 1831) and its devastating effect, as revealed by the great numbers of Hegel's friends, colleagues, and students who lost their composure at the funeral. Perhaps the most touching letter in the collection is the portrait of grief from August 1783 by Georg Christoph Lichtenberg. Lichtenberg was a physicist, astronomer, and mathematician who also argued against physiognomy in a highly publicized debate with Johann Caspar Lavater, its leading Enlightenment proponent. For all of the physiognomic concerns of *German Men and Women,* this letter does not touch explicitly upon that controversy, although its shadow looms large. Rather, Lichtenberg pours out his heart to G. H. Amelung, a childhood friend, as he grieves for his deceased beloved, a young woman whom he had hoped to marry. He lovingly describes her and what she meant to him and then abruptly concludes, "And then, on the evening of August 4, 1782, at sunset—O God!—this heavenly girl *died.* I had the best doctors—everything, everything in the world was done. Think of it, dearest friend, and allow me to stop here. It is impossible for me to continue."[84]

The inclusion of such letters in *German Men and Women* is significant because they open a space for the redemption of a co-opted, Nazified German culture. Even in the desperate political climate of 1936, the possibility of redeeming or eventually recovering a German culture tainted by nationalism persists. "In the wake of the Berlin Olympiad of 1936," Michael W. Jennings writes, "[*German Men and Women*] invokes another Germany, one where human relationships could be rooted, if not in peace, then at least in civility, amiability, and the possibility of shared mourning."[85] This chance for redemption inhabits the space of individual relationships and the language and letters that bind people. Significantly, the very last word of *German Men and Women* is "friendship."

As this comparison of August Sander's *Face of Our Time* and Walter Benjamin's *German Men and Women* has shown, the physiognomic revival in interwar Germany was tied closely to the culture of photo essays and written essays. Sander investigates German identity through photography, while Benjamin structures a letter series using photography as a conceptual paradigm. With both of these unfinished—and unfinishable—projects, a series of literal or textual images offers a formally novel and conceptually significant way to reflect on German identity in the modern age and, at the same time, to leave open space for different interpretations. Yet a key feature of both texts is the necessity of understanding them on their own terms, in their medium specificity as a photo essay (Sander) or a "photographic" essay (Benjamin), not as mere excerpts or anthologies of other projects. These physiognomic typologies of Germanness engage readers not only through individual images but also through the entirety of the structure that those images create. And while both texts trace declines, they offer different possibilities for hope and redemption, even among the profound changes of modernity and, eventually, during the rise of fascism.

Just as some of Benjamin's letters have postscripts, there are several postscripts to the dialogue between *Face of Our Time* and *German Men and Women.* The Nazis prevented Sander from completing the project he began with *Face of Our Time,* because, for reasons not entirely clear, they found the volume inconsistent with their views of German identity. Shortly after Sander's son Erich was sentenced to ten years in prison for his political activism, Nazi authorities confiscated all remaining copies of the book and destroyed the original plates.[86] Sander then turned to a subject matter with which he already had extensive experience: landscape photography. The fruits of this labor first appeared in a six-volume series of photobooks, some of which also included examples of his portraits. The series had, in this context, a notable title: Deutsche Lande—Deutsche Menschen (German lands—German men and women), later changed to Deutsches Land—Deutsches Volk.[87] In 1959, almost a quarter of a century later, the Swiss illustrated magazine *DU* dedicated an issue to Sander entitled "August Sander photographiert: Deutsche Menschen" (August Sander photographs: Germans).[88] It seems highly unlikely that the dialogue between Sander and Benjamin influenced either the title of the landscape photography series or that of the *DU* issue, but one can never be sure. Unlike Benjamin, Sander was not a committed Marxist intellectual. However, his son Erich Sander was.[89] Erich helped his father prepare his six radio lectures, and the copy of Benjamin's "Little History of Photography" in Sander's estate might have belonged to August, even if, in any case, Benjamin's essay appeared well after *Face of Our Time.*[90] These are best accounted for as historical coincidences, but they nevertheless remain an intriguing connection between two participants in an important dialogue on German identity that played itself out in the photo essays of Weimar Germany.

5

the snapshot and the moment of decision

The Moment of the Moment

In his 2007 history of Weimar Germany, Eric Weitz argues that "certain keywords and key phrases comprised the shared language of the Right." He cites richly evocative terms such as *Dolchstoß* (backstab), *Diktat von Versailles* (Versailles dictate), and *Judenrepublik* (Jewish republic), which were hardly subtle in their conspiratorial implications that Jews had stabbed Germany in the back during the Great War, dictated an excessively punitive peace treaty at Versailles, and established a republic that did not have Germany's best interests at heart. Collective nouns with an ethnonationalist bent such as *Deutschtum* (German community) and *Volkstum* (the racial community) betrayed a desire to purify Germany both racially and linguistically. Still other catchphrases of the Right, many now irrevocably tainted by National Socialism, portended a brighter future, one of a *Kampf* (struggle) led by a *Führer* (leader) that would culminate in a *drittes Reich* (third empire). Such phrases, Weitz compellingly argues, were "thundered from the pulpit; printed in the press, leaflets, and novels; declaimed in parliament; displayed on placards; and spoken around the dinner table."[1] This vocabulary became a central component of public discourse, even among those who objected to the radical Right.

To this list of terms one can add many more, many of them far less inflated but no less contested. In 1922, for instance, Karl Jaspers recognized that an ambiguous philosophical category was becoming a central topos of cultural discourse in Germany: the *Augenblick,* or moment. "The Moment," he wrote, "is the medium of the historical, in contrast to the clear divisions and timeless oppositions of mere conceptual forms. It is the impenetrable, the infinite, that which is absolutely filled, the medium of crises and creations."[2] As the German etymology of *Augenblick* suggests, the moment disappears within the blink of an eye. Moments are the fleeting occurrences, anonymous events, and transient interludes that make up a temporal continuum. Yet the *Augenblick* is also a temporal rupture. It stands out from its context and demonstratively contrasts with what precedes and follows it. The moment's suddenness coexists with—and yet radically departs from—an illusory even flow of history.

It is no stretch to say that the Right exploited Weimar Germany's "crisis moment" vocabulary with particular alacrity. Influential political and literary texts foregrounded catchphrases of struggle, crisis, decisive moments, and what would come after in their very titles: Arthur Moeller van den Bruck's *Das dritte Reich* (*The Third Empire*), Adolf Hitler's *Mein Kampf* (*My Struggle*), Ernst Jünger's *Der Kampf als inneres Erlebnis* (Struggle as inner experience), Oswald Spengler's *Jahre der Entscheidung* (*Years of Decision*), and countless other works.[3] This sort of temporally inflected language discursively constructed the Weimar Republic as having reached a historical juncture that necessitated decisive action, and it became common rhetorical currency.

Oswald Spengler and Carl Schmitt, for instance, were particularly egregious in their fetishizing of "the moment." In *Years of Decision,* published in 1933 shortly after the National Socialists' accession to power, Spengler retrospectively recast the final years of the Weimar Republic as a "decisive moment" and claimed that the sense of crisis was widespread. "Something *had to* come about, in some form, to free the deepest instincts of our blood from this pressure," Spengler wrote, "if we were to have a say in the coming decisions about this world-historical event, to actively participate in it, and not just be its victim."[4] This vague hydraulic metaphor and artificial positing of a community unified by blood epitomizes the Right's fascination with the "moment of crisis." To Spengler, the moment of conservative revolution was the moment when the *Volk* asserted "the deepest instincts of [its] blood" and began to recover not only the national pride lost at Versailles but also an eroding cultural heritage. Along similar lines, Carl Schmitt's decisionist political theory emerged as one of the most philosophically nuanced and influential articulations of struggle and the need for decisions in a time of crisis. Although not written expressly for the National Socialists, Schmitt's indictment of democratic institutions as illegitimate

later provided them with important intellectual support against the liberal order. In *Der Begriff des Politischen* (*The Concept of the Political*; 1927, repr. 1932), Schmitt argued that liberalism inherently obstructs conclusive and necessary decision making. It tries to reconcile antagonists whose beliefs are fundamentally irreconcilable, it futilely attempts to eradicate internal struggles by subjecting friends and foes alike to the same rule of law based on reason, and it transforms elemental struggles into discussion and compromise. Schmitt challenged the dogma of the all-powerful rule of law and proposed instead that only through a conclusive act of will by a Hobbesian "sovereign" can society overcome democracy's stasis, bickering, and irresolution.[5]

Nevertheless, representatives of no single political ideology had a monopoly on inflammatory rhetoric or oversimplified, ahistorical catchphrases. The language of struggles, decisions, critical moments, and the like did not belong exclusively to the Right. For instance, the novelist Lion Feuchtwanger, a fierce critic of the Nazi Party whose outspoken opposition led to the burning of his novels during the May 10, 1933, book burnings and eventually to his own forced exile, used right-wing catchphrases when he posed the question "Wie kämpfen wir gegen ein drittes Reich?" (How do we struggle against a third empire?). In this newspaper opinion piece from 1931, Feuchtwanger protested the liberal bourgeoisie's acquiescence to social conservatives on matters of culture, for as a German Jew, he had everything to lose.[6] But when he used the Right's own terms in his article's title and when he stated that "it is therefore the demand of naked self-preservation that all intellectuals struggle with body and soul and all their abilities against the Third Reich," Feuchtwanger implicitly allowed the Nazis to determine the very boundaries of discourse. He used this atavistic—and widespread—vocabulary even when he assertively repudiated it. So too did Kurt Tucholsky and John Heartfield in the satiric title of their 1929 collaboration *Deutschland, Deutschland über alles,* a collection of essayistic texts and photomontage that rebuked nationalism, militarism, and right-wing conspiracy theories.[7]

In short, the discourse of Weimar Germany as a time of crisis, struggle, decisive moments, and impending catastrophe did not simply report facts on the ground. The relentless repetition of inflammatory (and frequently uncritical and ahistorical) terms helped exacerbate and even create the situation. In using this incendiary vocabulary, the Weimar Republic's supporters and detractors not only reported a crisis but also performed and realized it. Their polarizing language cast a metaphysical aura around social problems, which were seen as unsolvable but for the intercession of a savior or revolution of world-historical proportions.[8] In addition to the essays of Spengler, Schmitt, Feuchtwanger, and Tucholsky, photo essays were an important tool that photographers used to address the issues of elemental struggles and moments of decision.

Photography and the Critical Moment

As the idea of a "critical moment" became an increasingly visible component of the cultural and political lexicon of Weimar Germany, snapshot photography offered a new way—or rather a new old way—to represent it visually. By the late 1920s, snapshots had already existed for almost half a century. The late 1870s had seen the introduction of factory-sensitized, gelatin-coated glass plates with significantly increased photosensitivity. Such innovations and subsequent improvements radically shortened exposure times and made the photography of objects in motion feasible. Roll film and smaller and more portable cameras helped simplify photography and opened the door for amateur photography (and the market in photographic materials) to flourish.[9] In photo historian Ulrich Keller's words, "Only the 1920s brought a dramatic narrowing of the gap between art and industry, technology, [and] mass communication."[10] A key technological moment of this "narrowing" came with the introduction of the Leica Modell I and Ernemann Ermanox cameras in 1925.[11] With its large-aperture Ernostar F.1.8 lens—at the time the world's fastest—Ermanox could accurately claim in its advertisements that "Alles was man sieht, soll photographiert werden können" (anything you can see, you can photograph).[12] The popularity of the illustrated press and the need for a steady supply of photographs of the day's events generated a market for such cameras and for *Momentaufnahmen* (snapshot photography in English, but the taking or capturing of a moment in German). Small-format cameras quickly became the instruments of choice for professional photojournalists and amateur shutterbugs alike. They provided a manageable and inexpensive means to record and access the secrets of the fugitive moment.

Through the snapshot, the fraught category of the "moment of decision" literally became the formal basis of important late Weimar photo essays. In photo essays constructed from snapshots, the *Augenblick* also became an important vehicle by which to affirm and critique the notion that Weimar Germany—and the institutions and culture that had so radically transformed Germany—was in a deep state of crisis and at a decisive moment. This chapter compares two key examples from 1931: *Der gefährliche Augenblick* (The dangerous moment), edited by Ferdinand Bucholtz and introduced by the conservative thinker Ernst Jünger, and *Berühmte Zeitgenossen in unbewachten Augenblicken* (Famous contemporaries in unguarded moments), by Erich Salomon. Both photo essays used snapshots to respond differently to the widespread rhetoric about the supposed ineffectualness of Weimar-era institutions and the corollary need (or lack thereof) for radical measures to establish order. These works demonstrate that the polemical essay culture in which Spengler, Schmitt, Feuchtwanger, Tucholsky, and many others actively participated was not limited to language alone.

Rather, photographers and anthology editors used the snapshot and the photo essay form to help shape the public sphere of the Weimar Republic.

The Dangerous Moment is an anthology of photographs procured from the files of the many photo agencies that met the vibrant Weimar media's insatiable demand for images. This volume stands out not because a single photojournalistic auteur took the photographs, as is the case with *Famous Contemporaries*. Rather, its legacy rests on the fact that a significant cultural and literary figure, the enigmatic Ernst Jünger (1895–1998), penned the introduction that unifies a set of snapshots taken by others. Whereas Ferdinand Bucholtz, the editor with whom Jünger collaborated on *The Dangerous Moment,* is today only a footnote in the history of photography, Jünger was a dominant figure in German letters throughout the twentieth century. Jünger's conservatism and concurrent embrace of modern technology made him, in Jeffery Herf's phrasing, a "reactionary modernist"—that is, a thinker who believed in the "reconciliation between the antimodernist, romantic, and irrationalist ideas present in German nationalism and the most obvious manifestation of means-ends rationality, that is, modern technology."[13] Like other key reactionary modernists in Weimar Germany, such as Oswald Spengler, Werner Sombart, Hans Freyer, and Carl Schmitt, Ernst Jünger was fascinated with technology—especially the camera—and its possibilities and implications. The camera was for him both a symbol of modern, technologized man and a tool with which to represent this new figure's emergence. *The Dangerous Moment* is best understood as a representative moment in a series of more than half a dozen Weimar-era books, essay collections, and photo essays in which Jünger and his collaborators merged text and photograph to comment on the modern world and modern subjectivity. In 1928, for instance, Jünger edited *Luftfahrt ist not!* (Aviation means trouble!), a book about the dangers of air travel in the era of gigantic zeppelins and Charles Lindbergh's transatlantic flight. In 1930, he published the photo essay *Das Antlitz des Weltkrieges: Fronterlebnisse deutscher Soldaten* (The face of the World War: German soldiers' experiences at the front) and the essay collection *Krieg und Krieger* (War and warriors) about experiences in World War I.

The reputation of *Famous Contemporaries* originates elsewhere. This work is remembered today not only because of the pioneering approach of its famous creator, Dr. Erich Salomon (1886–1944), but also because Salomon died tragically in Auschwitz.[14] Born to a wealthy banking family in Berlin, Salomon began his professional life not as a photojournalist but as an attorney and businessman. He came to photojournalism relatively late, in 1928, and became immensely successful after publishing photographs that he surreptitiously took at a sensational murder trial. As a journalist and as a Jew, Salomon now belonged to a profession that Jews, according to historian Peter Pulzer, "completely dominated."[15] Indeed, the list of famous Jewish

photojournalists from Weimar Germany reads like a "who's who" of the vocation and includes Felix H. Man, Tim Gidal, Martin Munkácsi, and Alfred Eisenstaedt, as well as the editors Stefan Lorant and Kurt Korff.[16]

The significant number of Jews in journalism provided grist for the anti-Semitic conspiracy-theory mill, as did the fact that Salomon used his extensive social, professional, and familial contacts to develop a uniquely reciprocal professional relationship with political and social figures in Germany and abroad. These elites allowed him to photograph their exclusive events "behind closed doors," and in turn he portrayed them candidly but humanely. With the help of his small and concealable cameras, Salomon developed a reputation as the master of the "candid camera," a "Houdini of photography." Once, when Aristide Briand caught him *in flagrante,* the French foreign minister remarked, "Ah! le voilà! le roi des indiscrets!" (Ah, there he is! The king of the indiscreet!) Salomon sold his exclusive images to the major politically mainstream illustrated magazines in Germany and abroad and soon became one of Weimar Germany's most important photojournalists. Millions of readers regularly saw his prominently featured images in the largest Illustrierten, including the *Berliner Illustrirte Zeitung,* with which he had an exclusive contract, and the *Münchner Illustrierte Presse.* The National Socialists forced Salomon into exile in the Netherlands after 1933, where he continued to freelance. But in 1943 he was captured with his wife and youngest son. Salomon eventually died in Auschwitz in 1944 after five months of internment in Theresienstadt.

For all of the profound differences in the provenance of the images in Bucholtz and Jünger's *The Dangerous Moment* and Salomon's *Famous Contemporaries,* there remain important contextual reasons to approach both works within the conceptual rubric of the photo essay aside from their shared form as book-length narratives created from snapshots. The most significant reason is thematic: both participated in the "crisis moment" discourse of the late Weimar period, and both exemplify how photographers and editors used photo essays to contribute to the discussion about a state of crisis and, through sensational imagery, even to help realize it. The books' respective introductions by Jünger and Salomon reveal a shared interest in photography's relationship to modern culture and what this new technology implies for modern man. To this end, each work's introduction characterizes it not merely as a photographically illustrated book but as a set of integrated text-image "Berichte" (reports). For instance, Salomon describes *Famous Contemporaries* as a "Bildbericht" (image report) and stresses that there is no reason to look at the photojournalist as being at a disadvantage vis-à-vis the text journalist.[17] The dust jacket for *The Dangerous Moment* similarly notes that the shocking photographs of dangerous moments are "ergänzt" (expanded upon) through the word "Augenzeugenbericht" (eyewitness report). Edmund Schultz's 1933 *Die veränderte Welt* (The changed world), another

photobook for which Jünger wrote the introduction, is even subtitled *Eine Bilderfibel unserer Zeit* (An image-primer of our time). In this work, Jünger claims for photographic narratives a status comparable to the feuilletons, lead articles, and news briefs in a newspaper.[18] Such explicit comparisons and textual tropes suggest that these works convey discrete arguments and narratives and aspire to—and in many respects accomplish—the work of traditional written language.

The overheated language of the moment had the potential to become something more than just another set of right-wing catchphrases. Even a superficial comparison of *The Dangerous Moment* and *Famous Contemporaries* and their authors' backgrounds conclusively shows that these terms transcended simple ideological boundaries. This discourse was given a visual form in their photo essays.

Ferdinand Bucholtz and Ernst Jünger's *The Dangerous Moment*

Ernst Jünger was duly qualified to contribute the introductory essay "Über die Gefahr" ("On Danger") to *The Dangerous Moment*. He experienced danger firsthand as a soldier in World War I, and frontline experiences became the central theme of his works *In Stahlgewittern* (*Storm of Steel*), *Das Wäldchen 125* (*Little Forest 125*), *Feuer und Blut* (*Fire and Blood*), *Der Kampf als inneres Erlebnis* (Struggle as inner experience), and other early writings.[19] Unlike antiwar texts such as Erich Maria Remarque's 1928 classic novel *Im Westen Nichts Neues* (*All Quiet on the Western Front*) or the pacifist Ernst Friedrich's *Krieg dem Kriege!* (*War Against War!*), a gruesome photograph collection documenting war's effects, Jünger valorized war and struggle in his writing.[20] Jünger's goal with such works was, in Julia Encke's reading, to immunize or inoculate mankind against the threats of a future war.[21] To perceive danger in its diverse and ubiquitous manifestations is to learn how to accommodate it, if not to control it. And such is the project of *The Dangerous Moment*. If August Sander's *Face of Our Time* was, in Walter Benjamin's understanding, a "training manual" for reading German types and if Werner Graeff's *Here Comes the New Photographer!* was a primer for how to use images in rhetorically effective ways, then *The Dangerous Moment* is also a training manual for dealing with the shock experiences of the modern world. These moments occur in the blink of an eye, and until the advent of the snapshot, they could not be recorded for posterity. Stop-motion photography may not allow one to avoid danger, but it does afford the opportunity to confront and study it in depth after the fact. Ultimately, it enables humanity to ready itself for and become more callous toward danger as an inevitable dimension of existence.

At first glance, *The Dangerous Moment* appears to be an anthology of adventure essays that Ferdinand Bucholtz interspersed with sensational snapshots of disasters,

assassinations, and car crashes. The text on the dust jacket, however, suggests that the photographs—not the essays—are at the heart of the work: "THE DANGEROUS MOMENT is presented here on two hundred pages with more than one hundred exciting snapshots from all parts of the world: earthquakes, volcanic eruptions, floods, conflagrations, technical catastrophes and sports accidents, war and civil war, crime and adventure. This material, both factual [*sachlich*] as well as fantastic, is expanded upon after every page of experience through a series of absorbing and frightening eyewitness reports. ERNST JÜNGER wrote the summary 'On Danger.' This book is more than exciting. It is excitement itself."[22] The dust jacket characterizes *The Dangerous Moment* as first and foremost a photographic work. As such, it fundamentally inverts the traditional text-image hierarchy, because it is the images that are "ergänzt" (expanded upon) by eyewitness reports and not the other way around. Multipage essays, many culled from magazines or books, effectively become extended captions for sensational and ultimately valorizing snapshots of dangerous and decisive moments.

Jünger's introductory essay, "On Danger," establishes photography's centrality to the book. Rather than criticize modern technology and Taylorist practices of scientific management as having leveled and standardized human experience, the reactionary modernist Jünger welcomes the technologization of modern life, in particular through the camera. To Jünger, the camera's cold indifference makes it the perfect technological embodiment of the subservient and soldierly subject or *Typus* (type) that the coming conservative revolution needs to succeed. Jünger understood war and "totale Mobilmachung" (total mobilization) as metaphors for modern existence.[23] In his 1932 tract *Der Arbeiter: Herrschaft und Gestalt* (The worker: Rule and form), for instance, he thoroughly attacked bourgeois values and proposed instead a new form of perpetually mobilized modern subjectivity that rejected liberalism, the social contract, and individuality. Jünger's worker is a new, steeled, and fearless breed of man who lives in a perpetual state of mobilization. This man is on "perpetual standby" for war because technology has made danger ubiquitous, and this ubiquity has dissolved the boundaries between war and peace.[24]

Technology was a key reason for danger's new prevalence. The invention of the car and the airplane not only made it possible to travel long distances in short amounts of time but also generated new dangers: the violent, high-speed car accident and the catastrophic airplane crash. But if technology created new possibilities for disasters, it also created new ways to experience and register them.[25] To Jünger, exposure to danger is an important part of existence. A close relationship to it spares humanity's inherently "adventurous heart"—as Jünger calls it in the 1929 essay collection of the same name—from the boredom of bourgeois society's security, stasis, and predictability.[26] Danger had nevertheless remained inaccessible, because it typically revealed itself only in fugitive and practically invisible *Augenblicke* (blinks of an eye). With the

popularization of snapshot photography, however, it was now possible to register these new forms of dangerous excitement and experience.

Herein lies the mission of *The Dangerous Moment*. Technological innovation is not just the material embodiment of the new era; it provides new means to access hitherto imperceptible and impenetrable moments of danger. In this photo essay, the camera has captured danger, registered it, and thereby provided the human consciousness with new ways to confront and comprehend it. At the same time, in presenting images of danger with steely indifference, *The Dangerous Moment* models the desired mode of subjectivity. The strikingly candid photographs of natural and man-made disasters illustrate Jünger's conservative claim about the centrality, importance, and ubiquity of danger and struggle to the human condition. So too do the accompanying essays, which serve as extended captions. *The Dangerous Moment's* table of contents is called a "Verzeichnis der Berichte" (table of reports), an allusion to the book's preface, where Bucholtz describes these texts like photographs—as detached, unsentimental "Augenzeugenberichten" (eyewitness accounts).[27] Many of the eighteen reports are excerpts from photographically illustrated magazine stories that were themselves adorned with snapshots. This form of "photographic" literature (or rather, extended caption) confers on the images a heightened sense of immediacy, urgency, catastrophe, and sublimity.

Structurally, *The Dangerous Moment* is organized around photographs and journalistic texts that celebrate danger. Each text is a snapshot in words complemented by literal snapshots. This photo essay demonstrates modern technology's ability—through stop-motion photography combined with essays in a bound form—to represent danger more intensely than language alone. The camera has frozen the dangerous moment in a grainy, blurry, but unquestionably authentic image. In tandem with the accompanying report, it renders this danger in new, direct, and graphic ways. Harrowing tales of brushes with death acquire even more shock value and a greater "reality effect" in the company of graphically candid photographs. The goal, ultimately, is to alert readers to danger's ubiquity and, at the same time, to make them better able to cope with it.

This project nevertheless carries ambiguous ethical implications. Eyewitness accounts of catastrophes, whether written or photographic, represent danger and give it a voice. But they do not intervene or try to mitigate it. Danger is observed with a cold indifference. Documentary forms thereby risk legitimizing danger and violence, because they can hide their toleration of bloodshed under the guise of needing to remain detached and objective. In the essay "Über den Schmerz" ("On Pain"), published three years after *The Dangerous Moment*, Jünger praised photography for this very quality. As a detached, technical eye, he writes, the camera does not fear danger. It instead engages the world with cold, soldier-like intrepidity and records what it

sees with cold indifference. "The photograph," Jünger states, "stands outside the realm of sensibility."[28]

"On Danger" begins *The Dangerous Moment* with a bold statement about danger that broadens its scope beyond the battlefield. Jünger observes, "Among the signs of the epoch we have now entered belongs the increased intrusion of danger into daily life. There is no accident concealing itself behind this fact but a comprehensive change in the inner and outer world."[29] Danger, he continues, constitutes the primary threat to the bourgeois order. A "penetration," "invasion," or "violation" of bourgeois existence, it signifies the absence of security, the bourgeois order's principal value. Unsurprisingly, bourgeois society thus creates rules, systems, and institutions to mitigate conflict, and through these normative political and moral structures it tries to eliminate danger altogether. The bourgeois order mobilizes reason—the primary weapon in its (futile) battle—to reconcile danger with its irreconcilable other, parliamentary democracy. Through reason, society reduces everything, even the irreducible "Leben der Seele" (life of the soul), into analyzable, computable cause-and-effect relationships. Any threat to this positivistic liberal order, Jünger claims, receives the implicitly normative designation of "das Sinnlose" (the senseless).[30] Through text and image, *The Dangerous Moment* renders this argument visually. Whether one is in the city or in the country, on land or at sea, at work or at play, the narrative suggests, one simply cannot escape danger.

Structurally, the work is divided into two halves. The first recounts natural catastrophes and accidents of modern technology, while the second shifts to tales of political unrest and premeditated acts of civil unrest and assassination. In both halves, the component texts and images express less interest in politics and more in the aesthetic contemplation of danger.[31] *The Dangerous Moment* elides the different causes of danger and instead posits it as a transhistorical, apolitical category. Human agency and free will are, in this understanding of danger, scarce.

Text and image freeze the dangerous moment and depict it as an existential metaphor, a defining instant precariously perched between the limits of human potential and the specter of death. However, the book's sequencing equates the unavoidable and undesired dangers of natural disasters and technological accidents with the intentionally created danger of political agitation. Of the first nine reports and their accompanying photographs, only one concerns a political event. The others document volcanic eruptions, shipwrecks, car wrecks, blimp crashes, animal maulings, and other unwelcome accidents. By contrast, the final nine *Berichte* and the images associated with them all concern assassinations, street battles, civil war, and intentional acts of political violence. The two halves thus use the same formal strategies to represent the concurrent horror and intensity of two qualitatively different kinds of danger. *The Dangerous Moment* blurs the boundaries between them because to Jünger

and Bucholtz such divisions are irrelevant. To them, danger is danger, regardless of its source, and their strategy is to naturalize and celebrate it and, at the same time, exploit the new power to contain it that the camera affords.

Consider, for instance, a typical chapter in the book's first half, excerpted from an article by the British daredevil Major H. O. D. Segrave in the September 1928 issue of *Automagazin*.[32] Throughout the 1920s, Segrave set several land speed records in his car, nicknamed the "Golden Bullet," and gained international renown as a celebrity.[33] The report "Wie ich die Weltgeschwindigkeitsrekord im Autofahren brach" (How I broke the world's automobile speed record) and the surrounding pictures of automobile, bicycle, and motorcycle crashes represent danger in word and image with cold indifference: "I was sure of my car. I knew what powers resided in its engine and knew that it could reach 200 miles per hour and even more. And it did! It is impossible for me to reproduce how it happened—I tried to put together the individual snapshots that I recall into a whole, but it is simply not within the realm of human possibility to describe more closely the impressions that bombarded me during these few seconds."[34] Segrave uses photographic metaphors to describe his record-breaking speeds and brushes with danger as a series of isolated snapshots. Yet he can only reproduce these experiences in short, telegraphic sentences that even he admits are inadequate for the task. Unlike the actual text, however, the snapshots situated before and after do not take Segrave himself as their subject. Images of car crashes depict instead the ominous "what could have been" of the record-setting attempt. Only a third-person narrator, here the camera, can represent this side of danger, because firsthand experience would result in death. While the essay stresses the excitement and heroism that new technologies make possible, the snapshots imply its subtext: technological triumphs always contain the capacity for violence and death, and photography is the new language required to describe them. Words alone are insufficient.

The similarities between Segrave's text and the surrounding snapshots underscore this dual potential for progress and catastrophe. Segrave documents his feat with simple, declarative sentences whose ostensible transparency and truth is their defining characteristic. They do not draw attention to their status as language. Similarly, even as the snapshots document the potentially negative outcomes of encounters with danger, their indifferent eyewitness quality is their central trait. Rather than detract from the image, blurriness, over- and underexposure, and other compositional "flaws" are moments of the photographic lexicon that authenticate dangerous experience. "Die letzte Sekunde" (The final second), a blurry and overexposed depiction of a race car accident, immediately precedes Segrave's report (fig. 34). As it portrays a dangerous moment, this decontextualized photograph dramatically enacts Jünger's claim that life is a constant struggle in a dangerous universe. The grainy

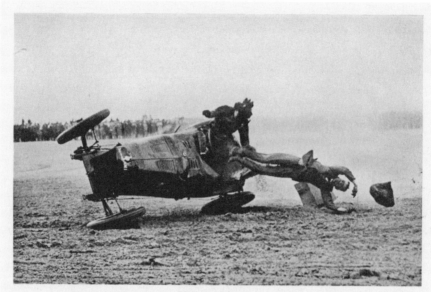

Die letzte Sekunde.

72

Fig. 34 "Die letzte Sekunde" (The final second), in Ferdinand Bucholtz, ed., *Der gefährliche Augenblick,*
with an introduction by Ernst Jünger (Berlin: Junker und Dünnhaupt Verlag, 1931), 72.

image captures the split second in which the driver has lost control. The car balances
precariously on two wheels, and the doomed riders are suspended in an existential
limbo. Although they are still alive, they have been ejected from the car and will likely
die in the next instant. The barren surroundings and dust clouds reinforce the sense
of doom. It is implied in this presentation of text and photograph that the brave new
modern world demands a cold, steely individual who can confront danger with the
same indifference as the camera. In some cases, the confrontation will yield success,
as it does in Segrave's report. At other times, catastrophe will result, as it does in
the photograph. The modern subject must be ready for both and accept the out-
come stoically. By the time *The Dangerous Moment* appeared in print, Segrave had in fact
died in a speedboat accident at Lake Windermere in England after his boat, the *Miss
England II,* hit a log.[35]

Whereas "How I Broke the World's Automobile Speed Record" concerns technol-
ogy's darker side, the essay "Kämpfe mit Riesenfischen" ("Battles with Giant Fish")
addresses a different but equally unavoidable struggle: man versus beast.[36] In spite
of the thematic difference, this text again represents danger as a *Kampf* (struggle)
and as the defining moment of existence. "Battles with Giant Fish," excerpted from
F. A. Mitchell-Hedges's book of the same title, depicts the narrator's survival of a har-
rowing event. The first-person narration, documentary tone, short paragraphs, and
imagistic language again authenticate the report, and once more the surrounding

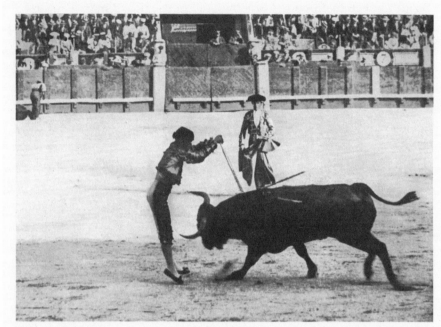

Stierkampf I.
Der Todesstoß.

Fig. 35 "Stierkampf I: Der Todesstoß" (Bullfight I: The fatal stab), in Ferdinand Bucholtz, *Der gefährliche Augenblick*, III.

images document the "what could have been" in dangerous man-versus-beast strug-
gles. In tandem, text and image articulate the dangerous moment's tense duality and
stress photography's unique ability to capture and represent it. Bucholtz and Jünger
notably choose not to reproduce the illustrations from the original English edition
of Mitchell-Hedges's book. As if to repudiate the book's auratic drawings in order
to emphasize instead the cold authenticity of the snapshot, they intersperse actual
photographs—not drawings inspired by photographs—of battles between man and
animal. Two sequenced images, entitled "Stierkampf I: Der Todesstoß" (Bullfight I:
The fatal stab; fig. 35) and "Stierkampf II: Das Ende des Matadors" (Bullfight II:
The end of the matador), again stress the camera's ability to communicate the coex-
istence of triumph and peril more effectively than the written word.[37] The first image
depicts the climactic moment of the bullfight when the matador stands on his toes,
ready to plunge his sword into the raging bull. In the second image, however, *el toro*
has overtaken and gored the matador, whose assistants can only watch in horror.

After "Battles with Giant Fish" and another (ostensible) man-versus-nature tale
entitled "Unter den Kopfjägern des Amazonas" (Among the headhunters of the
Amazon), *The Dangerous Moment* makes its subtle but crucial shift to reports of political
unrest. Although the equation of unanticipated natural disasters and undesired car

accidents with intentional political agitation and premeditated murder is logically fallacious, Jünger and Bucholtz do not differentiate among them. Danger is danger. To support this claim, the essays and photographs in this second half of *The Dangerous Moment* use the same authenticating strategies as the first half: snapshots of the moment and detailed first-person narratives. Many of the reports open by specifying temporal contexts. "Kriegsgericht an der Tagliamento-Brücke" (War tribunal at the Tagliamento Bridge), for instance, begins, "We reached the bank of the Tagliamento before daybreak."[38] "Das Attentat auf Rathenau" (The assassination of Rathenau) and "Die Ermordung des Minister Plehwe" (The murder of Minister Plehwe) are even more precise. The latter begins, "On July 14, 1904, in the evening, I met Schweizer in the Theater 'Bouffes.'"[39] Such specifics again associate the subsequent documentary tales of intentionally perpetrated violence with the preceding accounts of unavoidable natural disasters or accidents. The crucial thematic differences disappear amid a consistent formal rhythm. The step-by-step detail of the subsequent reports lends these narratives credibility, even as they falsely imply the inevitability of the events they depict.[40] In "Aussage des Feldzeugmeisters Oskar Potjorek, Augenzeuge des Attentats von Sarajevo" (Statement of the ordnance officer Oskar Potjorek, eyewitness to the assassination in Sarajevo), an Austrian general riding in the car that carried the Archduke Franz Ferdinand recounts the critical moments of the assassination. Potjorek's short, imagistic sentences noticeably lack emotion or any normative claims about the murder. He simply "tells it as it was," and his account implies danger's necessity, as does the telegraphic language of "Hinrichtung auf Cayenne" (Execution on Cayenne), which tells of a condemned man's final moments.[41] This story simply details the events before an execution: the last meal, the shaving of the prisoner's head, the drum roll, and finally the decapitation itself.

Unlike the catastrophes in the first half of *The Dangerous Moment,* the latter two reports and their surrounding photographs represent avoidable, politically motivated danger. The assassination of Archduke Franz Ferdinand was, of course, a defining moment of twentieth-century European politics, but less well-known is the fact that Cayenne was a French Guianese penal colony for political prisoners. One can safely assume that this report similarly concerns a politically motivated execution. Yet both accounts portray political violence as being as inevitable as natural disasters. Like the reports, the surrounding photographs have been chosen to suggest authenticity. Blurry, overexposed, or lacking compositional centers, they again represent the dangerous moment as an existential metaphor in which time is suspended and life hangs in the balance. In the snapshot "Die Verhaftung des Attentäters in Sarajevo" (The arrest of the assassin in Sarajevo), the Serbian Nationalist Gavrilo Princip is arrested, both in the judicial sense and in time (fig. 36). Chaos, danger, and struggle dominate the image in the form of equally blurry policemen and impassioned bystanders.

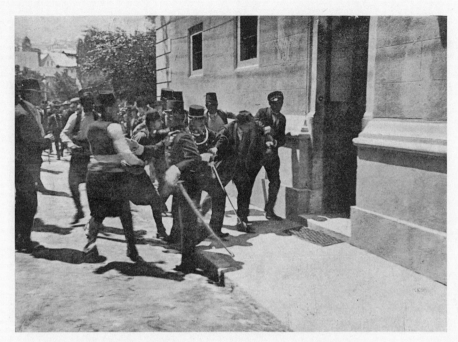

Die Verhaftung des Attentäters von Sarajewo.

Fig. 36 "Die Verhaftung des Attentäters in Sarajevo" (The arrest of the assassin in Sarajevo), in Ferdinand Bucholtz, *Der gefährliche Augenblick*, 189.

One final, significant snapshot from *The Dangerous Moment* is captioned "Berlin. Zusammenstoß zwischen Polizei und Rotfront. Im Fenster, unter den Gesichtern der Zuschauer, spiegelt sich eine andere Szene" (Berlin. Clash between police and the Red Front. Another scene is mirrored in the window under the spectators' faces; fig. 37). Compositionally, the image consists of three layers: a Communist and the police in the foreground, the spectators in front of and inside the store, and the reflected scene on the window. The spectators behind the window and those reflected on it watch a street fight between police and Communists. The prominently displayed word "Destillation" on the window creates an inadvertent visual pun: the sensationalistic content and modern form of the snapshot have distilled existence into its dangerous essence, at least in the view of Jünger and Bucholtz. In politics and in daily life, the moment of struggle pervades all spheres of existence, and snapshot photography lets it speak in an entirely new way.

Erich Salomon's *Famous Contemporaries in Unguarded Moments*

If for Ferdinand Bucholtz and Ernst Jünger the camera and the photo essay were the means to represent the moment of danger that typified the cold, objective, modern

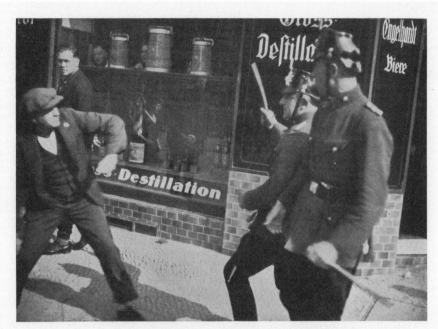

143

Berlin. Zusammenstoß zwischen Polizei und Rotfront.
Im Fenster, unter den Gesichtern der Zuschauer, spiegelt sich eine andere Szene.

Fig. 37 "Berlin. Zusammenstoß zwischen Polizei und Rotfront. Im Fenster, unter den Gesichtern der Zuschauer, spiegelt sich eine andere Szene" (Berlin. Clash between police and the Red Front. Another scene is mirrored in the window under the spectators' faces), in Ferdinand Bucholtz, *Der gefährliche Augenblick,* 143.

world, then for Dr. Erich Salomon snapshot photography played a very different role. Salomon's introduction to *Famous Contemporaries in Unguarded Moments* begins with an English-language quote that describes the author's photojournalism and its implicit role as a form of public advocacy: "'*That is quite impossible, that has never been done before!'* This is the sentence that was flung at me almost every time when, in early 1929, in the service of photojournalism, I attempted to illuminate with the camera the hitherto closed realm of English club and society life, the banquets with their medieval masters of ceremonies and similar things."[42] Salomon's description of his work—"That is quite impossible, that has never been done before!"—is the *leitmotiv* of *Famous Contemporaries'* three-part introduction and its photographs. As Salomon tells it, this objection always came from bureaucrats who tried—but ultimately failed—to prevent him from photographing private functions of government and high society so as to illuminate (*durchleuchten*) them for his readers. With such language, Salomon characterized himself as a mediator between governments and publics, and in this regard he fell in line with modern journalism's self-understanding as an endeavor that strove to be "objective"—a word that, significantly, also means "camera lens" in German.[43]

Throughout the introduction to *Famous Contemporaries,* Salomon describes his photographs as the spoils or "Beute" (booty) of a successful battle or struggle to access and photograph "famous contemporaries" when they thought they were not being watched. He uses the symbolically laden word *Kampf,* but in a manner completely different from Jünger. Each section of Salomon's introduction includes this word in its title: "Der Kampf um die Aufnahmemöglichkeit" (the struggle to access what he wanted to photograph), "Der Kampf bei der Aufnahme selbst" (the struggle to photograph surreptitiously), and "Der Kampf nach der Aufnahme" (the struggle to get his photographs into print in the face of censorship). Sometimes out of focus or formally clumsy, his surveillance photographs reveal the powerful and wealthy behind closed doors and freed from having to "perform" for the public. With the help of Salomon's secretive yet penetrating gaze, readers could (at least in principle) observe the authentic workings of power and government. The illustrated magazines in which he published his images, particularly the *Berliner Illustrirte Zeitung* and the *Münchner Illustrierte Presse,* celebrated his photographs for fulfilling this public-interest work.

The received wisdom about Salomon, which his contemporaries helped establish, is that he was the first to truly take advantage of the technology that allowed photographers to photograph in low-light conditions. In her *Photography and Society,* for instance, Gisèle Freund noted, "Salomon would be the first to photograph people in interior spaces without them noticing. These photos have a lively effect, because they are not posed. And here begins modern photojournalism. A photograph's value no longer depended on its sharpness, but rather on its subject and the feelings it arouses."[44]Along similar lines, the headline to a January 1929 photo story in the magazine *Uhu* that featured Salomon's photographs boldly proclaimed, "Ohne Pose: Wenn die Großen nicht wissen, daß sie fotografiert werden" (Without posing: When important people do not know that they are being photographed).[45] Recent scholarship has picked up on this characterization as well: Martin Parr and Gerry Badger write in their history of the photobook that Salomon was "renowned as the 'father of the candid camera'" and "a photographic spy with a difference."[46] Salomon promoted his work as novel, important, and unprecedented, and in his own time he became quite famous. The implicit political message of Salomon's approach was that readers need not make political judgments on the basis of the incendiary, exaggerated, or misinformed ranting of political radicals. Rather, they could decide firsthand on the basis of his objective and minimally mediated photographs of public lives in private situations. Although paparazzi photographers may not be respected today, Salomon and his contemporaries understood themselves as progressives whose work helped establish transparency in the public sphere.

As Gisèle Freund also noted, there was something "Daumier-like" about Salomon's photographs—an allusion to Honoré Daumier, the famous nineteenth-century

French political caricaturist. Salomon's photographs exhibit humor and playfulness, but unlike the images in *The Dangerous Moment* that show violence, deaths, and assassinations, they never cross such ethically dubious lines of propriety. His subjects may be "unguarded," but they are not fully exposed. Echoing Freund, historian of photography Pierre Vaisse has suggested that Salomon's stolen moments "are unexpected portraits, amusing, sometimes cruel, but for the most part betraying a real sympathy for his subjects."[47] Salomon did not cross these lines because to have done so would have compromised his livelihood: although he sometimes infiltrated elite political and social events to which he was not invited and even risked jail time when he photographed legal proceedings, at other times he could access events behind closed doors precisely because he had cultivated contacts with politicians and other public figures. They did not perceive him as a potential danger and allowed him to photograph these events, and he in turn generally used discretion in what he published. As a result, the eponymous famous contemporaries of Salomon's photo essay do not appear as the corrupt plutocrats one would have encountered in sensationalist boulevard newspapers. Rather, they are all-too-human politicians doing the best they can in a difficult time. In other words, Salomon's photographs are not simply images of famous contemporaries in unguarded moments, but rather the product of a symbiotic relationship between Salomon and members of the ruling elite. In this sense, he is a figure aptly characterized (and ultimately victimized) by the illusory notion of the "German Jewish symbiosis," for even if Salomon could exploit his cozy relationship with political and cultural figures in his work, doing so threatened to reinforce conspiracy narratives of Jewish parasitism among anti-Semites.[48]

This cooperation between the photographer and photographed points to an important structural dimension of *Famous Contemporaries,* namely, that this photo essay is not as candid or spontaneous as one might expect, and this "constructed candidness" furthermore betrays a political positioning on the part of Salomon. The work does not simply show famous contemporaries as they are, even if Salomon presents his images as spontaneous, unposed, and candid behind-the-scenes views of the workings of international diplomacy and high society. To the contrary, it is valuable to consider more closely which subject matters Salomon included in and excluded from this limited corpus of his photographs. Moreover, it is important to examine how this photo essay is punctuated by photographs that reveal the complicit participation of the ostensibly "unguarded" individuals. These aspects point to a great deal of forethought, complicate Salomon's claims of "candidness," and open this photo essay to historical interpretation as more than just an anthology of photojournalistic snapshots. In Claudia Schmölders's words, the context of *Famous Contemporaries* allows it to be read as a work that "opens windows to other artistic or political realities."[49] This photobook appeared among other photo essays and written essays about the

"moment of crisis," notably the many volumes associated with Ernst Jünger and the cultural pessimism of Oswald Spengler. In this historical context, Salomon's work may reasonably be read as one response to the fraught political and cultural discourse of the politics of the moment. The politics of his photo essay, however, are much subtler and more affirmative than those of Bucholtz and Jünger's *The Dangerous Moment.* Both works use the same medium (the snapshot) and appropriate the same discourse, and both react to the perceived crisis of Weimar democracy, yet they respond very differently.

Salomon did not organize the photographs in *Famous Contemporaries* chronologically.[50] Rather, they are arranged in thematic clusters about specific individuals, events, or institutions. For instance, the first four photographs depict President Paul von Hindenburg and King Fuad of Saudi Arabia. The fifth through eleventh all show Gustav Stresemann. A set of five images (14–19) portray the conferences and treaty negotiations that restructured German war reparations payments (the Second Hague Conference) and renounced war as a means of solving conflicts (the Kellogg-Briand Pact). Other image clusters depict British officials and diplomats (Lord Cecil, Chamberlain, and Lloyd George), media barons (Hearst, Hugenberg), and religious figures (Papal Nuncio Orsenigo, Papal Nuncio Monsignor Pacelli, Abbé Desgranges). Photographs of political deliberations (at the League of Nations and the Reichstag) also feature prominently throughout *Famous Contemporaries.* The photo essay concludes with an extended series of photographs—many of them posed—of figures in the arts (Pablo Casals, Max Liebermann, Alfred Kerr, Heinrich Mann) and ends, conspicuously, with a photograph of Salomon himself. In the first edition of *Famous Contemporaries,* each photograph (or in some cases groups of photographs) carries captions in German, English, French, and Italian. Some of the captions provide no information about when an image was taken and state simply, for instance, "Wilhelm Furtwängler dirigiert eine Symphonie von Haydn in der Berliner Philharmonie" (Wilhelm Furtwängler conducts a Haydn symphony at the Berlin Philharmonic). The lack of explicit dates alludes in part to the book's title: specific dates were not necessary because the photographed individuals were all "contemporaries" whom the intended readership of the early 1930s immediately recognized.

Within the broader cultural context of essays, feuilletons, polemics, and photobooks about a moment of crisis, including, of course, *The Dangerous Moment,* the political implications of Salomon's choice of subject matter are significant. *Famous Contemporaries* can, for several reasons, be read as Salomon's voice of advocacy for the anemic Weimar Republic. For one, he preferred to photograph his famous contemporaries in contexts that stressed the rule of law. His work includes scenes of meetings of parliament, courts of law, treaty negotiations, and galleries of spectators listening intently to orations by freely elected officials. Sometimes the images reveal

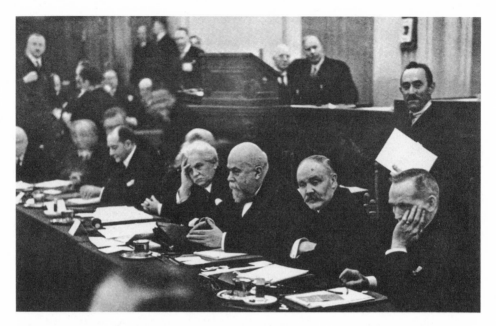

Fig. 38 Erich Salomon, "Schlußsitzung der 2. Haager Konferenz, Januar 1930. Von rechts: Snowden, Loucheur, Chéron, Jaspar, Curtius" (Final meeting of the Second Hague Conference, January 1930. From right to left, Snowden, Loucheur, Chéron, Jaspar, Curtius), in *Berühmte Zeitgenossen in unbewachten Augenblicken* (Stuttgart: J. Engelhorns Nachf., 1931; repr., Munich: Schirmer/Mosel, 1978), 16. Berlinische Galerie, Berlin.

the "warts" of the democratic process, but these moments still give a human face to politicians rather than simply attack them. Image 16, for example, depicts diplomats in decidedly unglamorous poses. Its caption reads, "Final meeting of the Second Hague Conference, January 1930. From right to left, Snowden, Loucheur, Chéron, Jaspar, Curtius" (fig. 38). This shot of tired politicians evokes the sense of tedium, lethargy, and distraction that accompanies the end of a long conference. The conference delegates, all dressed in monotonously dark suits, clasp their hands and hold their heads in poses that betray intense boredom. Snowden props up his head with his left hand and toys with an indiscernible object in his right, while Loucheur, his arms crossed and his eyes sagging, looks ready to fall asleep. The roughly two dozen people in the image stare in roughly two dozen directions. Not a single politician seems particularly inspired or enlightened. Nevertheless, Salomon's caption does not indict these politicians for appearing "asleep on the job." To the contrary, the subtle humor of this image and others like it in *Famous Contemporaries* generates sympathy for these exhausted politicians and the democratic institutions in whose service they toil. In that the Second Hague Conference concerned the need to revise (but not eliminate) the payment schedule for German reparations, Salomon's humanizing image becomes a voice of support for their actions, which were not universally popular in Germany.

As important as the choice of subject matter is for the implicit politics of this photo essay, the absences also speak loudly. Although Salomon is known to have photographed many politicians from Germany and abroad, *Famous Contemporaries* conspicuously lacks images of the once politically marginal figures who, by the end of the 1920s and early 1930s, were moving into the mainstream of German and European politics. *Famous Contemporaries* does contain three related images of Benito Mussolini (images 31–33). Clad in a tuxedo, Mussolini sits at a table with German Chancellor Heinrich Brüning and the respective foreign ministers of Germany and Italy at the time, Julius Curtius and Dino Grandi, in Rome's Hotel Excelsior. We do not see Mussolini as a fist-shaking authoritarian in military uniform, but as a bald and someone emasculated-looking politician who sits as an equal engaged in dialogue and negotiation. *Famous Contemporaries* lacks images of any prominent domestic politicians of the far Right or far Left, such as Adolf Hitler or Hermann Goering of the National Socialists or Ernst Thälmann of the Communist Party, even though these parties finished second and third, respectively, in the 1930 elections and their leaders would certainly have counted as famous contemporaries. Salomon did in fact photograph Nazis and Communists in the late 1920s and early 1930s, so his decision to leave them out of *Famous Contemporaries* is noticeable.[51] Such lacunae implicitly convey confidence in the figures and democratic processes Salomon does include. The inclusion of Nazis or Communists in this photo essay would equate them with democratic parties and implicitly legitimate them.

The absence of certain politically marginal subject matters that were becoming less marginal at the end of the 1920s invites the question of how else Salomon used *Famous Contemporaries* to engage Weimar debates about Germany having reached a critical moment. One answer lies in the presence of many images that, in spite of their ostensibly "candid" nature, reveal a great deal of complicity with the subjects. Even if *Famous Contemporaries* ultimately represents the political elites and institutions in a favorable manner, these posed or overly constructed photographs, in particular the final one, complicate the notion that the book depicts "authentic moments of spontaneity." Such images appear consistently throughout the photo essay, although not at fixed intervals.

The first photograph in *Famous Contemporaries*, for instance, shows Germany's president, Paul von Hindenburg, in the tearoom at the Berlin State Opera (fig. 39). This image, along with two of the next three, depicts him at events connected to the state visit of Saudi Arabia's King Fuad to Germany in early June 1929, including a gala opera performance. Compositionally, the photograph looks like a posed portrait. Hindenburg clenches his hands together in a relaxed pose, turning slightly to his right and looking straight at the camera. Only the caption, the grainy background, and a small blur at the bottom left testify to the "candidness" of the image. Given the

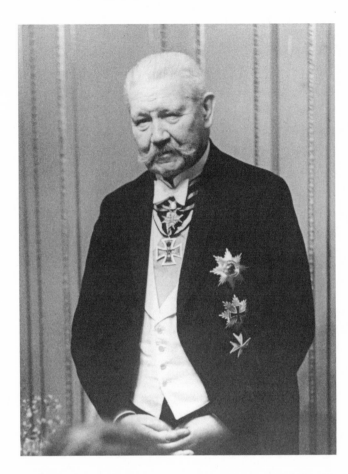

Fig. 39 Erich Salomon, "Reichspräsident Hindenburg im Teezimmer der Berliner Staatsoper" (President Paul von Hindenburg in the tearoom at the Berlin State Opera), in *Berühmte Zeitgenossen in unbewachten Augenblicken*, I. Berlinische Galerie, Berlin.

photograph's formality, it seems possible, even likely, that Hindenburg posed for it or, at the very least, did not object to being photographed at this function.

Other photographs more explicitly suggest that Salomon has taken a political position through *Famous Contemporaries*. He favorably portrays politicians, especially those of once hostile foreign powers, who sought to reintegrate Germany into the community of nations. In addition to the images from the reparations negotiations at the Second Hague Conference, *Famous Contemporaries* contains portraits of peace negotiators, notably Nobel Peace Prize laureates, British foreign minister Austen Chamberlain and U.S. vice president Charles Dawes (in 1925), and French prime minister Aristide Briand and German foreign minister Gustav Stresemann (in 1926). Image 21 again "constructs candidness" as it depicts a famous contemporary (Chamberlain) in a positive light (fig. 40). It is one of only two pictures in the photo essay that include Salomon. In English, its extensive caption reads,

Sir *Austen Chamberlain* in his office at the Foreign Office in London (April 1929) and the author, showing the former his photographs of the League of Nations.

Fig. 40 Erich Salomon, "Sir Austen Chamberlain in seinem Arbeitszimmer in London (April 1929) im Gespräch mit Erich Salomon" (Sir Austen Chamberlain in his office in London [April 1929] in conversation with Erich Salomon), in *Berühmte Zeitgenossen in unbewachten Augenblicken*, 21. Berlinische Galerie, Berlin.

(Self-portrait taken with automatic exposure release.) The photo could only be taken after great technical difficulties had been removed. Chamberlain wanted to remove a huge lamp from his writing desk. The electric wires were, however, held fast under the desk. After this had been lifted with a united effort, Chamberlain took the lamp away and in doing so pulled down the telephone, as the lamp wires were twisted together with the telephone wires. A great pile of red leather document cases then had to be removed from the desk, as they obstructed the view.[52]

Chamberlain appears to have paused in the middle of what he was doing, and the photograph looks like a candid snapshot of Salomon as he shows the British foreign minister examples of his own work, presumably images containing Chamberlain. But as Salomon's description clearly shows, the sense of spontaneity is deceptive. The serious-looking, monocle-clad Chamberlain may sit at a desk in his busy politician's office, but Salomon's caption reveals him as a human being subject to the same banal annoyances and klutziness of everyday life: Chamberlain wanted to look good for the camera and inadvertently knocked over the telephone. The image's

authenticity arises not from its spontaneity but from the humanizing caption and the intimacy and comfortable setting of Chamberlain's office. Salomon photographs Chamberlain "in his element." Whereas Bucholtz and Jünger efface the camera's power to construct reality and instead see it as a way to access danger more immediately, Salomon foregrounds the camera's ability to construct and manipulate the way "reality" is perceived.

Although Salomon does not appear in the two subsequent images, both seem to be of the same type as the Chamberlain photograph—that is, they are posed pictures of well-known British politicians in their offices, taken shortly after Salomon presented them with photographs of themselves. The caption to image 22 states simply, "Lloyd George in seinem Büro in London" (Lloyd George in his office in London). Closer inspection reveals that amid the papers on Lloyd George's desk sits a copy of the *Graphic,* a magazine for which Salomon photographed at the time. A blurry photograph on the magazine cover appears to show men in tuxedos, likely including Lloyd George himself. Image 23 continues this same thematic thread. The English prime minister Ramsay MacDonald has allowed Salomon into his office to watch him work, and the politician is shown dictating a letter ("beim Diktieren eines Briefes"). However, MacDonald is not dictating it at that very second. His mouth is closed, and he stares straight into the camera. He has clearly stopped working and posed willingly for Salomon, whom he has allowed into a private workspace that the photographer could not have wandered into uninvited.

Whereas the photographs of the first three-quarters of *Famous Contemporaries* portray political, religious, and judicial figures, the subject matter of the final images shifts to cultural personalities. In these figures, as Gisèle Freund noted, Salomon was photographing "alles, was Rang und Namen in der Kunst hat" (everything of distinction in the arts).[53] Although the images include painters (Max Liebermann in images 98 and 99) and writers (Thomas Mann, Heinrich Mann, Oskar Loerke, and others in 100 and 101), the cultural photographs are skewed toward musicians, in particular conductors and performers from the world of classical music that Salomon, on account of his upper-middle-class origins, happened to know especially well.[54] Nevertheless, Salomon's approach remains the same. Clusters of thematically similar photographs taken at different places and at different times again show famous contemporaries frozen at key moments in their "native" environments, and interspersed throughout these clusters are images of "posed candidness." Image 88, for instance, shows Richard Strauss directing his ballet *Whipped Cream* in Vienna; the pair of images next to caption 89 depict him again, this time with the singer Elisabeth Rethberg after the Dresden premiere of Strauss's *The Egyptian Helen* in 1928. The first photograph was taken without the pair's knowledge, while the second one was a posed picture ("gestellte Aufnahme") taken seconds after the first (fig. 41).

Fig. 41 Erich Salomon, "Richard Strauss und die Sängerin Elisabeth Rethberg nach der Premiere
der 'Ägyptischen Helena' in Dresden" (Richard Strauss and the singer Elisabeth Rethberg after the
premiere of *The Egyptian Helen* in Dresden), in *Berühmte Zeitgenossen in unbewachten Augenblicken,* 89. Berlinische
Galerie, Berlin.

Similarly, images 96 and 97 show the Spanish cellist Pablo Casals as he grimaces
intensely during performances in Munich and Berlin. Like the photographs of
political figures, these are often spontaneous images of celebrities, but they are not
necessarily intrusive or unexpected. Max Liebermann, for instance, welcomed Salo-
mon into his Berlin apartment and posed for several photographs. Once again, the
putative "candidness" of Salomon's photography comes into question.

The final image of *Famous Contemporaries* captures its most self-reflexive moment.
The caption, "Dr. Erich Salomon: Father comes home from work," inscribes *Famous
Contemporaries* within a discourse of normalcy and the bourgeois family, the very
antithesis of Jünger's antibourgeois sentiments (fig. 42). This photograph retroac-
tively transforms the preceding images into components of a "day in the life" nar-
rative like the many such "day in the life"—themed photo essays in the Illustrierten
to which Salomon contributed, even though the photographs in *Famous Contemporaries*
span over four years. Salomon's tired face betrays his exhaustion after a day at work.
He has returned home in his "uniform," which, given the highly specialized modus

Fig. 42 Erich Salomon, "Dr. Erich Salomon: Vater kommt von der Arbeit nach Hause" (Dr. Erich Salomon: Father comes home from work), in *Berühmte Zeitgenossen in unbewachten Augenblicken,* 104. Berlin-ische Galerie, Berlin.

operandi of infiltrating society events, means a tuxedo, top hat, and briefcase. In sharp contrast to the sometimes opulent settings in the preceding images, such as opera houses or the castles of media barons, Salomon's home is distinctly "normal," with its wrinkled carpet, chipped paint, and crooked pictures on the wall. By including this image, Salomon separates himself from the figures he photographs, but at the same time, he reinforces the notion that through his photography he serves as an intermediary between publics and elites. The well-dressed man in the decidedly unremarkable setting is the mediator.

This final photograph of Salomon ends *Famous Contemporaries* with a visual pun. Salomon, who was well known in his own lifetime, becomes the famous contemporary in the unguarded moment. But, as with the photographs before it, this image's spontaneity is dubious. It begs several questions: Did the child who took the photograph—if indeed it was taken by a child (for instance, Salomon's youngest son, Dirk, born in 1920)—stay awake all night in anticipation of his father's return to ambush him with the camera? Or did Salomon himself stage the image? It is impossible to know for sure, but considering that many of the previous images are presented as captured, fleeting moments but were nevertheless posed or at least not entirely spontaneous, this final photograph is a fitting coda. It epitomizes the tensions between spontaneity and deliberation that characterize the photographs in *Famous Contemporaries*.

Toward a Politics of the Snapshot

The preceding comparison of *The Dangerous Moment* and *Famous Contemporaries in Unguarded Moments* has argued that photo essays composed of snapshots became the tools that essayists, editors, and photographers used to address the tenuous political and cultural milieu of late Weimar Germany. These works provide further evidence that the photo essay blossomed as a form used not only to address crucial aesthetic, political, and cultural debates of the time but also to help construct public consciousness of Weimar Germany. These works make their cases in visually striking, rhetorically effective, technologically informed, and theoretically complex ways. At various points, intentionally and unintentionally, their introductory texts, captions, and snapshots speak to the urgency of the political and aesthetic moment, and they have distinct formal structures that help convey their arguments.

The Dangerous Moment's matter-of-fact reports and sensational snapshots create a new means to register and represent danger. Ferdinand Bucholtz and Ernst Jünger hone in on extraordinary moments of danger, recast them as normal and inevitable, and celebrate and naturalize struggle and violence as the foundations of a new

social order. The spontaneous snapshots included in their work contrast sharply with Erich Salomon's photographs, which are both subtler and, as we have seen, sometimes posed and self-referential. Salomon's *Famous Contemporaries* suggests less faith in the camera's disinterestedness and a greater understanding of photography's potential to manipulate opinion. With his candid images, he took celebrities whom audiences knew as larger than life and cast them as profoundly human, a gesture that at once "brought them down to earth" and, considering the political and cultural minefields that they had to navigate, showed them to be extraordinary. Like *The Dangerous Moment,* this photo essay also employs a narrative structure. Salomon presents clusters of thematically related candid images and then intersperses them with images that are clearly not entirely spontaneous. And he tellingly concludes this photo essay with a self-referential image that foregrounds the issue of the constructed nature of photographs. Such stylistic differences strongly point to the fact that Salomon did not simply photograph famous contemporaries in unguarded moments. Rather, he presented these images to a citizenry used to crisis rhetoric and not always convinced that its country's politicians (and their allies abroad) were working in its best interests.

Salomon's photography, and later his tragic fate as a victim of Nazi persecution, raise a question clearly informed by the clarity of hindsight. When Salomon used words such as *Kampf* and *Augenblick,* was he naïvely trafficking in the same discourse as Weimar Germany's radical Right, or was his work an attempt to combat it on its own terms? In *The Dangerous Moment,* Bucholtz and Jünger offer a particularly vivid example of how this language, when coupled with photographs, could be placed in the service of a right-wing cultural agenda. By using snapshots to highlight the constructed nature of what was supposedly just "captured" from the world, however, Salomon's *Famous Contemporaries* shows that, in fact, those who would use photography to "report" a crisis were doing much more—they were performing, enacting, and realizing the very crisis to which they claimed merely to offer a window. Salomon and the many republican-leaning contemporaries he photographed may simply have been naïve. Or they may have underestimated the radical Right's ability to co-opt the same discourse. This puzzle will continue to provide fodder for speculation.

epilogue
crisis, photographed: the afterlife
of the weimar photo essay

When the National Socialists took the reins of the German chancellorship in 1933, the culture of illustrated magazines, photo essays, and photobooks that had come of age during the Weimar Republic was still alive and well. And it continued to thrive. Whereas some realms of German culture, notably literature and painting, immediately found themselves under attack, the changes that took place in photography were subtler. Well-known leftist photographers such as László Moholy-Nagy and John Heartfield immediately found their work banned, but it took several years for Joseph Goebbels's propaganda ministry to develop a consistent policy.[1] One need only look at the editions of the leading German photography annual *Das Deutsche Lichtbild* (The German photograph) to see that with photography, the *Gleichschaltung*, or bringing into line, occurred somewhat gradually and was never total. *The German Photograph* was subject to this censorship after 1933, but its changes were more thematic than formal, at least initially. *The German Photograph* usually arranged images in complementary pairs across facing pages. But where previously it had presented close-ups of plants and urban scenes, some incorporating avant-garde photographic techniques, there now appeared photographs of people in folk costume, photographs with conspicuous swastikas, and even explicitly political images.[2] In this regard, *The German Photograph* epitomized the mix of modernist techniques and premodernist themes, as well as modern forms and *völkisch* themes, that characterized the "reactionary modernism" of National Socialist Germany.[3]

The conceptual pretense remained intact that photographs organized into sequences or extended narratives offered a useful tool with which to examine key issues of the time in depth and to "see" them more clearly. Nevertheless, the sense of optimism about technology and photography that photo essays helped nurture in the 1920s and 1930s left a population vulnerable to propagandists all too willing to mobilize narrative photography's suggestive and associative powers for their own ends. Rolf Sachsse has described this dual purpose of photography in National Socialist Germany as an "Erziehung zum Wegsehen," an untranslatable pun that means both "education to see the way" (of National Socialist ideology) and "education to look away" (from its injustices).[4]

As much as any medium, Illustrierten in Hitler's Germany became a space in which Germans could simultaneously look at and look away from their ideologically co-opted world. While communist papers such as the *Arbeiter Illustrierte Zeitung* went into exile and eventually out of business altogether, politically mainstream titles such as the *Berliner Illustrirte Zeitung* and the *Münchner Illustrierte Presse* retained the look and feel of their Weimar predecessors. They continued to sell large numbers of copies. Yet their content changed markedly. Idealized Aryan types became frequent cover models, as did Hitler himself. After the *Gleichschaltung*, photo essays in Illustrierten maintained their avante-garde-inspired layouts, but the focus of these human-interest stories often shifted to Nazi Party rallies or "day in the life" features about members of the SA or SS. Many Illustrierten ceased publication in the 1940s during wartime paper shortages or at the war's end in 1945, but the legacy of this key site of Weimar photo essays was secured. Illustrated magazines remained popular in Germany and abroad until television and other media cut into their sales.

Aside from Illustrierten, the volumes on the shelves of German bookstores in the late 1930s would also have testified to the persistence of narrative photography within the parameters of new ideological constraints. Booksellers continued to sell titles from Karl Robert Langwiesche's decidedly *völkisch* Blue Books series about German history, art, landscape, and people in a decidedly realist, nonexperimental photographic idiom. Aside from Paul Dobe's *Wildflowers of German Flora*, titles such as *Deutsche Dorfkirchen* (German village churches), *Der deutsche Ritterorden und seine Burgen* (The Teutonic knights and their castles), and *Deutsche Bauernhäuser* (German farmers' houses) connected the Germany of the 1930s to a mythic Germanic past.[5] These books and similar ones sold briskly throughout the 1930s. The Blue Books series' most popular title, *Die schöne Heimat: Bilder aus Deutschland* (The beautiful homeland: Images from Germany), first appeared in 1915. Dedicated "to those who protected their and our homeland," this exemplary moment of *Heimatphotographie* had by 1940 sold more than 300,000 copies and by the mid-1950s almost 450,000 copies.[6]

Alongside such works about German landscapes and other perceived sources of traditional culture, one would have found photobooks that examined German identity with physiognomic typologies, but not in the critical mode of August Sander or Walter Benjamin. In fact, shortly after the National Socialists seized power, they destroyed the printing plates and confiscated all remaining copies of Sander's *Face of Our Time*. Alfred Döblin, who wrote the foreword, fled into exile in February 1933. Identity discourse remained closely tied to "scientific" titles such as Dr. Hans F. K. Günther's *Kleine Rassenkunde des deutschen Volkes* (Little racial science book of the German people) or Ludwig Ferdinand Clauss's *Die nordische Seele* (The Nordic soul).[7] Günther, for instance, presented sets of photographs of skulls, noses, and faces and the pseudoscientific jargon of "race science" as proof of Aryan superiority. Many of these titles had already appeared in the 1920s, but following Germany's politically decisive shift to the right, they found renewed popularity and went through multiple editions.

In the realm of artistic portrait photography, photobooks by the likes of Erna Lendvai-Dircksen and Erich Retzlaff continued to enjoy popularity. Throughout the 1930s and 1940s, Lendvai-Dircksen produced her series The Face of the Germanic Folk. However, she shifted her geographic focus to include Germanic types who lived outside of Germany's political boundaries, notably in her 1935 work *Das Gesicht des deutschen Ostens* (The face of the German East).[8] The presentation of non-German citizens as Germanic both reflected and legitimized Nazi Germany's expansionist aims. By the 1940s, Lendvai-Dircksen had produced photobooks about newly annexed or occupied territories, including Flanders, Denmark, and the "Ostmark" (Austria).[9]

Photobooks about Germany's leading politicians continued to appropriate the candid visual idiom that Erich Salomon popularized. They still relied on the notion that readers would perceive a series of snapshots taken in unguarded moments as a form that could offer special insight about the inner workings of government. The best examples of this aesthetic appear in the popular photobooks by Heinrich Hoffmann, Adolf Hitler's personal photographer. Hoffmann created a series of "behind-the-scenes" books that portrayed Hitler not simply as a leader at political rallies but as an avuncular private citizen, one who equally loved children, animals, and the alpine landscape. Throughout the mid-1930s, Hoffmann published books that would have drawn on readers' familiarity with the paparazzo style pioneered by Salomon, although any sense of candidness in these works was much more choreographed than anything Salomon produced. Hoffmann's *Hitler wie ihn keiner kennt* (Hitler as no one knows him; 1932), *Jugend um Hitler* (Youth Around Hitler; 1934), *Hitler abseits vom Alltag* (Hitler aside from everyday life; 1937), and several other works met with enormous success. Each appeared in editions of more than 200,000 copies, and *Hitler wie ihn keiner kennt* sold more than 400,000.[10] In Weimar Germany and during

the Third Reich, such books played important roles in helping establish the "Führer myth," the image of Adolf Hitler as the hardworking, self-sacrificing, and paternal figure who made the new National Socialist era possible by rising to the task of leadership at a critical moment.[11]

The reactionary ideas and photographically illustrated forms that held sway in Nazi Germany did not emerge with Hitler's rise to power in January 1933. Rather, they germinated throughout the 1920s, during the same years that frequent economic uncertainty, radical societal transformation, and constant political unrest forced German society into a fundamental identity crisis. Artists, writers, and significantly— as we have seen—photographers addressed a series of fundamental questions: What is the origin of German identity and what does it mean to be German? How and where does it manifest itself? And what is to be done to preserve, strengthen, and perpetuate it? National Socialism provided one set of answers to these questions, one that stressed the centrality of race, blood, iron, and soil. At least in part, artists, writers, and photographers found answers in an enthusiasm for photography and in new forms constructed with the aid of this new technology. They encouraged people to view the world as though it were a sequence of images. Whether in books or newspapers, the photo essays of Weimar Germany are the material deposit of this shift in seeing and, at least in part, a failure to account for its potential consequences. They point to a profound sense of crisis but also to a faith in technology that did not adequately anticipate how photographs created and organized in suggestive ways might be co-opted for propaganda. While today these photo essays may claim the status of artworks, in the 1920s they were the salvos of ideological warfare.

When Friedrich Seidenstücker photographed the crowded newsstand on the Kaiserallee in 1932, he could not have grasped the extent to which his image captured a critical juncture in the history of Germany and visual media. By the time he snapped a second image of German print culture in 1947, the situation had changed dramatically, even if, in other ways, it remained the same. The 1932 image "Newspaper kiosk on the Kaiserallee with 966 Titles" (fig. 1) and the 1947 image of the window display at Gerd Rosen's used bookstore and art gallery (fig. 43) are separated by a mere fifteen years. Yet the photographs and the historical situations in which they are embedded are mirror images of form and content. The kiosk photograph situates its viewers as spectators who look in from the outside at a tantalizing array of newspapers and magazines. In 1947, the vector reverses. This time, the camera gazes out from inside the store at the curious window-shoppers. Whereas a newspaper kiosk overflowing with glossy titles suggests wealth, prosperity, and dynamism, the postwar bookstore offers a relatively modest selection of used, dusty books spread across the tabletop.

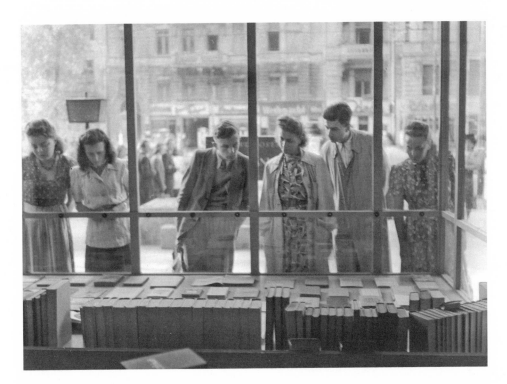

Fig. 43 Friedrich Seidenstücker, "Reges Interesse an den ersten Buchauslagen der 'Buchhandlung und Galerie Gerd Rosen' am Kurfürstendamm 215" (Brisk interest in the first window displays at Gerd Rosen's bookstore and gallery at 215 Kurfürstendamm), 1947. Berlinische Galerie, Berlin. © Bildarchiv Preußischer Kulturbesitz.

With both photographs, the captions supply crucial temporal information. In the late 1940s, Seidenstücker continued to work as a photographer in Berlin, just as he had freelanced for the illustrated press in the 1920s. His best-known postwar photographs, many of which appeared in the illustrated press, powerfully depict how war transformed the once mighty capital and paradigmatic site of modernity into a space of utter devastation. While at the surface level the 1947 photograph of the used bookstore seems merely to be an image of window-shoppers, its date makes it one those documents of ruin. It encapsulates both the continuities and radical displacements in the history of media and the history of Germany in the mid-twentieth century.

In this second photograph, the shoppers again stand before print media on sale at the establishment of Gerd Rosen, a Jewish gallery owner and seller of art books who barely survived the Holocaust. Rosen played a significant role in helping restart the trade in modernist art and art books in Berlin. His gallery was, in fact, the first gallery to open in the city following World War II.[12] But in this image, the window forms a barrier. It separates consumer goods that, in all likelihood, were relatively expensive and that the impoverished citizenry probably could not afford in a

depressed postwar economy. Moreover, the window-shoppers are noticeably women and two somewhat feminine-looking men, an unambiguous allusion to the war's emasculating demographic consequences.

In spite of the change in material circumstances, in both photographs, the readers' desire for books and magazines remains consistently healthy. Just as they did before the war, text and images together helped form the ideological matrix through which German citizens perceived, understood, and impacted their world. The illustrated magazines, books, and photographs of the 1920s and early 1930s—the photography of crisis—both fueled and, in other cases, tried to extinguish the fires of the 1940s. Today, those images remain as both documents and veterans of a pivotal historical epoch. They are crisis, photographed.

notes

Regarding translations from the German, I have generally quoted from published English translations when they were available. Unless this is noted, the English translations in the text are my own. Additionally, in the citations that follow, page numbers for newspapers and magazines are provided when known. In some instances, they were unavailable.

Introduction

1. Simmel, "Die Großstädte und das Geistesleben."

2. Cadava, *Words of Light,* xxviii.

3. "Mehr als sechs Millionen Arbeitslose," *Vossische Zeitung,* February 10, 1932.

4. "Die Revolverschlacht in Reinickendorf: Vorbereitetes politisches Attentat," *Vossische Zeitung,* January 19, 1932.

5. Witkovsky, *Foto,* 20.

6. Moholy-Nagy, "Fotografie ist Lichtgestaltung," 5.

7. Molzahn, "Nicht mehr lesen! Sehen!"

8. Renger-Patzsch, "Ziele." The quote is from Joel Agee's English translation, entitled "Aims," in Phillips, *Photography in the Modern Era,* 104–5.

9. Stetler, "Bound Vision," xviii.

10. Fulda, *Press and Politics,* 9.

11. See, for instance, the special issue of the journal *Fotogeschichte* (vol. 30, Summer 2010) dedicated to photobooks in the twentieth century. The issue examines photobooks in isolation from other photo essay forms.

12. Edlef Köppen, "Das Magazin als Zeichen der Zeit," *Der Hellweg,* June 17, 1925, 457. See also Don Reneau's English translation, entitled "The Magazine as a Sign of the Times," in Kaes, Jay, and Dimendberg, *The Weimar Republic Sourcebook,* 644–45. The essay is representative of the nine total essays in the section of this sourcebook about the visual turn.

13. Witkovsky, *Foto,* 47–48. See also Beckers and Moortgat, "Ihr Garten Eden ist das Magazin."

14. In the individual chapters of *Foto,* Witkovsky addresses some of these important topoi of interwar photography, such as recovery from war, New Women and New Men, modern living, and the spread of surrealism.

15. Witkovsky, *Foto,* 20.

16. For examples of Renger-Patzsch's commercial photography, see his photographs of Walter Gropius's Fagus shoe last factory in Alfred an der Leine. Jaeggi, *Fagus.*

17. Parr and Badger, *Photobook,* vol. 1. In a review of the first volume of Parr and Badger's work on the photobook, Herbert Molderings criticizes the book's chapter breakdown for its lack of conceptual rigor: "The classification of photobooks in nine chapters . . . does not adhere strictly to functional or theoretical categories and has more in common with a freely rambling fantasy through stock phrases of history and photo-historical 'catch words.'" See Molderings, review of *The Photobook.*

18. Parr and Badger, *Photobook,* 1:6–11.

19. Lebeck and von Dewitz, *Kiosk,* 7.

20. Gidal, *Modern Photojournalism.* See also Gidal's summary of photoreportage in *Jews in Germany,* 379.

21. See, for instance, Eskildsen, *Fotografieren hieß teilnehmen.*

22. Jennings, "Trugbild der Stabilität," 517.

23. Witkovsky, *Foto,* 100.

24. For more on the *Denkbild,* see Richter, *Thought-Images.*

25. Benjamin, "Brezel, Feder, Pause, Klage, Firlefanz," in *Gesammelte Schriften,* 4:433. The quote is from the English translation "Pretzel, Feather, Pause, Lament, Clowning" in Benjamin, *Walter Benjamin: Selected Writings,* 2:726.

26. Eco, *Open Work,* 8.

27. Davis, *Critical Excess.*

28. Mitchell, *Picture Theory*, 288–89.

29. Adorno, "Essay as Form," 3–4.

30. Rohner, *Der deutsche Essay*.

Chapter 1

1. Bertrand, "Beaumont Newhall's 'Photography 1839–1937.'"

2. See Witkovsky, *Foto*, 20.

3. Phillips, *Photography in the Modern Era*, xiii.

4. Auerbach, *Mimesis*.

5. Georg Lukács discusses the idea of "second nature" in the chapter "Reification and the Consciousness of the Proletariat" in *Geschichte und Klassenbewusstsein*. For the English translation by Rodney Livingstone, see Lukács, *History and Class Consciousness*, 86.

6. Bunnell, "Towards New Photography," 311. For general histories of pictorialism, see also Hammond, "Naturalistic Vision and Symbolist Image." For more specific histories of pictorialism in Germany, see Matthies-Masuren, *Künstlerische Photographie*, and Eskildsen and Appel, *Heinrich Kühn*.

7. Austin, *How to Do Things with Words*, 40.

8. Deutscher Werkbund, *Internationale Ausstellung des Deutschen Werkbunds*, 10.

9. Graeff, "Nach einem halben Jahrhundert," 5.

10. Graeff, *Bau und Wohnung*; Deutscher Werkbund, *Innenräume*.

11. Caws, "Poetics of the Manifesto," xx.

12. Graeff, *Es kommt der neue Fotograf!*, 4.

13. Panofsky, *Die Perspektive als "symbolische Form."* For the English translation by Christopher S. Wood, see Panofsky, *Perspective as Symbolic Form*.

14. Wood, "Perspective: An Overview."

15. Kühn, *Technik der Lichtbildnerei*, 410.

16. Simmel, "Die Großstädte und das Geistesleben"; Benjamin, "Der Flâneur," in *Gesammelte Schriften*, 1:537–69.

17. For more on the G-Group, see Mertins and Jennings, *G: An Avant-Garde Journal of Art*.

18. Graeff, *Es kommt der neue Fotograf!*, 28.

19. Buerkle, "Gendered Spectatorship, Jewish Women." See also Otto and Rocco, *New Woman International*, and Weinbaum and Modern Girl Around the World Research Group, *Modern Girl Around the World*.

20. Eskildsen, "A Chance to Participate." Ganeva's recent *Women in Weimar Fashion* also offers valuable background material on women photographers.

21. Graeff, *Es kommt der neue Fotograf!*, 47–49.

22. Ibid., 123–24.

23. See Molzahn, "Nicht mehr lesen! Sehen!," and Moholy-Nagy, "Fotografie ist Lichtgestaltung," 5.

24. Von Wilpert, *Sachwörterbuch der Literatur*, 297–98.

25. Rittelmann, "Constructed Identities," 41.

26. Benjamin, "Kleine Geschichte der Photographie," in *Gesammelte Schriften*, 2:380.

27. Bois and Hubert, "El Lissitzky."

28. Graeff, "Wir wollen nicht länger Analphabeten sein."

29. Krampen, "Icons of the Road."

30. Graeff, "Wir wollen nicht länger Analphabeten sein."

31. Hans Georg Puttnies, "Zum Tode von Werner Graeff: Es kommt der neue Fotograf," *Frankfurter Allgemeine Zeitung*, September 14, 1978.

32. Parr and Badger's two-volume *The Photobook: A History* is an important catalogue of some of the most important illustrated books, including those of the interwar period.

33. Berger, review of *Der sichtbare Mensch*, 331.

34. "*Here Comes the New Photographer!* von Werner Graeff," *Photographie für Alle*, July 15, 1929, 20.

35. Kb., review of *Es kommt der neue Photograph*."

36. Graeff, "Nach einem halben Jahrhundert," 5.

Chapter 2

1. Examples of photographers omitted from this foundational narrative include women photographers such as Else Neuländer-Simon (Yva) and Lotte Jacobi, and conservative nationalists such as Erna Lendvai-Dircksen and Heinrich Hoffmann.

2. *Der Illustrierte Beobachter*, July 1926, 2–3.

3. Molderings, "Amerikanismus und Neue Sachlichkeit," 80.

4. Witkovsky, *Foto*, 97.

5. Steinorth, "Der Weg zum Fotoessay," 13.

6. For instance, in 1886, the French photographer Nadar (Gaspard-Félix Tournachon) and his son Paul Tournachon published photographs of one-hundred-year-old chemistry professor Michel Eugène Chevreul in *Le Petit Journal illustré*. These were accompanied by an interview with the centenarian entitled "The Art of Living Longer." See "L'art de vivre cent ans: Trois entretiens avec Monsieur Chevreul," *Le Petit Journal illustré*, September 5, 1886; reprinted in Lebeck and von Dewitz, *Kiosk*, 46. Similarly, in the first decade of the twentieth century, publications such as *Collier's Weekly* and *Frank Leslie's Illustrated Newspaper* in the United States, the *Graphic* and the *Illustrated London News* in England, and *Excelsior* and *L'Illustration* in France regularly printed multiple captioned images on the same subject. These magazines all testify to the popularity of photographically illustrated media in Europe and North America. Bernd Weise has written a series of articles that trace

in detail the advances in technology, infrastructure, and commercial practices that shaped the German illustrated press. See Weise, "Pressefotografie. I," "Pressefotografie. II," "Pressefotografie. III," "Pressefotografie. IV," and "Pressefotografie. V."

7. Graeff, *Es kommt der neue Fotograf!*, 110.

8. Sontag, *On Photography*, 99.

9. Berger and Mohr, *Another Way of Telling*.

10. Molderings, "Fotografie in der Weimarer Republik," 192.

11. Petro, *Joyless Streets*, 92.

12. Sontag, *On Photography*, 99. Although gauging the precise impact of Illustrierten is impossible, Bernhard Fulda points out a common trope among interwar media critics: they shared the belief that *others* were much more strongly influenced by the modern mass media than they were themselves. Fulda, *Press and Politics*, 9.

13. Edlef Köppen, "Das Magazin als Zeichen der Zeit," *Der Hellweg*, June 17, 1925, 457. See also Don Reneau's English translation, entitled "The Magazine as a Sign of the Times," in Kaes, Jay, and Dimendberg, *The Weimar Republic Sourcebook*, 644–45.

14. See Kracauer, *Die Angestellten*, 229–30. For the English translation by Quintin Hoare, see Kracauer, *The Salaried Masses*, 38–39. *Die Angestellten* originally appeared as a twelve-part feuilleton series in the *Frankfurter Zeitung* in December 1929 and January 1930. For details on the serialized publication of *Die Angestellten*, including the exact dates of the individual feuilletons, see Levin, *Siegfried Kracauer*, 225–30.

15. In its title, the *BIZ* retained the anachronistic German spelling *Illustrirte* instead of *Illustrierte*.

16. Moholy-Nagy, "Die neue Typographie." The quote is from Sibyl Moholy-Nagy's English translation; see Moholy-Nagy, "New Typography," 21–22.

17. Moholy-Nagy, *Painting Photography Film*, 39–40.

18. Dresler, *Geschichte des "Völkischen Beobachters,"* 168.

19. The best-known counterargument to this technological optimism is Herf's *Reactionary Modernism*.

20. Gidal, *Modern Photojournalism*, 30. Stefan Lorant later criticized Gidal for having "idealized his work into 'the beginning of the history of photography.'" See Hallett, *Stefan Lorant*, 36.

21. Fritzsche, *Reading Berlin*, 1.

22. Fulda, *Press and Politics*, 3. See also Führer, "Auf dem Weg zur 'Massenkultur'?"

23. The standard histories of Weimar newspapers and magazines are de Mendelssohn's *Zeitungsstadt Berlin* and Koszyk's *Deutsche Presse*. See also Eskildsen, "Germany." Eskildsen has focused more specifically on the history of photography in Illustrierten in *Fotografie in deutschen Zeitschriften*. For more on the

tradition of nineteenth-century family magazines, see Belgum, *Popularizing the Nation*.

24. Marckwardt, *Die Illustrierten der Weimarer Zeit*, 70.

25. Marckwardt describes in detail the competitiveness of the market and documents the numbers of illustrated titles that were founded, closed, consolidated, or relaunched between 1918 and 1932. Ibid., 67–94.

26. See also the bibliography of illustrated periodicals in Lebeck and von Dewitz, *Kiosk*, 316–19.

27. Gidal, *Jews in Germany*, 374–81.

28. Korff, "Die 'Berliner Illustrirte.'" The quote is from Don Reneau's English translation, entitled "The Illustrated Magazine," in Kaes, Jay, and Dimendberg, *The Weimar Republic Sourcebook*, 646–47.

29. "Wie entsteht ein Magazin," *Literarische Welt*, July 19, 1929. Quoted in Eskildsen, *Fotografie in deutschen Zeitschriften*, 10.

30. Two recent full-length biographies of Stefan Lorant are Willimowski's *Stefan Lorant* and Hallett's *Stefan Lorant*. The subsequent biographical information about Lorant's work in the Berlin press comes from Hallett, *Stefan Lorant*, 22–32.

31. Hallett, *Stefan Lorant*, 29.

32. Newhall, *Photography*, 272–74.

33. Marckwardt, *Die Illustrierten der Weimarer Zeit*, 121.

34. Gidal, *Modern Photojournalism*, 18.

35. In *Joyless Streets*, for instance, Patrice Petro examines the role of illustrated magazines, including those specifically marketed at women (notably *Die Dame*), to argue that women responded differently to the challenges of Weimar society.

36. Dresler, *Geschichte des "Völkischen Beobachters,"* 16.

37. Four of John Heartfield's best-known photomontages appeared in the *AIZ* in the summer and autumn of 1932: "Adolf, der Übermensch: Schluckt Gold und redet Blech" [Adolf, the superman: Swallows gold and spouts rubbish], *AIZ*, July 17, 1932; "Der Sinn des Hitlergrüsses: Motto: Millionen Stehen Hinter Mir!" [The meaning of the Hitler salute: Motto: Millions are behind me], *AIZ*, October 16, 1932; "6 Millionen kommunistische Stimmen" [6 million Communists vote], *AIZ*, November 20, 1932; "Der Sinn von Genf" [The meaning of Geneva], *AIZ*, November 27, 1932. These covers and several more are reproduced in Lebeck and von Dewitz, *Kiosk*.

38. Durus [Alfred Kemény], "Fotomontage als Waffe im Klassenkampf," *Der Arbeiter-Fotograf*, March 1932, 55–57. See also Joel Agee's English translation, entitled "Photomontage as a Weapon in Class Struggle," in Phillips, *Photography in the Modern Era*, 204–6.

39. Teitelbaum, *Montage and Modern Life*, 8.

40. Ades, *Photomontage*, 45. A more recent reading of Weimar photomontage considers the work of John Heartfield, Hannah Höch, and Raoul Hausmann as models of the impact of technology on perception and as the representation of a new model of hybrid identity. See Biro, *The Dada Cyborg*.

41. See, for instance, Zervigón, "Persuading with the Unseen?," 150–52. Zervigón explores this topic in depth in *John Heartfield and the Agitated Image*. He also curated the Getty Research Institute's 2006 exhibition *Agitated Images: John Heartfield and German Photomontage, 1920–1938*; see http://getty.museum/art/exhibitions/heartfield/ (accessed July 14, 2010).

42. "Bruno Walter dirigiert" is reproduced in Eskildsen, *Fotografie in deutschen Zeitschriften*, 22.

43. Nervous gesturing is a stereotypical Jewish trait. For instance, Jean-Paul Sartre describes how he recognized a Jew by his "quick and nervous gestures." Sartre, *Anti-Semite and Jew*, 63.

44. "Mussolini bei der Arbeit," *Münchner Illustrierte Presse*, March 1, 1931. Quoted in Eskildsen, *Fotografie in deutschen Zeitschriften*, 12.

45. Other well-known photojournalists, none of them trained press photographers, included Wolfgang Weber, Walter Bosshard, Otto Umbehr (Umbo), Martin Munkácsi, and the brothers Tim and Georg Gidal. See Gidal, *Modern Photojournalism*, 26–27 (for descriptions of these photographers' main interests) and 91–93 (for their biographies).

46. Molderings, "Eine Schule der modernen Fotoreportage."

47. Kisch, *Der rasende Reporter*. In a well-known photomontage from 1926 that shared the title of Kisch's book, Umbo depicted Kisch as a cyborg with a human head and a mechanical body. The machine body was equipped with a built-in camera lens for an eye, a phonograph horn in place of an ear, and an airplane and race car in lieu of feet. See Witkovsky, *Foto*, 104–5.

48. For instance, for all of Stefan Lorant's significance in the field of photojournalism, his papers at the Getty Research Institute in Los Angeles consist mainly of postwar correspondence and materials related to the many illustrated books he published later in life. Many of Lotte Jacobi's negatives were also lost during her hasty flight from Germany. See Beckers and Moortgat, *Lotte Jacobi*, 132–34.

49. Scott, *Spoken Image*, 186.

50. In *Kiosk*, Lebeck and von Dewitz reproduce photo stories in isolation, without the context of the serialized novels, advertisements, and other features among which they appeared. Eskildsen takes a similar approach in her analysis of Illustrierten in *Fotografie in deutschen Zeitschriften*.

51. Beaton, *Wandering Years*.

52. Among the best recent biographies of Stresemann is Jonathan Wright's *Gustav Stresemann*.

53. "Das Ende . . . , " *Der Illustrierte Beobachter*, October 12, 1929, 532.

54. "Bilder der Woche," *Arbeiter Illustrierte Zeitung*, October 12, 1929, 2.

55. Auer, *Fotographie im Gespräch*, 114.

56. "Die Duncan-Schule bei Salzburg," *Münchner Illustrierte Presse*, October 13, 1929.

57. Toepfer, *Empire of Ecstasy*, 98.

58. Kaes, Jay, and Dimendberg, *The Weimar Republic Sourcebook*, 673–75.

59. On pictorialism in Germany, see Matthies-Masuren, *Künstlerische Photographie*.

60. Hallett, *Stefan Lorant*, 39.

61. "Die Wahrheit über Dachau," *Münchner Illustrierte Presse*, July 16, 1933. See also Ute Wrocklage's presentation at the Fondation pour la Mémoire de la Shoah, "The 'Einmagazinierung' of Concentration Camps."

62. Sachsse, *Die Erziehung zum Wegsehen*.

63. Köppen, "Das Magazin als Zeichen der Zeit." The quote is from Reneau's translation in Kaes, Jay, and Dimendberg, *The Weimar Republic Sourcebook*, 645.

64. Thomas Mann, review of *Die Welt ist schön*, *Berliner Illustrirte Zeitung*, December 23, 1928, 1261.

65. Robert Breuer, "Grüne Architektur," *Uhu*, June 1926, 28–38.

Chapter 3

1. Hau, *Cult of Health and Beauty*, 1.

2. Williams, *Turning to Nature in Germany*. Williams offers a corrective to the work of George Mosse and Hans Kohn, specifically their tendency to condemn back-to-nature movements in early twentieth-century Germany as "antirationalist, antimodern, and illiberal" (ibid., 4).

3. Batchen, *Burning with Desire*, 101.

4. Sander, "Wesen und Werden der Photographie III."

5. Kracauer, *Mass Ornament*, 5.

6. Reitter, *Anti-journalist*, 1.

7. Ibid., 6, 59.

8. Roth, *Briefe*, 87–89.

9. Ward, *Weimar Surfaces*, 8.

10. Stetler, "Bound Vision," 203.

11. Dobe, *Wilde Blumen der deutschen Flora*, 5, 7–8.

12. Ibid., book jacket.

13. Ibid., 5.

14. Ibid., 8.

15. Stapel, "Blumen und Tiere in Bildern," 479.

16. Stapel, "Der Geistige und sein Volk." Reproduced in Kähler, *Berlin*, 88–99, and excerpted (in translation) in Kaes, Jay, and Dimendberg,

The Weimar Republic Sourcebook, 423–25. See also Wilhelm von Schramm, "Berlin als geistiger Kriegsschauplatz," *Süddeutsche Monatshefte*, April 1931, 513–18.

17. Stapel, "Der Geistige und sein Volk," 7–8. These lines appear in translation in Kaes, Jay, and Dimendberg, *The Weimar Republic Sourcebook*, 424–25.

18. Stapel, "Der Geistige und sein Volk," 5. See also Frecot and Sembach, *Berlin im Licht*.

19. Stapel, "Der Geistige und sein Volk," 7.

20. Spengler, *Der Untergang des Abendlandes*. Chapter 4 discusses Spengler's theories of culture in greater detail.

21. Stapel, review of *Aus zoologischen Gärten*. See Wolff, *Aus zoologischen Gärten*.

22. Stapel, "Blumen und Tiere in Bildern."

23. Ibid., 479.

24. See, for instance, Traeger, *Philipp Otto Runge und sein Werk*.

25. Stapel, "Blumen und Tiere in Bildern," 479.

26. Serner, *Letzte Lockerung*. This how-to guide describes specific tactics that the modern individual must use to survive in the cold modern world. See also Lethen, *Verhaltenslehre der Kälte*. Lethen interprets the "coldness" of New Objectivity as a response to the perceived need after World War I for a code of conduct.

27. Victor Auburtin, "Erste Eindrücke in Berlin: Von einem Auslandsdeutschen," *Berliner Tageblatt*, October 16, 1927. This essay is reprinted in Jäger and Schütz, *Glänzender Asphalt*, 22–23.

28. Georg Simmel addresses this attitude in the seminal essay "Die Großstädte und das Geistesleben" ("The Metropolis and Mental Life"). As its synesthetic title suggests, Walter Ruttmann's 1927 avant-garde documentary *Berlin: Symphonie einer Großstadt* interprets the city's myriad sense impressions more positively, as a kind of music.

29. Von Ankum, *Women in the Metropolis*, 1, 11. See also Veth, "Literatur von Frauen," 464–68.

30. Keun, *Das kunstseidene Mädchen*. The quote is from Kathie von Ankum's English translation; see Keun, *The Artificial Silk Girl*, 55.

31. Hamsun, *Mysterien*; Ganghofer, *Der Jäger von Fall*; Frenssen, *Jörn Uhl*.

32. Haß, "Vom 'Aufstand der Landschaft gegen Berlin.'"

33. Von Schramm, "Berlin als geistiger Kriegsschauplatz."

34. Ignaz Wrobel [Kurt Tucholsky], "Berlin und die Provinz," *Die Weltbühne*, March 13, 1928, 405–8. The quote is from the English translation "Berlin and the Provinces" in Kaes, Jay, and Dimendberg, *The Weimar Republic Sourcebook*, 420.

35. Peter Panter [Kurt Tucholsky], "Neues Licht: Die Photo-Sammlung 'Das deutsche Lichtbild,'" *Vossische Zeitung*, March 4, 1928.

36. Auburtin, "Erste Eindrücke in Berlin."

37. Spengler, *Der Untergang des Abendlandes*, 1:10. The quote is from Charles Francis Atkinson's English translation; see Spengler, *Decline of the West*, 1:10.

38. Spengler, *Der Untergang des Abendlandes*, 1:142. The quote is from Spengler, *Decline of the West*, 1:106.

39. Weber, "Die protestantische Ethik und der 'Geist' des Kapitalismus I"; Weber, "Die protestantische Ethik und der 'Geist' des Kapitalismus II." For the English translation of these essays by Talcott Parsons, see Weber, *The Protestant Ethic and the Spirit of Capitalism*. See also Tiryakian, "Sociological Import of a Metaphor."

40. Albert Renger-Patzsch, "Ketzergedanken über künstlerische Photographie." The quote is from Virginia Heckert's English translation; see Renger-Patzsch, "Heretical Thoughts on Artistic Photography," 179.

41. Renger-Patzsch, "Ein Vortrag, der nicht gehalten wurde."

42. Albert Renger-Patzsch to Dr. Walter Hans, November 26, 1957, Albert Renger-Patzsch Collection, Getty Research Center, box 4, folder 47.

43. Klingbeil, *Die Bilder wechseln*, 38–39; Starl, "Die Bildbände der Reihe 'Blauen Bücher.'"

44. Benjamin, "Der Autor als Produzent," in *Gesammelte Schriften*, 2:683–701. See also Rodney Livingstone's English translation, entitled "The Author as Producer," in Benjamin, *Walter Benjamin: Selected Writings*, 2:768–82.

45. Hirsch, *Family Frames*.

46. Grossman, *Reforming Sex*.

47. Jennings, "Agriculture, Industry," 54.

48. Simms, "Just Photography."

49. Jaeggi, *Fagus*, 114–18. Jaeggi stresses the importance of Renger-Patzsch's images in promoting a new way to look at and interpret the Fagus Factory's Bauhaus architecture. She notes, moreover, that only one of his photographs has been documented as actually having been used in an advertising brochure.

50. Albert Renger-Patzsch, "Einiges über Hände und Händeaufnahmen," 177–78.

51. Novalis, *Heinrich von Ofterdingen*.

52. Benjamin, "Traumkitsch," in *Gesammelte Schriften*, 2:620–22. The quote is from Rodney Livingstone's English translation, entitled "Dream Kitsch: Gloss on Surrealism," in Benjamin, *Walter Benjamin: Selected Writings*, 2:3.

Chapter 4

1. On the broader history of the physiognomic revival in Weimar Germany, see the essays in Schmölders and Gilman, *Gesichter der Weimarer Republik*.

2. Gray, *About Face*, 180–81.

3. Schmölders, *Das Vorurteil im Leibe.* Schmölders's book includes a collection of sources that trace the physiognomic tradition through German intellectual history back to antiquity. See also Weingart, *Doppel-Leben.*

4. Koonz, *The Nazi Conscience*, 1–3.

5. Some of the leading late nineteenth- and early twentieth-century writers in Germany who advocated physiognomy—notably Alfred Ploetz, Wilhelm Schallmayer, and Alfred Grotjahn—were Socialists and even Communists. See Campe and Schneider, *Geschichten der Physiognomik*, and Grotjahn, *Sociale Pathologie.*

6. In *Defenders of the Race*, John M. Efron examines the curious history of Jewish race scientists. As further evidence that physiognomic discourses did not break down according to easy dichotomies, Claudia Koonz notes that even the key racial theorist Ludwig Ferdinand Clauss falsified racial identity papers to protect a Jewish co-worker. See Koonz, *Nazi Conscience*, 263–64.

7. Schmölders and Gilman's *Gesichter der Weimarer Republik* contains an extensive bibliography of physiognomy-themed articles, books, and periodicals from the Weimar era (and beyond); see 302–11.

8. Lethen, "Neue Sachlichkeit," 176.

9. Hake, "Zur Wiederkehr des Physiognomischen in der modernen Photographie," 477.

10. For histories of photographic portraiture and its relationship to physiognomy in this time period, see Gray, *About Face*, esp. 351–80, and Brückle, "Kein Portrait mehr?"

11. Uecker, "Face of the Weimar Republic," 472.

12. Lendvai-Dircksen, *Das Deutsche Volksgesicht.*

13. For more on the background of the politics of photographic physiognomies, see Rittelmann, "Facing Off." See also Pepper Stetler's analysis of *Köpfe des Alltags* in "Bound Vision," 295–327, as well as Eskildsen and Horak's exhibition catalogue *Helmar Lerski, Lichtbildner.*

14. Two scholarly editions of Sander's larger project exist. The 1981 edition, *Menschen des 20. Jahrhunderts: Portraitphotographien von 1892–1952*, was edited by Gunther Sander and contains a magisterial introduction by Ulrich Keller. Subsequent references to Ulrich Keller's introduction cite Linda Keller's translation in the 1986 English edition; see Keller, introduction to *Citizens of the Twentieth Century.* More recently, the August Sander Archiv in Cologne produced a new scholarly edition of Sander's work; see Sander, *Menschen des 20. Jahrhunderts: Die Gesamtausgabe.*

15. Keller, introduction to *Citizens of the Twentieth Century*, 23–35. Keller discusses the technical aspects

of Sander's approach in detail and situates his work within late nineteenth- and early twentieth-century cultural and art historical contexts.

16. Remarkable for its breadth of interests, the Rhineland art circle of 1920s Cologne included painters (Franz Wilhelm Seiwert, Anton Räderscheidt, Heinrich Hoerle), sculptors (Hans Schmitz, Ingeborg von Rath), musicians (Paul Hindemith, Hermann Abendroth, Emanuel Feuermann, Willy Lamping), writers (Otto Brües, Ludwig Mathar, Theodor Haerten, Paul Bourfeind, Dettmar Heinrich Sarnetzki), architects (Fritz August Breuhaus de Groot, Wilhelm Riphahn), actors (Rosy Bársony, Tony van Eyck, Paul Kemp), and even a famous philosopher (Max Scheler). See also Die Photographische Sammlung, SK Stiftung Kultur, *Zeitgenossen.*

17. Michalski, *Neue Sachlichkeit*, 113–19.

18. Ibid., 188.

19. Gronert, *Die Düsseldorfer Photoschule.*

20. Holz, *Deutsche Menschen.* Scholars often refer to this work by its German title, *Deutsche Menschen*, because of the multiple connotations of *Mensch* aside from just people. In this chapter, I use the same title as the recent English translation of this work in Benjamin, *Walter Benjamin: Selected Writings*, 3:167–235—namely, *German Men and Women.*

21. Brodersen, *Spinne im eigenen Netz*, 240–47.

22. See, for instance, Lange, "Ein Bekenntnis zur Photographie," 16. See also Keller, introduction to *Citizens of the Twentieth Century*, esp. 36–55.

23. Among the notable exceptions are Stetler, "Bound Vision"; Rittelmann, "Constructed Identities"; and Jennings, "Agriculture, Industry."

24. Hahn and Wizisla, *Walter Benjamins "Deutsche Menschen."*

25. Author's personal correspondence with Gerd Sander, August 6, 2002.

26. One prime example of this approach is Becker's "Passagen und Passanten." Becker does not mention *German Men and Women* at all.

27. Richter, *Thought-Images.* Richter's book is the most recent English-language title that surveys the literary genre of the *Denkbild.* For a broader discussion of the significance of photography in Benjamin's thought, see Cadava, *Words of Light.*

28. Keller, introduction to *Citizens of the Twentieth Century*, 50. Leo Rubinfien makes a similar argument in "The Mask Behind the Face."

29. Benjamin, "German Letters," in *Walter Benjamin: Selected Writings*, 2:266–68.

30. Spengler, *Der Untergang des Abendlandes.* All subsequent citations are to the English translation of this work by Charles Francis Atkinson; see Spengler, *Decline of the West.*

31. Farrenkopf, *Prophet of Decline*, 30.

32. The most famous examination of this trend is Fritz Stern's *Politics of Cultural Despair*.

33. Weitz, *Weimar Germany*, 334.

34. Spengler, *Decline of the West*, 101.

35. Ibid., 100.

36. Farrenkopf discusses the history of these controversies in his chapter "The Decline of the West: A Controversy Without End" in *Prophet of Decline*, 100–112.

37. Keller, introduction to *Citizens of the Twentieth Century*, 38–39.

38. Spengler, *Decline of the West*, 6–7. See also Gray, *About Face*, 183.

39. The title of the lecture series might also be translated as "The Being and Becoming of Photography."

40. Sander, "Wesen und Werden der Photographie V." For the English translation by Anne Halley, see Sander, "Lecture 5."

41. In "On the Invention of Photographic Meaning," Alan Sekula makes precisely the opposite claim. He cites an anecdotal report by the anthropologist Melville Herskovits. Herskovits showed a Bushwoman a photograph of her own son, but she failed to recognize it as a representation of her child until this fact was pointed out to her. Whereas Sander argues for a universal photographic literacy, Sekula contests its existence.

42. Sander, "Lecture 5," 678.

43. Ibid.

44. Ibid, 675.

45. Döblin, "Faces, Images and Their Truth," 15.

46. Ibid., 14.

47. For more on the reception of *Face of Our Time*, see Keller's introduction to Sander, *Menschen des 20. Jahrhunderts: Portraitphotographien von 1892–1952*, 66–69. For an English translation, see Keller, introduction to *Citizens of the Twentieth Century*, 54–55.

48. Döblin, "Faces, Images and Their Truth," 13

49. The German descriptions of the seasons in these paragraphs are from table 1 in Spengler, *Der Untergang des Abendlandes*. The English translations are from Spengler, *Decline of the West*.

50. Keller, introduction to *Citizens of the Twentieth Century*, 39–41.

51. See Jensen, *Body by Weimar*. Jensen argues that "sportswomen and men embodied modernity—quite literally—in all of its competitive, time-oriented excess and thereby helped to popularize, and even to naturalize, the sometimes threatening process of economic rationalization by linking it to their own personal success stories." See also Herbert Jhering, "Boxen," *Das Tagebuch* 8 (1927), in Kaes, Jay, and Dimendberg, *The Weimar Republic Sourcebook*, 587–89.

52. Buerkle, "Gendered Spectatorship, Jewish Women." See also Otto and Rocco, *New Woman International*, and Weinbaum and Modern Girl Around the World Research Group, *Modern Girl Around the World*.

53. For more on the relationship between August Sander and Walter Benjamin, see Becker, "Passagen und Passanten."

54. Benjamin, "Little History of Photography" in *Walter Benjamin: Selected Writings*, 2:520.

55. Brodersen, "Die Entstehung der *Deutschen Menschen*," 11. Brodersen also discusses several other anthologies and physiognomic projects that did not come to fruition.

56. Ibid., 13–16.

57. Benjamin, "On the Trail of Old Letters," in *Walter Benjamin: Selected Writings*, 3:557. See also Andreas and von Scholz, *Die Grossen Deutschen*; Emil Ludwig, *Goethe*; Ludwig, *Bismarck*; Ludwig, *Wilhelm der Zweite*; and Ludwig, *Hindenburg und die Sage von der deutschen Republik*.

58. Oesterle, "Erschriebene Gelassenheit," 95.

59. Diers, "Einbandlektüre, fortgesetzt," 23–44.

60. Benjamin, *German Men and Women*, in *Walter Benjamin: Selected Writings*, 3:168. On Goethe's significance for *German Men and Women* and for Benjamin in general, see Villwock, "Goethe in Benjamins Briefe-Projekt," 157–75.

61. Günter Oesterle isolates and catalogues the humanistic emotions, sentiments, and linguistic "gestures" of each of the twenty-five letters. Oesterle, "Erschriebene Gelassenheit," 102–3.

62. Benjamin, *German Men and Women*, 3:168.

63. Benjamin, "German Letters," 2:466.

64. See note 7, above.

65. Benjamin, *German Men and Women*, 3:180.

66. Benjamin, "Bücher, die übersetzt werden sollten," in *Gesammelte Schriften*, 3:178.

67. Oesterle, "Erschriebene Gelassenheit," 102–3.

68. Dingwerth, *Die Geschichte der deutschen Schreibmaschinen-Fabriken*, 257.

69. Benjamin, *German Men and Women*, 3:175–76.

70. Ludwig Klages's most significant works on graphology include *Der Geist als Widersacher der Seele* and *Graphologie, mit 81 Schriftproben*.

71. Benjamin, "Review of *Der Mensch in der Handschrift* by Anja and Georg Mendelssohn," in *Walter Benjamin: Selected Writings*, 2:131–34.

72. Benjamin, "On the Mimetic Faculty," in *Walter Benjamin: Selected Writings*, 2:722.

73. Benjamin, *German Men and Women*, 3:211.

74. Grimm and Grimm, *Deutsches Wörterbuch*, 1:lxviii. Quoted in Benjamin, *German Men and Women*, 3:210.

75. Klemperer, *LTI.* Klemperer documents the German language's decay into nationalistic cliché during the Third Reich.

76. Jennings, "Agriculture, Industry." Jennings reads photo essays by Alfred Renger-Patzsch, August Sander, Franz Roh, and Jan Tschichold as specific arguments about the changing relationship of nature and technology in the late 1920s.

77. Walter, *Arcades Project,* 100, 386, 806. See also Benjamin, "Brecht's *Threepenny Novel,*" in *Walter Benjamin: Selected Writings,* 3:8.

78. McFarland, "Die Kunst, in anderer Leute Köpfe zu denken," 121–23.

79. Fritzsche, *Life and Death in the Third Reich.* Fritzsche's work is a history of the Nazified concept of the *Volksgemeinschaft,* or racially based community.

80. Mattenklott, "Benjamin als Korrespondent."

81. Wizisla, "'Plaquette für Freunde,'" 56–62. In this section of his essay, Wizisla reconstructs the history of the dedications that Benjamin wrote to friends and colleagues in individual copies of the book.

82. Benjamin, *German Men and Women,* 3:167.

83. Michael W. Jennings, "Chronology, 1935–1938," in Benjamin, *Walter Benjamin: Selected Writings,* 3:431.

84. Benjamin, *German Men and Women,* 3:170.

85. Jennings, "Chronology, 1935–1938," 3:431.

86. Lange, "Ein Bekenntnis zur Photographie," 23.

87. The book series was published by the Düsseldorf publisher Schwann until 1933. In 1934, the series title was changed to include the more nationalistic word *Volk,* and the publisher changed to Holzwarth in Bad Rothenfelde. For more on this landscape series, see Sander, *Landschaften.*

88. "August Sander photographiert: Deutsche Menschen," *DU: Kulturelle Monatsschrift,* November 1959.

89. Author's personal correspondence with Gerd Sander, August 6, 2002.

90. Ibid.; author's personal correspondence with Ulrich Keller, May 22, 2000. Keller, who edited the first major edition of *Menschen des 20. Jahrhunderts,* bases this insight on his discussions with August Sander's son Gunther, with whom he worked to prepare this scholarly reconstruction.

Chapter 5

1. Weitz, *Weimar Germany,* 333.

2. Jaspers, *Psychologie der Weltanschauungen,* 111.

3. There are, of course, many other examples aside from these obvious ones. Library catalogue searches that use any of these fraught terms generate dozens of fiction and nonfiction titles from the Weimar era.

4. Spengler, *Jahre der Entscheidung,* vii.

5. Schmitt, *Der Begriff des Politischen.* For the English translation by George Schwab, see Schmitt, *Concept of the Political.* See also *Routledge Encyclopedia of Philosophy,* s.v. "Schmitt, Carl (1888–1985)," and Ritter, "Dezision, Dezisionismus."

6. Lion Feuchtwanger, "Wie kämpfen wir gegen ein Drittes Reich?" *Welt am Abend,* January 21, 1931. See also Don Reneau's English translation, entitled "How Do We Struggle Against a Third Reich?," in Kaes, Jay, and Dimendberg, *The Weimar Republic Sourcebook,* 167.

7. In a recent article, An Paenhuysen argues that this "picture-book" by Tucholsky and Heartfield not only criticized militarism, right-wing nationalism, democracy, and capitalism, but also reflected Tucholsky's increasing frustration with the reductionistic aspects of urban modernity. Paenhuysen, "Kurt Tucholsky, John Heartfield."

8. This crisis rhetoric also influenced subsequent scholarship. Although dozens of works about Weimar Germany foreground "crisis"—perhaps most notably Peukert's *Die Weimarer Republik*—recent scholarship is historicizing and ultimately demythologizing the Weimar Republic as solely a crisis period, or at least removing the stigma of crisis as necessarily negative. See, for instance, Föllmer and Graf's essay collection *Die "Krise" der Weimarer Republik.*

9. Jenkins, *Images and Enterprise.* See in particular chapter 3, "The Gelatin Revolution, 1880–95" (66–95), and chapter 4, "Origins of the Roll Film System, 1884–89" (96–121).

10. Keller, "Photojournalism Around 1900," 290.

11. Stenger, *Die Geschichte der Kleinbildkamera bis zur Leica,* 55–57.

12. Gernsheim, *Creative Photography,* 209.

13. Herf, *Reactionary Modernism,* 1.

14. For extensive biographical material on Erich Salomon, see Barents, "Dr. Erich Salomon." The exhibition catalogue *Erich Salomon,* by Janos Frecot, also contains extensive background information about Salomon and his family and a timeline of Salomon's life and work.

15. Pulzer, *Rise of Political Anti-Semitism,* 13. Paul Reitter also examines the history of the perception of Jewish influence in German-language journalism in *Anti-Journalist,* 5–12.

16. Gidal, *Jews in Germany,* 378–81.

17. "Es ist nicht einzusehen, warum der Bildberichterstatter dem Textberichterstatter gegenüber benachteiligt werden soll." Salomon, *Berühmte*

Zeitgenossen in unbewachten Augenblicken, 7. All citations to this source refer to the 1978 reprint.

18. "So sehr sich die Zeitungen in bezug auf ihre Leitartikel, ihre Feuilletons, ja selbst ihre Tatsachenberichte unterscheiden, so einheitlich wirken sie in bezug auf ihren Bilderteil." Schultz, *Die veränderte Welt 1918–1932,* 5–6.

19. A thorough bibliography of Ernst Jünger's voluminous output (and relevant secondary material) is available in Martus, *Ernst Jünger,* 239–64.

20. Describing Friedrich's *Krieg dem Kriege!,* Susan Sontag wrote, "This is photography as shock therapy: an album of more than one hundred and eighty photographs mostly drawn from German military and medical archives, many of which were deemed unpublishable by government censors while the war was still on." Sontag, *Regarding the Pain of Others,* 14–15, quote on 14.

21. Encke, *Augenblicke der Gefahr,* 10. See also the special issue of *New German Critique* dedicated to Ernst Jünger (vol. 59, Spring/Summer 1993).

22. Bucholtz, *Der gefährliche Augenblick,* book jacket.

23. Martus, *Ernst Jünger,* 62–67.

24. See Jünger, *Der Arbeiter,* and Kaes, "Cold Gaze."

25. Jünger, "Über die Gefahr," 11–16.

26. Jünger, *Das abenteuerliche Herz.*

27. Bucholtz, *Der gefährliche Augenblick,* 5.

28. Jünger, "Über den Schmerz." The quote is from Joel Agee's English translation, entitled "Photography and the 'Second Consciousness': An Excerpt from 'On Pain,'" in Phillips, *Photography in the Modern Era,* 208.

29. Jünger, "Über die Gefahr," 11. The quote is from Don Reneau's English translation; see Jünger, "On Danger," 27.

30. Jünger, "Über die Gefahr," 12.

31. Bullock, *Violent Eye,* 101. In *Die Ästhetik des Schreckens,* Karl Heinz Bohrer has articulated a view of Jünger that separates aesthetics and politics.

32. Bucholtz, *Der gefährliche Augenblick,* 73–86. The article was originally published as Major H. O. D. Segrave, "Wie ich den Weltgeschwindigkeitsrekord im Autofahren brach," *Automagazin,* September 1928.

33. Marcel Wallenstein, "Shoots His Racing Car at a Target," *Popular Science,* January 1929, 22, 152.

34. Bucholtz, *Der gefährliche Augenblick,* 85.

35. Wood, "Breaking 100 on Water," 140.

36. Bucholtz, *Der gefährliche Augenblick,* 102–14. For the original text from which the essay was excerpted, see Mitchell-Hedges, *Battles with Giant Fish.*

37. Bucholtz, *Der gefährliche Augenblick,* 110–11. Compare the bullfighting images from the photo story "Ein Barbarischer Sport: Bilder aus einer spanischen Stierkampf-Arena," *Berliner Illustrirte Zeitung,* January 30, 1921, 60.

38. Bucholtz, *Der gefährliche Augenblick,* 119.

39. Ibid., 179.

40. Ibid., 188–99.

41. Ibid., 186–87.

42. Salomon, *Berühmte Zeitgenossen in unbewachten Augenblicken,* 7.

43. Several factors account for the rise of "objectivity" as a key goal of modern journalism, including nineteenth-century positivism, the rise of journalism schools and journalism as a profession, and contemporaries who stressed the media's role in liberal democracy. Stephen J. Ward historicizes the concept of "journalistic objectivity" in *Invention of Journalism Ethics.*

44. Freund, *Photographie und Gesellschaft,* 126.

45. Quoted in Lebeck and von Dewitz, *Kiosk,* 112.

46. Parr and Badger, *Photobook,* 1:131.

47. Vaisse, "Portrait of Society," 500.

48. Vital, *A People Apart,* 826.

49. Schmölders, "Der sanfte Jäger," 24–25.

50. The photographs in the exhibition catalogue *Erich Salomon: "Mit Frack und Linse durch Politik und Gesellschaft" Photographien 1928–1938,* edited by Janos Freçot, encompass a much broader time span than *Famous Contemporaries.* Nevertheless, the chapter organization of this catalogue attests to Salomon's consistent interest in certain themes throughout his career, most of which feature prominently in *Famous Contemporaries,* including group pictures of politicians, judicial scenes, orators and their audiences, and conductors.

51. See ibid. Frecot's exhibition catalogue includes several photographs that, judging from their dates, Salomon could have but did not include in *Famous Contemporaries.* Among them are "Die Linke im Reichstag: Blick auf die Bänke der Kommunisten" (The left in the Reichstag: A glance at the Communists' benches, 1928) and "Nationalsozialisten in Parteiuniform im Reichstag 30.10.1930" (National Socialists in party uniform in the Reichstag, October 30, 1930).

52. Salomon, *Berühmte Zeitgenossen in unbewachten Augenblicken,* 21.

53. Freund, *Photographie und Gesellschaft,* 126.

54. Frecot, *Erich Salomon,* 186.

Epilogue

1. Rittelmann, "Constructed Identities," 276.

2. See, for instance, Elsaesser, "Moderne und Modernisierung." This observation comes from

a revised version of "Moderne und Modernisier-
ung" that Elsaesser delivered on the occasion of
the retrospective Cinema Tedesco dalle origine al
Terzo Reich, on October 23, 1993, in Pesaro, Italy.
The text is available at http://home.hum.uva.nl/oz/
elsaesser/essay-Nazi%20Modernity.pdf (accessed
July 14, 2010), 1–2.

 3. Kasher, *"Das Deutsche Lichtbild."*

 4. Sachsse, *Die Erziehung zum Wegsehen.*

 5. Scharfe, *Deutsche Dorfkirchen*; Winning,
Der deutsche Ritterorden und seine Burgen; Thiede, *Deutsche
Bauernhäuser.*

 6. *Die schöne Heimat.* These figures derive from
the numbers listed in reprints. The 1954 edition,
for instance, numbered 433,000–447,000 copies.

 7. See Gray, *About Face*, esp. 273–301. Gray dis-
cusses different approaches to racial science in Nazi
Germany, notably Günther's "natural-scientific
orientation" and Clauss's "psychological direction."
Both authors published voluminously on race, and
many of their books included portraits of different
racial types.

 8. See also Liulevicius, *German Myth of the East.*
Liulevicius traces the mythologizing of the image
of "the East" in German history. Lendvai-Dircksen
participated very directly in this discourse.

 9. Lendvai-Dircksen, *Das germanische Volksgesicht:
Flandern*; Lendvai-Dircksen, *Das germanische Volksesicht:
Dänemark*; Lendvai-Dircksen, *Das germanische Volksgesicht:
Tirol und Vorarlberg.*

 10. See Herz, *Hoffmann und Hitler,* 244.

 11. Kershaw, *The Hitler Myth.*

 12. For more on Gerd Rosen and his gallery,
see Krause, *Galerie Gerd Rosen.*

bibliography

Illustrated Magazines

Arbeiter Illustrierte Zeitung (Berlin, 1925–33)
Berliner Illustrirte Zeitung (Berlin, 1891–1945)
Die Dame (Berlin, 1912–43)
Hamburger Illustrierte Zeitung (Hamburg, 1918–44; *Hamburger Illustrierte* after 1929)
Der Illustrierte Beobachter (Munich, 1926–45)
Das Illustrierte Blatt (Frankfurt, 1913–44; *Frankfurter Illustrierte Zeitung* after 1929)
Kölnische Illustrierte Zeitung (Cologne, 1926–44)
Münchner Illustrierte Presse (Munich, 1923–44)
Uhu: Das neue Ullsteinmagazin (Berlin, 1924–34)
Volk und Zeit (Berlin, 1919–33)
Der Welt-Spiegel (Berlin, 1899–1939)
Die Woche (Berlin, 1899–1944)

Other Sources

Ades, Dawn. *Photomontage.* London: Thames and Hudson, 1986.
Adorno, Theodor W. "The Essay as Form." In *Notes to Literature*, vol. 1, translated by Shierry Weber Nicholsen, 3–23. New York: Columbia University Press, 1991.
Andreas, Willy, and Wilhelm von Scholz, eds. *Die Grossen Deutschen.* Berlin: Ullstein, 1935/36–57.
Auer, Anna. *Fotographie im Gespräch.* Passau: Dietmar Klinger Verlag, 2001.
Auerbach, Erich. *Mimesis: Dargestellte Wirklichkeit in der abenländischen Literatur.* Bern: A. Francke Verlag, 1946.
Austin, J. L. *How to Do Things with Words.* Oxford: Clarendon, 1962.
Barents, Els. "Dr. Erich Salomon (1886–1944)." In *Dr. Erich Salomon 1886–1944: Aus dem Leben eines Fotografen*, edited by Els Barents and

W. H. Roobol, 9–34. Munich: Schirmer/Mosel, 1981.
Bartels, Karl Otte. *Blüte und Frucht im Leben der Bäume.* Königstein im Taunus: Langwiesche, 1930.
Barthes, Roland. "The Photographic Message." In *Image, Music, Text*, translated by Stephen Heath, 15–31. New York: Hill and Wang, 1977.
Batchen, Geoffrey. *Burning with Desire: The Conception of Photography.* Cambridge, Mass.: MIT Press, 1997.
Beaton, Cecil. *The Wandering Years: Diaries, 1922–1939.* London: Weidenfeld and Nicholson, 1961.
Becker, Jochen. "Passagen und Passanten: Zu Walter Benjamin und August Sander." *Fotogeschichte* 8, no. 32 (1989): 37–48.
Beckers, Marion, and Elisabeth Moortgat. "Ihr Garten Eden ist das Magazin: Zu Bildgeschichten von Yva im UHU 1930–1933." In *Fotografieren hieß teilnehmen: Fotografinnen der Weimarer Republik*, edited by Ute Eskildsen, 239–49. Düsseldorf: Richter, 1994.
———, eds. *Lotte Jacobi: Berlin, New York.* Berlin: Nicolai, 1998.
Belgum, Kirsten. *Popularizing the Nation: Audience, Representation, and the Production of Identity in "Die Gartenlaube," 1853–1900.* Lincoln: University of Nebraska Press, 1998.
Benjamin, Walter. *The Arcades Project.* Translated by Howard Eiland and Kevin McLaughlin. Cambridge, Mass.: Harvard University Press, 1999.
———. *Gesammelte Schriften.* Edited by Rolf Tiedemann and Hermann Schweppenhäuser. 7 vols. Frankfurt: Suhrkamp, 1991.
———. *Walter Benjamin: Selected Writings.* Vol. 2, *1927–1934.* Edited by Michael W. Jennings. Cambridge, Mass.: Harvard University Press, 1999.

———. *Walter Benjamin: Selected Writings*. Vol. 3, *1935–1938*. Edited by Howard Eiland and Michael W. Jennings. Cambridge, Mass.: Harvard University Press, 2002.

———. *Walter Benjamin: Selected Writings*. Vol. 4, *1938–1940*. Edited by Howard Eiland and Michael W. Jennings. Cambridge, Mass.: Harvard University Press, 2003.

Berger, Jean, and Jean Mohr. *Another Way of Telling*. New York: Vintage International, 1995.

Berger, Klaus. Review of *Der sichtbare Mensch: Eine Film-dramaturgie*, 2nd ed., by Béla Balázs; *Filmregie und Filmmanuskript*, by Wladimir Pudowkin; *Der kommende Film*, by Guido Bagier; *Malerei, Photographie [sic], Film*, by László Moholy-Nagy; *Die Welt ist schön*, by Albert Renger-Patzsch; *Filmgegner von heute—Filmfreunde von morgen*, by Hans Richter; *Es kommt der neue Photograph! [sic]*, by Werner Gräf [sic]. *Zeitschrift für Ästhetik und Allgemeine Kunstwissenschaft* 24, no. 1 (1930): 328–31.

Bertrand, Allison. "Beaumont Newhall's 'Photography 1839–1937': Making History." *History of Photography* 21, no. 2 (1997): 137–46.

Biro, Matthew. *The Dada Cyborg: Visions of the New Human in Weimar Berlin*. Minneapolis: University of Minnesota Press, 2009.

Blossfeldt, Karl. *Urformen der Kunst: Photographische Pflanzenbilder*. Edited with an introduction by Karl Nierendorf. Berlin: E. Wasmuth, 1928.

Bohrer, Karl Heinz. *Die Ästhetik des Schreckens: Die pessimistische Romantik und Ernst Jüngers Frühwerk*. Munich: Carl Hanser, 1978.

———. *Plötzlichkeit: Zum Augenblick des ästhetischen Scheines*. Frankfurt: Suhrkamp, 1981. Translated by Ruth Crowley as *Suddenness: On the Moment of Aesthetic Appearance*. New York: Columbia University Press, 1994.

Bois, Yve-Alain, and Christian Hubert. "El Lissitzky: Reading Lessons." *October* 11 (Winter 1979): 113–28.

Brodersen, Momme. "Die Entstehung der *Deutschen Menschen*." In Hahn and Wizisla, *Walter Benjamins "Deutsche Menschen*," 9–22.

———. *Spinne im eigenen Netz: Walter Benjamin Leben und Werk*. Bühl-Moos: Elster Verlag, 1990.

Brückle, Wolfgang. "Kein Portrait mehr? Physiognomik in der deutschen Bildnisphotographie um 1930." In *Gesichter der Weimarer Republik: Eine physiognomische Kulturgeschichte*, edited by Claudia Schmölders and Sander L. Gilman, 131–55. Cologne: Dumont, 2000.

Bucholtz, Ferdinand, ed. *Der gefährliche Augenblick*. With an introduction by Ernst Jünger. Berlin: Junker und Dünnhaupt Verlag, 1931.

Buerkle, Darcy. "Gendered Spectatorship, Jewish Women, and Psychological Advertising in Weimar Germany." *Women's History Review* 15, no. 4 (2006): 625–36.

Bullock, Marcus Paul. *The Violent Eye: Ernst Jünger's Visions and Revisions on the European Right*. Detroit: Wayne State University Press, 1992.

Bunnell, Peter C. "Towards New Photography: Renewals of Pictorialism." In *A New History of Photography*, edited by Michel Frizot, 311–33. Cologne: Könemann, 1998.

Cadava, Eduardo. *Words of Light: Theses on the Photography of History*. Princeton: Princeton University Press, 1996.

Campe, Rüdiger, and Manfred Schneider, eds. *Geschichten der Physiognomik: Text, Bild, Wissen*. Freiburg im Breisgau: Rombach Verlag, 1996.

Caws, Mary Ann, ed. *Manifesto: A Century of Isms*. Lincoln: University of Nebraska Press, 2001.

———. "The Poetics of the Manifesto: Nowness and Newness." In *Manifesto: A Century of Isms*, edited by Mary Ann Caws, xix–xxxi. Lincoln: University of Nebraska Press, 2001.

Clauss, Ludwig Ferdinand. *Die nordische Seele: Eine Einführung in die Rassenseelenkunde*. Munich: J. F. Lehmann, 1932.

Davis, Colin. *Critical Excess: Overreading in Derrida, Deleuze, Levinas, Žižek, and Cavell*. Palo Alto: Stanford University Press, 2010.

de Mendelssohn, Peter. *Zeitungsstadt Berlin: Menschen und Mächte in der Geschichte der deutschen Presse*. Berlin: Ullstein, 1959.

Deutscher Werkbund, ed. *Innenräume: Räume und Inneneinrichtungen aus der Werkbundausstellung "Die Wohnung," insbesondere aus den Bauten der städtischen Weißenhofsiedlung in Stuttgart*. Exhibition catalogue. Stuttgart: Akademischer Verlag Fr. Wedekind und Co., 1928.

———. *Internationale Ausstellung des Deutschen Werkbunds: Film und Foto*. Exhibition catalogue. Stuttgart, 1929. Reprint, Stuttgart: Deutsch-Verlags-Austalt, 1979.

Diers, Michael. "Einbandlektüre, fortgesetzt: Zur politischen Physiognomie der Briefanthologie." In Hahn and Wizisla, *Walter Benjamins "Deutsche Menschen*," 23–44.

Dingwerth, Leonhard. *Die Geschichte der deutschen Schreibmaschinen-Fabriken*. Vol. 2, *Mittlere und kleine Hersteller*. Delbrück: Verlag Kunstgraphik, 2008.

Dobe, Paul. *Wilde Blumen der deutschen Flora: Hundert Naturaufnahmen mit Vorbemerkung*. Königstein im Taunus: Langewiesche, 1929.

Döblin, Alfred. *Berlin Alexanderplatz: Die Geschichte von Franz Biberkopf*. Berlin: S. Fischer, 1929.

——. "Faces, Images and Their Truth." Foreword
to *Face of Our Time*, by August Sander, 7–15.
Munich: Schirmer/Mosel, 1994.

Dresler, Adolf. *Geschichte des "Völkischen Beobachters"
und des Zentralverlages der NSDAP, Franz Eher Nachf.*
Munich: Franz Eher Nachf., 1937.

Eco, Umberto. *The Open Work*. Translated by Anna
Cancogni. Cambridge, Mass.: Harvard Uni-
versity Press, 1989.

Efron, John M. *Defenders of the Race: Jewish Doctors and
Race Science in Fin-de-Siècle Europe*. New Haven:
Yale University Press, 1994.

Eipper, Paul. *Tiere sehen dich an, mit 32 Bildnisstudien
nach Originalaufnahmen von Hedda Walther*. Berlin:
Reimer, 1928.

——. *Tierkinder, mit 32 Bildnisstudien nach Originalaufnahmen
von Hedda Walther*. Berlin: Reimer, 1929.

Elsaesser, Thomas. "Moderne und Modernisierung:
Der deutsche Film der dreißiger Jahre." *Mon-
tage AV* 3, no. 2 (1994): 23–40.

Encke, Julia. *Augenblicke der Gefahr: Der Krieg und die
Sinne (1914–1934)*. Paderborn: Wilhelm Fink,
2006.

Eskildsen, Ute. "A Chance to Participate: A Tran-
sitional Time for Women Photographers."
In *Visions of the "Neue Frau": Women and the Visual Arts
in Weimar Germany*, edited by Marsha Meskim-
mon and Shearer West, 63–76. Aldershot,
UK: Scolar Press, 1995.

——, ed. *Fotografie in deutschen Zeitschriften 1924–1933*.
Stuttgart: Institut für Auslandsbeziehungen,
1982.

——. *Fotografieren hieß teilnehmen: Fotografinnen der Weimarer
Republik*. Essen: Museum Folkwang, 1995.

——. "Germany: The Weimar Republic." In
A History of Photography, edited by Jean-Claude
Lemagny and Andre Rouillé, 141–49.
New York: Cambridge University Press, 1987.

Eskildsen, Ute, and Odette M. Appel. *Heinrich
Kühn 1866–1944: 110 Bilder aus der Fotografischen
Sammlung Museum Folkwang, Essen*. Essen: Museum
Folkwang, 1978.

Eskildsen, Ute, and Jan-Christopher Horak, eds.
*Helmar Lerski, Lichtbildner: Fotografien und Filme,
1910–1947*. Essen: Museum Folkwang, 1982.

Farrenkopf, John. *Prophet of Decline: Spengler on World
History and Politics*. Baton Rouge: Louisiana State
University Press, 2001.

Föllmer, Moritz, and Rüdiger Graf, eds. *Die "Krise"
der Weimarer Republik: Zur Kritik eines Deutungsmusters*.
Frankfurt: Campus Verlag, 2003.

Frecot, Janos, ed. *Erich Salomon: "Mit Frack und Linse durch
Politik und Gesellschaft" Photographien 1928–1938*.
Munich: Schirmer/Mosel, 2004.

Frecot, Janos, and Klaus-Jürgen Sembach, eds.
Berlin im Licht: Photographien der nächtlichen Stadt.
Berlin: Nicolai, 2002.

Frenssen, Gustav. *Jörn Uhl: Roman*. Berlin: Grote,
1901.

Freund, Gisèle. *Photographie und Gesellschaft*. Translated
by Dietrich Lubbe. Hamburg: Rowohlt, 1979.

Friedrich, Ernst. *Krieg dem Kriege!* Berlin: Anti-Krieg
Museum, 1924.

Fritzsche, Peter. *Life and Death in the Third Reich*. Cam-
bridge, Mass.: Harvard University Press,
2008.

——. *Reading Berlin, 1900*. Cambridge, Mass.: Har-
vard University Press, 1996.

Frizot, Michel, ed. *A New History of Photography*.
Cologne: Könemann, 1998.

Führer, Karl Christian. "Auf dem Weg zur 'Massen-
kultur'?" *Historische Zeitschrift* 262, no. 3 (1996):
739–81.

50 Jahre Ullstein: 1877–1927. Berlin: Ullstein, 1927.

Fulda, Bernhard. *Press and Politics in the Weimar Republic*.
Oxford: Oxford University Press, 2009.

Ganeva, Mila. *Women in Weimar Fashion: Discourses and
Displays in German Culture, 1918–1933*. Rochester,
N.Y.: Camden House, 2008.

Ganghofer, Ludwig. *Der Jäger von Fall: Eine Erzählung aus
dem bayerischen Hochlande*. Stuttgart: Bonz, 1883.

Gernsheim, Helmut. *Creative Photography: Aesthetic
Trends, 1839 to Modern Times*. New York: Bonanza
Books, 1991.

Gidal, Tim N. *Jews in Germany: From Roman Times to the
Weimar Republic*. Cologne: Könemann, 1998.

——. *Modern Photojournalism: Origin and Evolution,
1910–1933*. New York: Macmillan, 1973.

Graeff, Werner. *Autofahren und was man dazu wissen muß!
Ein Heft für alle Autofreunde*. Berlin: Ullstein
Verlag, 1929.

——. *Bau und Wohnung: Die Bauten der Weißenhofsiedlung in
Stuttgart errichtet 1927 nach Vorschlägen des Deutschen
Werkbundes im Auftrag der Stadt Stuttgart und im Rahmen
der Werkbundausstellung "Die Wohnung."* Stuttgart:
Akademischer Verlag Dr. Fr. Wedekind, 1927.

——. *Es kommt der neue Fotograf!* Berlin: Hermann
Reckendorf, 1929.

——. "Nach einem halben Jahrhundert." In *Es kommt
der neue Fotograf!*, 5. 2nd ed. Cologne: Verlag
der Buchhandlung Walther König, 1978.

——. *Eine Stunde Auto: Ein kurzgefaßtes Lehrbuch*. Stuttgart:
Akademischer Verlag Dr. Fritz Wedekind,
1928.

——. "Wir wollen nicht länger Analphabeten
sein: Zum Problem einer Internationale
n-Verkehrszeichensprache." *De Stijl* 7, nos.
79–84 (1927): 100.

Gray, Richard T. *About Face: German Physiognomic Thought from Lavater to Auschwitz.* Detroit: Wayne State University Press, 2004.

Grimm, Wilhelm, and Jacob Grimm, eds. *Deutsches Wörterbuch.* 32 vols. Leipzig: Verlag von S. Hirzel, 1854–1961.

Gronert, Stefan. *Die Düsseldorfer Photoschule.* Munich: Schirmer/Mosel, 2010.

Grossman, Atina. *Reforming Sex: The German Movement for Birth Control and Abortion Reform, 1920–1950.* New York: Oxford University Press, 1995.

Grotjahn, Alfred. *Sociale Pathologie: Versuch einer Lehre von den sozialen Beziehungen der Krankheiten als Grundlage der sozialen Hygiene.* Berlin: August Hirschwald Verlag, 1915.

Günther, Hans F. K. *Kleine Rassenkunde des deutschen Volkes.* Munich: J. F. Lehmann, 1929.

Hahn, Barbara, and Erdmut Wizisla, eds. *Walter Benjamins "Deutsche Menschen."* Göttingen: Wallstein Verlag, 2008.

Hake, Sabine. "Zur Wiederkehr des Physiognomischen in der modernen Photographie." In *Geschichten der Physiognomik: Text, Bild, Wissen,* edited by Rüdiger Campe and Manfred Schneider, 475–513. Freiburg im Breisgau: Rombach Verlag, 1996.

Hallett, Michael. *Stefan Lorant: Godfather of Photojournalism.* Lanham, Md.: Scarecrow Press, 2005.

Hammond, Anne. "Naturalistic Vision and Symbolist Image: The Pictorialist Impulse." In *A New History of Photography,* edited by Michel Frizot, 293–310. Cologne: Könemann, 1998.

Hamsun, Knut. *Mysterien: Roman.* Translated by Maria v. Borch. Cologne: H. Langen, 1894.

Haß, Ulrike. "Vom 'Aufstand der Landschaft gegen Berlin.'" In *Literatur der Weimarer Republik: 1918–1933,* vol. 8, *Hansers Sozialgeschichte der deutschen Literatur,* edited by Bernard Weyergraf, 340–70. Munich: Hanser, 1995.

Hau, Michael. *The Cult of Health and Beauty in Germany: A Social History, 1890–1930.* Chicago: University of Chicago Press, 2003.

Herf, Jeffrey. *Reactionary Modernism: Technology, Culture, and Politics in Weimar and the Third Reich.* Cambridge: Cambridge University Press, 1984.

Herz, Rudolf. *Hoffmann und Hitler: Fotografie als Medium des Führer-Mythos.* Munich: Münchner Stadtmuseum, 1994.

Hirsch, Marianne. *Family Frames: Photography, Narrative, and Postmemory.* Cambridge, Mass.: Harvard University Press, 1997.

Hitler, Adolf. *Mein Kampf.* Munich: Verlag Franz Eher Nachf., 1927.

Hoffmann, Heinrich. *Hitler abseits vom Alltag: 100 Bilddokumente aus der Umgebung des Führers.* Berlin: Verlag Zeitgeschichte, 1937.

——. *Hitler wie ihn keiner kennt: 100 Bilddokumente aus dem Leben des Führers.* Berlin: Verlag Zeitgeschichte, 1932.

——. *Jugend um Hitler: Bilddokumente aus der Umgebung des Führers.* Berlin: Verlag Zeitgeschichte, 1934.

Holz, Detlef [Walter Benjamin]. *Deutsche Menschen: Eine Folge von Briefen.* Lucerne: Vita Nova, 1936. Reprinted with an afterword by Theodor W. Adorno. Frankfurt: Suhrkamp, 1962.

Hürlimann, Martin. *Ceylon und Indochina: Burma, Siam, Kambodscha, Annam, Tongking, Tünnan: Baukunst, Landschaft, Volksleben.* Berlin: Atlantis, 1929.

——. *Indien: Baukunst, Landschaft, Volksleben.* Berlin: Atlantis, 1928.

Jaeggi, Annemarie. *Fagus: Industrial Culture from Werkbund to Bauhaus.* New York: Princeton Architectural Press, 2000.

Jäger, Christian, and Erhard Schütz, eds. *Glänzender Asphalt: Berlin im Feuilleton der Weimarer Republik.* Berlin: Fannei u. Walz Verlag, 1994.

Jaspers, Karl. *Psychologie der Weltanschauungen.* 2nd ed. Berlin: Verlag von Julius Springer, 1922.

Jenkins, Reese V. *Images and Enterprise: Technology and the American Photographic Industry, 1839 to 1925.* Baltimore: Johns Hopkins University Press, 1975.

Jennings, Michael W. "Agriculture, Industry, and the Birth of the Photo-Essay in the Late Weimar Republic." *October* 93 (Summer 2000): 23–56.

——. "Trugbild der Stabilität: Weimarer Politik und Montage-Theorie in Benjamin's 'Einbahnstraße.'" In *Global Benjamin: Internationaler Walter Benjamin-Kongreß 1992,* edited by Klaus Garber and Ludwig Rehm, 517–28. Munich: Wilhelm Fink, 1999.

Jensen, Erik. *Body by Weimar: Athletes, Gender, and German Modernity.* New York: Oxford University Press, 2010.

Jünger, Ernst. *Das abenteuerliche Herz: Aufzeichnungen bei Tag und Nacht.* Berlin: Frundsberg, 1929.

——, ed. *Das Antlitz des Weltkrieges: Fronterlebnisse deutscher Soldaten.* Berlin: Neufeld u. Henius, 1930.

——. *Der Arbeiter: Herrschaft und Gestalt.* Hamburg: Hanseatische Verlagsanstalt, 1932.

——. *Der Kampf als inneres Erlebnis.* Berlin: Verlag Mittler, 1922.

——, ed. *Krieg und Krieger.* Berlin: Junker und Dünnhaupt, 1930.

——, ed. *Luftfahrt ist not!* Leipzig: Vaterländischer Buchvertrieb Thankmar Rudolf, 1928.

——. "On Danger." Translated by Donald Reneau. *New German Critique* 59 (Spring/Summer 1993): 27–32.

——. "Über den Schmerz." In *Blätter und Steine,* 200–203. Hamburg: Hanseatische Verlagsanstalt, 1934.

———. "Über die Gefahr." In *Der gefährliche Augenblick*, edited by Ferdinand Bucholtz, 11–16. Berlin: Junker und Dünnhaupt Verlag, 1931.

Kaes, Anton. "The Cold Gaze: Notes on Mobilization and Modernity." *New German Critique* 59 (Spring/Summer 1993): 105–17.

Kaes, Anton, Martin Jay, and Edward Dimendberg, eds. *The Weimar Republic Sourcebook*. Berkeley: University of California Press, 1995.

Kähler, Hermann, ed. *Berlin: Asphalt und Licht: Die grosse Stadt in der Literatur der Weimarer Republik*. Berlin: Dietz Verlag, 1986.

Kasher, Steven. "*Das Deutsche Lichtbild* and the Militarization of German Photography." *Afterimage* 18, no. 7 (1991): 10–14.

Kb. [pseud.]. Review of *Es kommt der neue Photograph* [*sic*], by Werner Graeff. *Die Kinotechnik* 12, no. 15 (August 5, 1929): 417.

Keller, Ulrich. Introduction to *Citizens of the Twentieth Century: Portrait Photographs, 1892–1952*, by August Sander, edited by Gunther Sander, 1–63. Essay translated by Linda Keller. Cambridge, Mass.: MIT Press, 1986.

———. "Photojournalism Around 1900: The Institutionalization of a Mass Medium." In *Shadow and Substance: Essays on the History of Photography in Honor of Heinz K. Henisch*, edited by Kathleen Collins, 283–99. Bloomfield Hills, Mich.: Amorphous Institute Press, 1990.

Kempas, Thomas, and Gabriele Saure, eds. *Photo-Sequenzen: Reportagen, Bildgeschichten. Serien aus dem Ullstein Bilderdienst von 1925 bis 1944. Ausstellung und Katalog*. Berlin: Reiter-Druck, 1992.

Kershaw, Ian. *The Hitler Myth: Image and Reality in the Third Reich*. New York: Oxford University Press, 2001.

Keun, Irmgard. *The Artificial Silk Girl*. Translated by Kathie von Ankum. New York: Other Press, 2002.

———. *Das kunstseidene Mädchen: Roman*. Berlin: Universitas, 1932.

Kisch, Egon Erwin. *Der rasende Reporter*. Berlin: E. Reiss, 1925.

Klages, Ludwig. *Der Geist als Widersacher der Seele*. 3 vols. Leipzig: J. A. Barth, 1929–32.

———. *Graphologie, mit 81 Schriftproben*. Leipzig: Verlag Quelle u. Meyer, 1932.

Klemperer, Victor. *LTI: Notizbuch eines Philologen*. Berlin: Aufbau Verlag, 1949.

Klingbeil, Almut. *Die Bilder wechseln: Meereslandschaften in deutschen Fotobüchern der 20er bis 40er Jahre*. Hamburg: ConferencePoint Verlag, 2000.

Koonz, Claudia. *The Nazi Conscience*. Cambridge, Mass.: Harvard University Press, 2003.

Korff, Kurt. "Die 'Berliner Illustrirte.'" In *50 Jahre Ullstein: 1877–1927*, 279–302. Berlin: Ullstein, 1927.

Koszyk, Kurt. *Deutsche Presse: 1914–1945*. Berlin: Colloquium Verlag, 1972.

Kracauer, Siegfried. *Die Angestellten: Aus dem neuesten Deutschland*. In *Siegfried Kracauer: Werke*, edited by Inka Mülder-Bach and Ingrid Belke, 1:211–310. Frankfurt: Suhrkamp, 2006.

———. *The Mass Ornament: Weimar Essays*. Translated, edited, and with an introduction by Thomas Y. Levin. Cambridge, Mass.: Harvard University Press, 1995.

———. *The Salaried Masses: Duty and Distraction in Weimar Germany*. Edited by Quintin Hoare. London: Verso, 1998.

———. *Siegfried Kracauer: Werke*. Edited by Inka Mülder-Bach and Ingrid Belke. Frankfurt: Suhrkamp, 2006.

Krampen, Martin. "Icons of the Road." Special issue. *Semiotica* 43, no. 1/2 (1983).

Krause, Markus. *Galerie Gerd Rosen: Die Avantgarde in Berlin 1945–1950*. Berlin: Ars Nicolai, 1995.

Kühn, Heinrich. *Technik der Lichtbildnerei*. Halle: W. Knapp, 1921.

Lange, Susanne. "Ein Bekenntnis zur Photographie: Überlegungen zum Leben und Werk von August Sander." In *August Sander, 1876–1964*, edited by Manfred Heiting, 16–27. Cologne: Taschen, 1999.

Lebeck, Robert, and Bodo von Dewitz, eds. *Kiosk: Eine Geschichte der Fotoreportage 1839–1973*. Cologne: Steidl, 2001.

Lendvai-Dircksen, Erna. *Das Deutsche Volksgesicht*. Berlin: Kulturelle Verlagsgesellschaft, 1932.

———. *Das germanische Volksgesicht: Dänemark*. Bayreuth: Gauverlag Bayreuth, 1943.

———. *Das germanische Volksgesicht: Flandern*. Bayreuth: Gauverlag Bayreuth, 1942.

———. *Das germanische Volksgesicht: Tirol und Vorarlberg*. Bayreuth: Gauverlag Bayreuth, 1941.

———. *Das Gesicht des deutschen Ostens*. Berlin: Zeitgeschichte Verlag und Vertriebs-Gesellschaft, 1935.

Lerski, Helmar. *Köpfe des Alltags*. Berlin: Hermann Reckendorf, 1931.

Lethen, Helmut. "Neue Sachlichkeit." In *Deutsche Literatur: Eine Sozialgeschichte*, edited by H. A. Glaser, 168–79. Reinbek: Rowohlt, 1983.

———. *Neue Sachlichkeit 1924–1932: Studien zur Literatur des "Weißen Sozialismus."* Stuttgart: Metzler, 1970.

———. *Verhaltenslehre der Kälte: Lebensversuche zwischen den Kriegen*. Frankfurt: Suhrkamp, 1994.

Levin, Thomas Y. *Siegfried Kracauer: Eine Bibliographie seiner Schriften*. Marbach am Neckar: Deutsche Schillergesellschaft, 1989.

Lhotzky, Heinrich. *Das Buch der Ehe*. Königstein im Taunus: Langwiesche, 1911.

———. *Die Seele Deines Kindes*. Königstein im Taunus: Langwiesche, 1908.

Liulevicius, Vejas. *The German Myth of the East: 1800 to the Present*. New York: Oxford University Press, 2009.

Ludwig, Emil. *Bismarck: Geschichte eines Kämpfers*. Berlin: E. Rowohlt, 1926.

———. *Goethe: Geschichte eines Menschen*. Stuttgart: Cotta, 1920.

———. *Hindenburg und die Sage von der deutschen Republik*. Amsterdam: Querido Verlag, 1935.

———. *Wilhelm der Zweite*. Berlin: E. Rowohlt, 1926.

Lugon, Oliver. "'Photo-Inflation': Image Profusion in German Photography, 1925–1945." *History of Photography* 32, no. 3 (2008): 219–34.

Lukács, Georg. *Geschichte und Klassenbewusstsein: Studien über marxistische Dialektik*. Berlin: Malik Verlag, 1923.

———. *History and Class Consciousness: Studies in Marxist Dialectics*. Translated by Rodney Livingstone. Cambridge, Mass.: MIT Press, 1972.

Man, Felix H. [Hans Baumann]. *Felix H. Man: 60 Jahre Fotografie*. Bielefeld: Kunsthalle Bielefeld, 1978.

Marckwardt, Wilhelm. *Die Illustrierten der Weimarer Zeit: Publizistische Funktion, ökonomische Entwicklung und inhältliche Tendenzen unter Einschluß einer Bibliographie dieses Pressetypus 1918–1932*. Munich: Minerva, 1982.

Martus, Steffen. *Ernst Jünger*. Stuttgart: J. B. Metzler, 2001.

Mattenklott, Gerd. "Benjamin als Korrespondent, als Herausgeber, als Theoretiker." In *Global Benjamin: Internationaler Walter Benjamin-Kongreß 1992*, edited by Klaus Garber and Ludwig Rehm, 273–82. Munich: Wilhelm Fink, 1999.

Matthies-Masuren, Fritz. *Künstlerische Photographie: Entwicklung und Einfluss in Deutschland*. Foreword by Alfred Lichtwark. Berlin: Marquardt, 1907.

McFarland, James. "Die Kunst, in anderer Leute Köpfe zu denken: *Deutsche Menschen* als politisches Projekt." In Hahn and Wizisla, *Walter Benjamins "Deutsche Menschen*," 121–31.

Mertins, Detlef, and Michael W. Jennings, eds. *G: An Avant-Garde Journal of Art, Architecture, Design, and Film, 1923–1926*. Los Angeles: Getty Research Institute Press, 2010.

Michalski, Sergiusz. *Neue Sachlichkeit: Painting, Graphic Art, and Photography in Weimar Germany, 1919–1933*. Cologne: Taschen, 1992.

Mitchell, W. J. T. *Picture Theory: Essays on Verbal and Visual Representation*. Chicago: University of Chicago Press, 1994.

Mitchell-Hedges, Frederick Albert. *Battles with Giant Fish*. With illustrations from photographs by Lady Richmond Brown. London: Duckworth, 1923.

Moeller van den Bruck, Arthur. *Das Dritte Reich*. Berlin: Ring Verlag, 1923.

Moholy-Nagy, László. "Fotografie ist Lichtgestaltung." *Bauhaus: Zeitschrift für Bau und Gestaltung* 1 (1928): 2–9.

———. *Malerei Fotografie Film*. Munich: Albert Langen, 1925.

———. "Die neue Typographie." In *Staatliches Bauhaus in Weimar 1919–23*, 141. Weimar: Bauhausverlag, 1923.

———. "The New Typography." Translated by Sibyl Moholy-Nagy. In *Looking Closer*, vol. 3, *Classic Writings on Graphic Design*, 21–22. New York: Allworth Press, 1999.

———. *Painting Photography Film*. Translated by Janet Seligman. Cambridge, Mass.: MIT Press, 1969.

———. "Produktion-Reproduktion." *De Stijl* 5, no. 7 (1922): 98–100.

Molderings, Herbert. "Amerikanismus und Neue Sachlichkeit in der deutschen Fotografie der zwanziger Jahre." In Molderings, *Die Moderne der Fotografie*, 71–92.

———. "Fotografie in der Weimarer Republik." In Molderings, *Die Moderne der Fotografie*, 181–218.

———. *Die Moderne der Fotografie: Aufsätze und Essays*. Hamburg: Philo Fine Arts Verlag, 2007.

———. Review of *The Photobook: A History*, vol. 1, by Martin Parr and Gerry Badger. *Sehepunkte* 5, no. 7/8 (2005).

———. "Eine Schule der modernen Fotoreportage: Die Fotoagentur Dephot (Deutscher Photodienst) 1928 bis 1933." *Fotogeschichte* 28, no. 107 (2008): 4–21.

Molzahn, Johannes. "Nicht mehr lesen! Sehen!" *Das Kunstblatt* 12 (1928): 78–82.

Newhall, Beaumont, ed. *Photography: Essays and Images*. New York: Museum of Modern Art, 1980.

Novalis [Georg Philipp Friedrich von Hardenberg]. *Heinrich von Ofterdingen*. Berlin: Reimer, 1801.

Oesterle, Günter. "Erschriebene Gelassenheit: Kompositionsprinzipien." In Hahn and Wizisla, *Walter Benjamins "Deutsche Menschen*," 91–110.

Otto, Elizabeth, and Vanessa Rocco, eds. *The New Woman International: Representations in Photography and Film from the 1870s Through the 1960s*. Ann Arbor: University of Michigan Press, 2011.

Paenhuysen, An. "Kurt Tucholsky, John Heartfield, and *Deutschland, Deutschland über Alles*." *History of Photography* 33, no. 1 (2009): 39–54.

Panofsky, Erwin. *Perspective as Symbolic Form*. Translated by Christopher S. Wood. Cambridge, Mass.: Zone Books, 1991.

——. *Die Perspektive als "symbolische Form."* Leipzig: Teubner, 1927.

Parr, Martin, and Gerry Badger. *The Photobook: A History.* 2 vols. London: Phaidon, 2004–6.

Petro, Patrice. *Joyless Streets: Women and Melodramatic Representation in Weimar Germany.* Princeton, N.J.: Princeton University Press, 1989.

Peukert, Detlev J. K. *Die Weimarer Republik: Krisenjahre der klassischen Moderne.* Frankfurt: Suhrkamp, 1987.

Phillips, Christopher, ed. *Photography in the Modern Era: European Documents and Critical Writings, 1913–1940.* New York: Metropolitan Museum of Art/ Aperture, 1989.

Die Photographische Sammlung, SK Stiftung Kultur, ed. *Zeitgenossen: August Sander und die Kunstszene der 20er Jahre im Rheinland.* Göttingen: Steidl, 2000.

Pulzer, Peter G. J. *The Rise of Political Anti-Semitism in Germany and Austria.* Cambridge, Mass.: Harvard University Press, 1988.

Puttnies, Hans Georg. "Zum Tode von Werner Graeff: Es kommt der neue Fotograf." *Frankfurter Allgemeine Zeitung,* September 14, 1978.

Reitter, Paul. *The Anti-journalist: Karl Kraus and Jewish Self-Fashioning in Fin-de-Siècle Europe.* Chicago: University of Chicago Press, 2007.

Remarque, Erich Maria. *Im Westen Nichts Neues.* Berlin: Propylaen, 1929.

Renger-Patzsch, Albert. "Einiges über Hände und Händeaufnahmen." *Photographie für Alle,* June 1, 1927, 177–78.

——. "Heretical Thoughts on Artistic Photography." Translated by Virginia Heckert. *History of Photography* 21, no. 3 (1997): 179–81.

——. "Ketzergedanken über künstlerische Photographie." *Photographie für Alle,* April 15, 1925.

——. "Ein Vortrag, der nicht gehalten wurde." *Foto Prisma* 17 (1966): 535–38.

——. *Die Welt ist schön: Einhundert photographische Aufnahmen.* Edited with an introduction by Carl Georg Heise. Munich: Kurt Wolff Verlag, 1928.

——. "Ziele." In *Das Deutsche Lichtbild: Jahresschau 1927,* 18. Berlin: Robert und Bruno Schultz, 1927.

Richter, Gerhard. *Thought-Images: Frankfurt School Writers' Reflections from Damaged Life.* Palo Alto: Stanford University Press, 2007.

Rittelmann, Leesa L. "Constructed Identities: The German Photobook from Weimar to the Third Reich." Ph.D. diss., University of Pittsburgh, 2003.

——. "Facing Off: Photography, Physiognomy, and National Identity in the Modern German Photobook." *Radical History Review* 106 (Winter 2010): 137–61.

Ritter, Joachim, ed. "Dezision, Dezisionismus." In *Historisches Wörterbuch der Philosophie,* 2:159–61. Darmstadt: Wissenschaftliche Buchgesellschaft, 1972.

Rohner, Ludwig, ed. *Der deutsche Essay: Materialien zur Geschichte und Ästhetik einer literarischen Gattung.* 4 vols. Neuwied: Luchterhand, 1966.

Roth, Andrew. *The Book of 101 Books: Seminal Photographic Books of the Twentieth Century.* New York: Roth Horowitz, 2001.

——, ed. *The Open Book: A History of the Photographic Book from 1878 to the Present.* Gothenburg: Hasselblad Center, 2004.

Roth, Joseph. *Briefe, 1911–1939.* Edited by Hermann Kesten. Cologne: Kiepenhauer u. Witsch, 1970.

Routledge Encyclopedia of Philosophy. Edited by Edward Craig. 10 vols. New York: Routledge, 1998.

Rubinfien, Leo. "The Mask Behind the Face." *Art in America,* June/July 2004, 101–6.

Sachsse, Rolf. *Die Erziehung zum Wegsehen: Photographie im NS-Staat.* Dresden: Philo Arts Verlag, 2003.

Salomon, Erich. *Berühmte Zeitgenossen in unbewachten Augenblicken.* Stuttgart: J. Engelhorns Nachf., 1931. Reprint, Munich: Schirmer/Mosel, 1978.

Sander, August. *Antlitz der Zeit: Sechzig Aufnahmen deutscher Menschen des 20. Jahrhunderts.* Munich: Transmare Verlag/Kurt Wolff, 1929.

——. *Landschaften.* Edited by Die Photographische Sammlung, SK Stiftung Kultur. Munich: Schirmer/Mosel, 1999.

——. "Lecture 5: Photography as a Universal Language." Translated by Anne Halley. *Massachusetts Review* 19, no. 4 (1978): 674–79.

——. *Menschen des 20. Jahrhunderts: Die Gesamtausgabe.* Edited by Susanne Lange. Munich: Schirmer/ Mosel, 2002.

——. *Menschen des 20. Jahrhunderts: Portraitphotographien von 1892–1952.* Edited by Gunther Sander with an introduction by Ulrich Keller. Munich: Schirmer/Mosel, 1981.

——. *Menschen des 20. Jahrhunderts: Studienband.* Munich: Schirmer/Mosel, 2001.

——. "Wesen und Werden der Photographie III: Rückblick und Ausblick: Die Photographie um die Jahrhundertwende." Radio lecture for Westdeutscher Rundfunk, 1931. Unpublished manuscript. Die Photographische Sammlung, SK Stiftung Kultur, Cologne.

——. "Wesen und Werden der Photographie V: Photographie als Weltsprache." Radio lecture for Westdeutscher Rundfunk, 1931. Unpublished manuscript. Die Photographische Sammlung, SK Stiftung Kultur, Cologne.

Sartre, Jean-Paul. *Anti-Semite and Jew.* Translated by George Becker. New York: Schocken, 1965.

Scharfe, Siegfried. *Deutsche Dorfkirchen.* Königstein im Taunus: Langwiesche, 1938.

Schmitt, Carl. "Der Begriff des Politischen." *Heidelberger Archiv für Sozialwissenschaft und Sozialpolitik* 58, no. 1 (1927): 1–33.

———. *Der Begriff des Politischen: Text von 1932 mit einem Vorwort und drei Corollarien.* Berlin: Duncker u. Humblot, 1996.

———. *The Concept of the Political.* Translated by George Schwab. Chicago: University of Chicago Press, 1996.

Schmölders, Claudia. "Der sanfte Jäger: Über Erich Salomons physiognomischen Bildsinn." In *Erich Salomon: "Mit Frack und Linse durch Politik und Gesellschaft" Photographien 1928–1938,* edited by Janos Frecot, 21–26. Munich: Schirmer/Mosel, 2004.

———. *Das Vorurteil im Leibe: Eine Einführung in die Physiognomik.* Berlin: Akademie, 2007.

Schmölders, Claudia, and Sander L. Gilman, eds. *Gesichter der Weimarer Republik: Eine physiognomische Kulturgeschichte.* Cologne: Dumont, 2000.

Die schöne Heimat: Bilder aus Deutschland. Königstein im Taunus: Langwiesche, 1915.

Schultz, Edmund, ed. *Die veränderte Welt 1918–1932: Eine Bilderfibel unserer Zeit.* With an introduction by Ernst Jünger. Breslau: W. G. Korn Verlag, 1933.

Scott, Clive. *The Spoken Image: Photography and Language.* London: Reaktion Books, 1999.

Sekula, Alan. "On the Invention of Photographic Meaning." *Artforum* 13, no. 5 (1975): 36–45. Reprinted in *Photography in Print,* edited by Vicki Goldberg, 452–73. Albuquerque: University of New Mexico Press, 1981.

Serner, Walter. *Letzte Lockerung: Ein Handbrevier für Hochstapler und solche die es werden wollen.* Berlin: Paul Steegemann Verlag, 1927.

Sieker, Hugo. "Lichtbild und Persönlichkeit: Ein Gespräch zur gegenwärtigen lichtbildnerischen Situation erlauscht von Hugo Sieker." In *Das Deutsche Lichtbild: Jahresschau 1932,* T9–T17. Berlin: Verlag Robert u. Bruno Schultz, 1932.

Simmel, Georg. "Die Großstädte und das Geistesleben." In *Die Großstadt: Vorträge und Aufsätze zur Städteausstellung,* edited by Th. Petermann, 9:185–206. Dresden: Zahn u. Jaensch, 1903.

Simms, Matthew. "Just Photography: Albert Renger-Patzsch's *Die Welt ist schön.*" *History of Photography* 21, no. 3 (1997): 197–204.

Sontag, Susan. *On Photography.* New York: Farrar, Straus, and Giroux, 1977.

———. *Regarding the Pain of Others.* New York: Farrar, Straus, and Giroux, 2003.

Spengler, Oswald. *The Decline of the West.* Translated by Charles Francis Atkinson. 2 vols. New York: Alfred A. Knopf, 1928.

———. *Jahre der Entscheidung.* Munich: C. H. Beck'sche Verlagsbuchhandlung, 1933.

———. *Der Untergang des Abendlandes.* 2 vols. Munich: C. H. Beck'sche Verlagsbuchhandlung, 1919–23.

Stapel, Wilhelm. "Blumen und Tiere in Bildern." *Deutsches Volkstum* 11, no. 6 (1929): 477–79.

———. "Der Geistige und sein Volk: Eine Parole." *Deutsches Volkstum* 12, no. 1 (1930): 1–8.

———. Review of *Aus zoologischen Gärten,* by Paul Wolff. *Deutsches Volkstum* 12, no. 1 (1930): 84.

Starl, Timm. "Die Bildbände der Reihe 'Blauen Bücher': Zur Entstehungs-und Entwicklungsgeschichte einer Bildbandreihe: Bibliographie 1907–1944." *Fotogeschichte* 1, no. 1 (1981): 73–82.

Steinorth, Karl. "Der Weg zum Fotoessay." In *Photo-Sequenzen: Reportagen, Bildgeschichten. Serien aus dem Ullstein Bilderdienst von 1925 bis 1944. Ausstellung und Katalog,* edited by Thomas Kempas und Gabriele Saure, 13–18. Berlin: Reiter-Druck, 1992.

Stenger, Erich. *Die Geschichte der Kleinbildkamera bis zur Leica.* Wetzlar: Ernst Leitz, 1949.

Stern, Fritz. *The Politics of Cultural Despair: A Study in the Rise of the Germanic Ideology.* Berkeley: University of California Press, 1961.

Stetler, Pepper. "Bound Vision: Reading the Photographic Book in the Weimar Republic." Ph.D. diss., University of Delaware, 2009.

Teitelbaum, Matthew, ed. *Montage and Modern Life.* Cambridge, Mass.: MIT Press, 1992.

Thiede, Klaus. *Deutsche Bauernhäuser.* Königstein im Taunus: Langwiesche, 1935.

Tiryakian, Edward A. "The Sociological Import of a Metaphor: Tracking the Source of Max Weber's 'Iron Cage.'" *Sociological Inquiry* 31 no. 1 (1981): 27–33.

Toepfer, Karl. *Empire of Ecstasy: Nudity and Movement in German Body Culture, 1910–1935.* Berkeley: University of California Press, 1997.

Traeger, Jörg. *Philipp Otto Runge und sein Werk.* Munich: Prestel, 1975.

Tucholsky, Kurt. *Deutschland, Deutschland über alles.* Photographs assembled by John Heartfield. Berlin: Neuer Deutscher Verlag, 1929. Translated by Anne Halley with an afterword and notes by Harry Zohn. Amherst: University of Massachusetts Press, 1972.

Uecker, Matthias. "The Face of the Weimar Republic: Photography, Physiognomy, and

Propaganda in Weimar Germany." *Monatshefte* 99, no. 3 (2007): 469–84.

Vaisse, Pierre. "Portrait of Society: The Anonymous and the Famous." In *A New History of Photography*, edited by Michel Frizot, 494–513. Cologne: Könemann, 1998.

Veth, Hilke. "Literatur von Frauen." In *Literatur der Weimarer Republik: 1918–1933*, vol. 8, *Hansers Sozialgeschichte der deutschen Literatur*, edited by Bernhard Weyergraf, 446–82. Munich: Hanser, 1995.

Villwock, Peter. "Goethe in Benjamins *Briefe*-Projekt." In Hahn and Wizisla, *Walter Benjamins "Deutsche Menschen,"* 157–75.

Vital, David. *A People Apart: A Political History of the Jews in Europe, 1789–1939*. New York: Oxford University Press, 2001.

von Ankum, Katharina, ed. *Women in the Metropolis: Gender and Modernity in Weimar Culture*. Berkeley: University of California Press, 1997.

von Schramm, Wilhelm. "Berlin als geistiger Kriegsschauplatz." *Süddeutsche Monatshefte*, no. 27 (1931): 513–14.

von Wilpert, Gero. *Sachwörterbuch der Literatur*. 7th ed. Stuttgart: Alfred Kröner Verlag, 1989.

Vorobeichic, Moishe. *Ein Ghetto im Osten: Wilna*. Zurich: Orell Füssli Verlag, 1931.

Walter, Hedda. *Mein Hundebuch: 48 Bildnisstudien*. Berlin: Riemer, 1931.

Wallstein, Marcel. "Shoots His Racing Car at a Target." *Popular Science*, January 1929, 22, 152.

Ward, Janet. *Weimar Surfaces: Urban Visual Culture in 1920s Germany*. Berkeley: University of California Press, 2001.

Ward, Stephen J. *The Invention of Journalism Ethics: The Path to Objectivity and Beyond*. Montreal: McGill-Queen's University Press, 2006.

Weber, Max. *The Protestant Ethic and the Spirit of Capitalism*. Translated by Talcott Parsons. New York: Scribner's, 1930.

———. "Die protestantische Ethik und der 'Geist' des Kapitalismus I." *Archiv für Sozialwissenschaft und Sozialpolitik*, no. 20 (1904): 1–54.

———. "Die protestantische Ethik und der 'Geist' des Kapitalismus II." *Archiv für Sozialwissenschaft und Sozialpolitik*, no. 21 (1905): 1–110.

Weinbaum, Alys, and Modern Girl Around the World Research Group. *The Modern Girl Around the World: Consumption, Modernity, and Globalization*. Durham: Duke University Press, 2008.

Weingart, Peter. *Doppel-Leben: Ludwig Ferdinand Clauss. Zwischen Rassenforschung und Widerstand*. Frankfurt: Campus, 1995.

Weise, Bernd. "Pressefotografie. I. Die Anfänge in Deutschland, ausgehend von einer Kritik bisheriger Forschungsansätze." *Fotogeschichte* 9, no. 31 (1989): 15–40.

———. "Pressefotografie. II. Fortschritte der Fotografie- und Drucktechnik und Veränderungen des Pressemarktes im deutschen Kaiserreich." *Fotogeschichte* 9, no. 33 (1989): 27–62.

———. "Pressefotografie. III. Das Geschäft mit dem aktuellen Foto: Fotografen, Bildagenturen, Interessenverbände, Arbeitstechnik: Die Entwicklung in Deutschland bis zum Ersten Weltkrieg." *Fotogeschichte* 10, no. 37 (1990): 13–36.

———. "Pressefotografie. IV. Die Entwicklung des Fotorechts und der Handel mit der Bildnachricht." *Fotogeschichte* 14, no. 52 (1994): 27–40.

———. "Pressefotografie. V. Probleme zwischen Fotografen und Redaktionen und der Beginn der Bildtelegrafie in Deutschland bis 1914." *Fotogeschichte* 16, no. 59 (1996): 33–50.

Weitz, Eric D. *Weimar Germany: Promise and Tragedy*. Princeton: Princeton University Press, 2007.

Weyergraf, Bernhard, ed. *Literatur der Weimarer Republik: 1918–1933*. Vol. 8, *Hansers Sozialgeschichte der deutschen Literatur*. Munich: Hanser, 1995.

Williams, John A. *Turning to Nature in Germany: Hiking, Nudism, and Conservation, 1900–1940*. Palo Alto: Stanford University Press, 2007.

Willimowski, Thomas. *Stefan Lorant: Eine Karriere im Exil*. Berlin: Wissenschaftlicher Verlag, 2005.

Winning, August. *Der deutsche Ritterorden und seine Burgen*. Königstein im Taunus: Langwiesche, 1939.

Witkovsky, Matthew S. *Foto: Modernity in Central Europe, 1918–1945*. New York: Thames and Hudson, 2007.

Wizisla, Erdmut. "'Plaquette für Freunde': Widmungen für die ersten Leser." In Hahn and Wizisla, *Walter Benjamins "Deutsche Menschen,"* 45–67.

Wolff, Paul. *Aus zoologischen Gärten*. Königstein im Taunus: Langwiesche, 1929.

———. *Formen des Lebens: Botanische Lichtbildstudien von Dr. Paul Wolff*. Königstein im Taunus: Langwiesche, 1931.

Wood, Christopher S. "Perspective: An Overview." In *Encyclopedia of Aesthetics*, edited by Michael Kelly, 3: 477–81. New York: Oxford University Press, 1998.

Wood, Gar. "Breaking 100 on Water." In *The Rudder Treasury: A Companion for Lovers of Small Craft*, edited by Tom Davin, 136–40. Dobbs Ferry, N.Y.: Sheridan House, 2003.

Wright, Jonathan. *Gustav Stresemann: Weimar's Greatest Statesman*. Princeton: Princeton University Press, 2002.

Wrocklage, Ute. "The 'Einmagazinierung' of Con-
 centration Camps, 1933–1939: Photographs
 and Visual Reports in the German Illustrated
 Press." Paper presented at the Séminaire des
 boursiers de la Fondation pour la Mémoire
 de la Shoah, Paris, December 14–15, 2009.
 http://www.fondationshoah.org/FMS/IMG/
 pdf/8-_Ute_Wrocklage.pdf (accessed June 30,
 2010).

Zervigón, Andrés Mario. *John Heartfield and the
 Agitated Image: Photography, Persuasion, and the Rise of
 Avant-Garde Photomontage.* Chicago: University of
 Chicago Press, 2012.
———. "Persuading with the Unseen? *Die
 Arbeiter-Illustrierte-Zeitung,* Photography, and
 German Communism's Iconophobia." *Visual
 Resources* 26, no. 2 (2010): 147–64.

index